SOUTHERN APPALACHIAN CELEBRATION

THE UNIVERSITY OF NORTH CAROLINA PRESS *Chapel Hill*

In Praise of Ancient Mountains, Old-Growth Forests, & Wilderness

James Valentine

with text by CHRIS BOLGIANO *and Foreword by* WILLIAM H. MEADOWS

This book is fervently dedicated to my dear father, J. Manson Valentine.
His unending love for the Appalachian Mountains and the world as a post-
Victorian naturalist, scientist, photographer, explorer, and evolutionist
gave me the inspiration to "respect nature—suspect theory."

© 2011 James Valentine Text © 2011 Chris Bolgiano Foreword © The University of North Carolina Press
All rights reserved. Designed and set by Kimberly Bryant in Espinosa Nova with Avenir types.

Manufactured in China. The paper in this book meets the guidelines for permanence and durability
of the Committee on Production Guidelines for Book Longevity of the Council on Library Resources.
The University of North Carolina Press has been a member of the Green Press Initiative since 2003.

Library of Congress Cataloging-in-Publication Data
Valentine, James.
Southern Appalachian celebration / James Valentine ; with text by Chris Bolgiano ; foreword by William H. Meadows.
 p. cm.
Includes index.
ISBN 978-0-8078-3514-2 (cloth : alk. paper)
1. Natural history—Appalachian Region, Southern—Pictorial works. 2. Biodiversity—Appalachian Region,
Southern—Pictorial works. 3. Habitat (Ecology)—Appalachian Region, Southern—Pictorial works. 4. Appalachian
Region, Southern—Pictorial works. I. Title.
QH104.5.A62V35 2011
508.9756′8—dc22 2011005519
cloth 15 14 13 12 11 5 4 3 2 1

Image on p. i: *Mature forest, Wildacres Retreat, Little Switzerland, North Carolina.*
Towering trees contribute their quiet grace to the retreat center's goal of fostering interfaith dialogue.
Many visitors feel closer to divinity in an old, undisturbed forest, which some call a natural cathedral.

Image on pp. ii–iii: *Rhododendrons, Craggy Gardens, Blue Ridge Parkway Milepost 364, North Carolina.*
A mid-June sunrise lights rhododendrons in full bloom on a bald, a treeless summit. Balds add a unique—
and puzzling—set of habitats to the diverse natural communities of the Southern Appalachians.

Contents

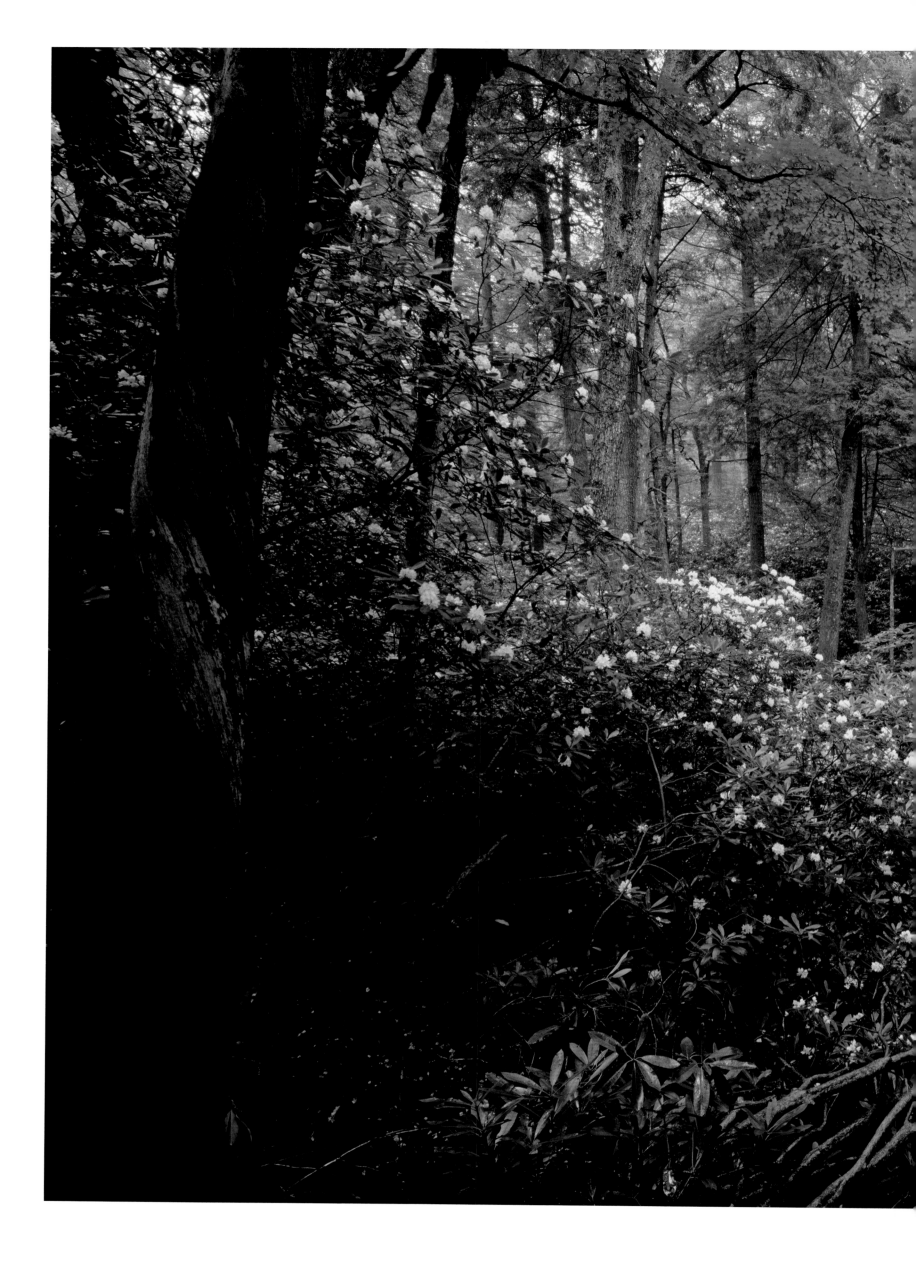

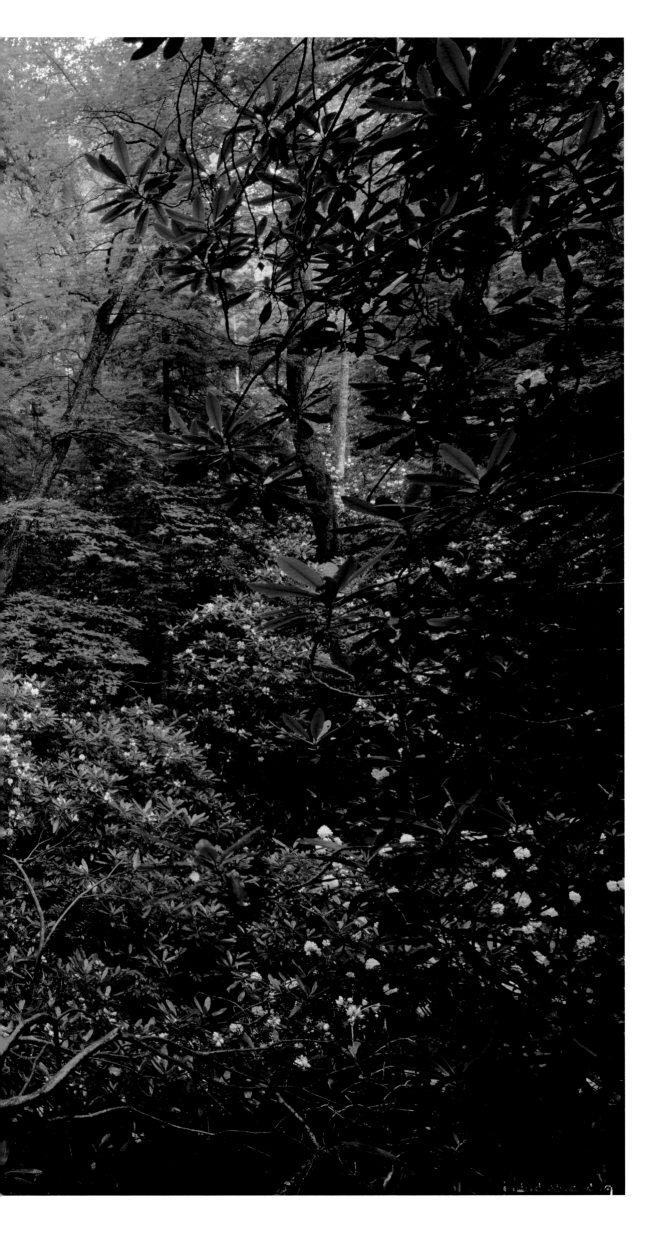

Coker Rhododendron Trail, Highlands Biological Station, Highlands, North Carolina Rhododendrons thrive in the shade of hemlocks and hardwoods in an old-growth forest study area. Part of the University of North Carolina system, Highlands Biological Station operates year-round as a field laboratory for studies of biodiversity, the variety of living organisms.

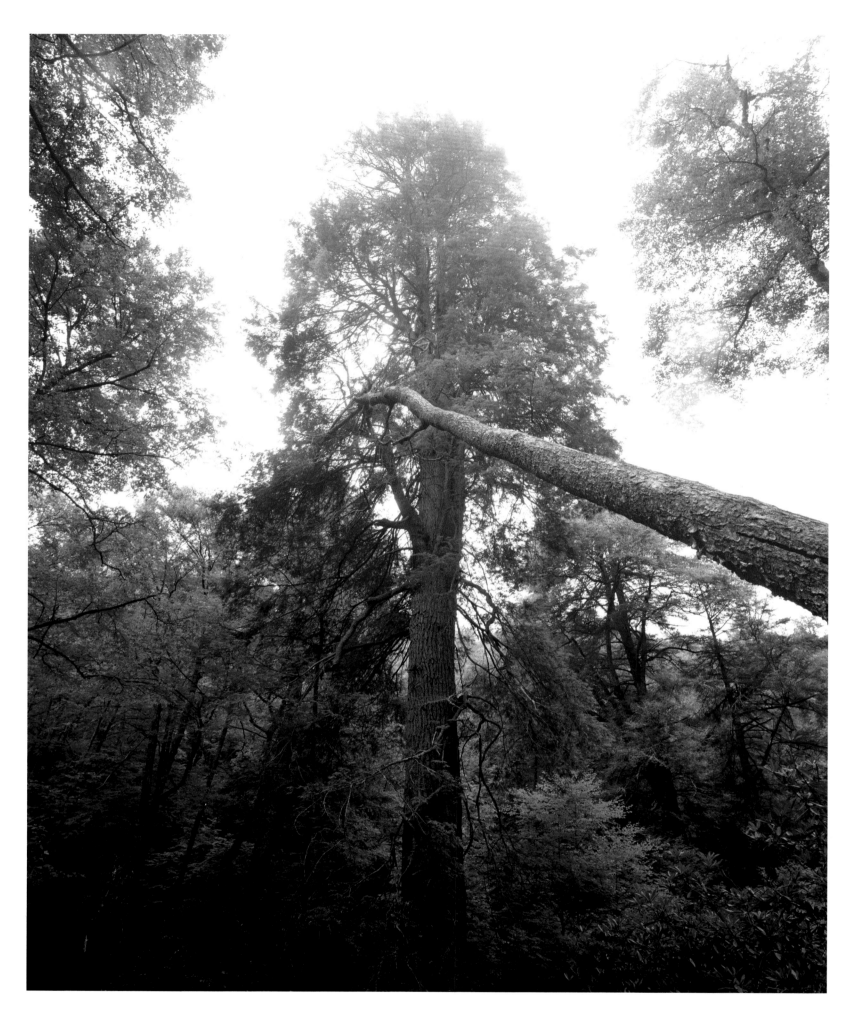

Eastern hemlock, 61.1 inches diameter at breast height, Henry Wright Preserve,
Highlands-Cashiers Land Trust, Highlands, North Carolina

Measured by expert arborist Will Blozan, this hemlock is nearly 159 feet tall, contains 1,564 cubic feet of wood, and has been nominated as the national champion tree of its tribe. Insecticide treatments keep hemlock woolly adelgids, a tiny, white, and fuzzy nonnative sucking insect, from killing this tree. But a recent storm blew a birch tree into it, enacting the often perilous dynamics that open small gaps across the forest.

The Southern Appalachians are my home country. Growing up in Tennessee, I learned to love the region's verdant hills and valleys, and I enjoy returning to visit my southern roots to this day. The idea of preserving wilderness in the Southern Appalachians (where skeptics insisted it could not be found) became a personal quest of mine during the 1970s while I was volunteering for the local chapter of the Sierra Club.

William H. Meadows
President, The Wilderness Society

Foreword

The Club's advocacy campaign to pass the proposed Eastern Wilderness Act sent a few of us on the road to present slide shows to church groups and civic organizations in order to raise awareness about the wild character of the landscape just outside their doors. Congress enacted the legislation in 1973, and I had my first real taste of wilderness at about that same time—during a hike into the Gee Creek Wilderness Area, a small watershed within the Cherokee National Forest.

Now serving as president of The Wilderness Society, I have the privilege of leading an organization that has long recognized the intrinsic value of the Southern Appalachians' singular wild lands and that is deeply committed to making certain they remain intact for generations to come.

This book is a paean to the Southern Appalachians, remarkable for its multi-hued depiction of a heartbreakingly beautiful and biologically rich part of our country, whose unique values are at risk from a host of human-caused pressures. Population growth and sprawl, road-building, off-road vehicle abuse, and air pollution present enormous problems for the Southern Appalachians, as does the most environmentally devastating threat facing our planet in the twenty-first century: climate change.

Few photographers could surpass the care and artistry reflected in Jim Valentine's evocative images or draw such a colorful portrait of a region he knows so intimately and cherishes for the unending well of inspiration it provides. Jim has always impressed me with his enthusiasm for wild places, a fervor matched only by his relentless drive to bring the Southern Appalachian story to life.

It took more than a decade and countless sojourns in the backcountry with a camera, from valley floor to mountaintop, to capture this collection of eloquent photographs. They open a new window on the Southern Appalachian region, one that offers us the chance to take a rare journey with him and experience those magical moments when the sheer splendor of the landscape would shine through the lens.

Chris Bolgiano's text is the book's grace note, both sparkling and spare. She has judiciously chosen each descriptive phrase to weave together a succinct history of the ecology and culture that define this beloved region. Using an economy of words, Chris ties the photographs together into a cohesive whole and at the same time keeps the reader engaged and moving forward.

Those of us who relish the ecological diversity and natural wonders of the Southern Appalachian mountains recognize that the time to protect them is running out. If The Wilderness Society has its way, Congress will soon see fit to place some of the wildest, most remote and vulnerable corners of this landscape into the National Wilderness Preservation System. This book takes a huge leap in helping achieve that wilderness goal by shining a spotlight on the spectacular wildness still left in the East—and by giving us cause to celebrate a real treasure in our midst.

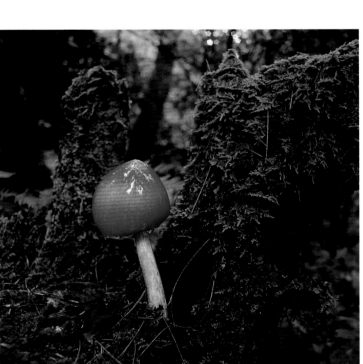

Mushroom, Highlands Biological Station, Highlands, North Carolina
Mushrooms hint at a universe of unseen life below ground. Fungi are among the most diverse of all life-forms in the forest, with some 2,800 species identified in the Southern Appalachians and more still being discovered. The roots of many species of trees and flowers entwine with specific fungi that help to absorb nutrients.

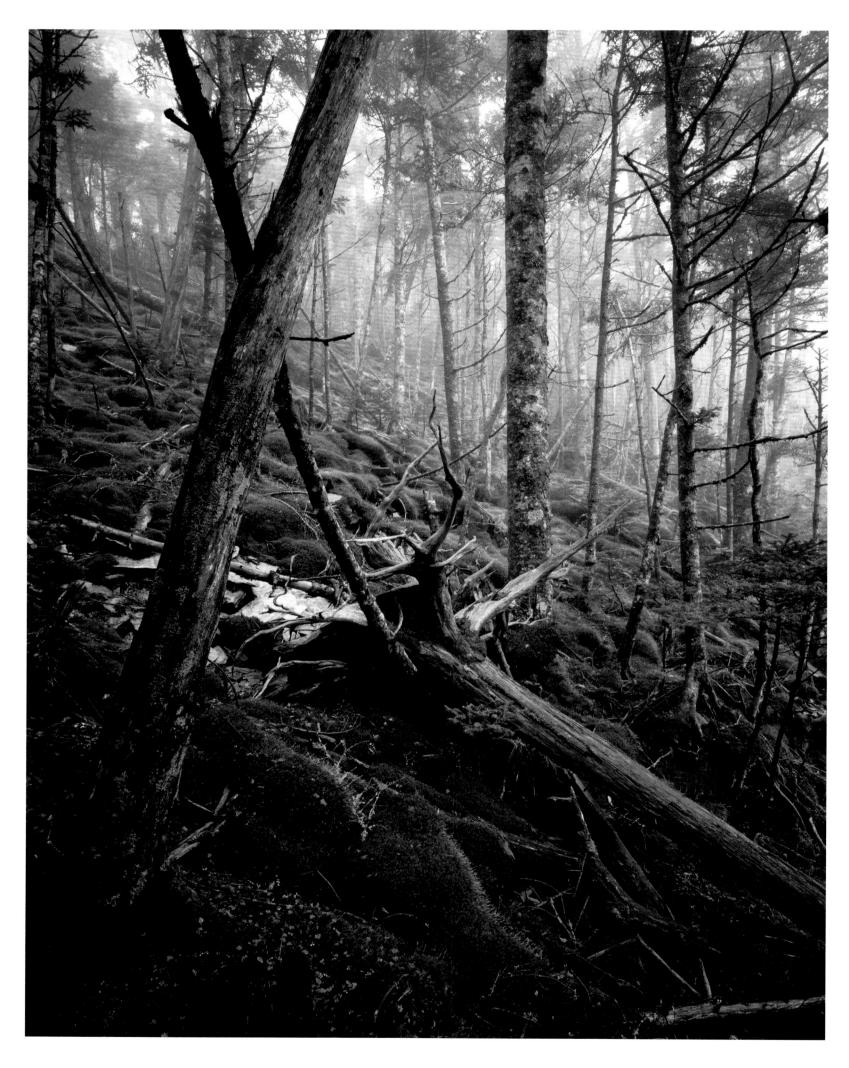

Mt. LeConte, Great Smoky Mountains National Park, North Carolina/Tennessee
Several hundred species of moss upholster the slopes of the Great Smoky Mountains. More plant and animal species
live in the 800 square miles of the park than in any other area of equal size in the world's temperate climate zone.

One of my earliest childhood recollections of the Southern Appalachians came in the form of crawling on my hands and knees collecting tiny beetles for my father, J. Manson Valentine, a noted Smithsonian naturalist, entomologist, and biologist, who came to North Carolina in the 1940s. What a joy to witness the minute world scuttle out from under tiny leaves, as I introduced my own rainstorm by scooping water from a nearby stream. At six years old, I received a *bio-logical* awakening from this miniature sacred wonderland. This indelible experience really put me in touch with how the infinitesimal world holds the planet together. As Thoreau said so well, "Nature is mythical and mystical always, and spends her whole genius on the least work."

James Valentine

Today I still sit with awe, speechless under the canopy of temperate Appalachian "Old Growth Landscapes," a term I have coined to connote rare, remote wilderness hillsides, mountaintops, and gorges that have never succumbed to the ax. A multitude of old-growth tree and herbaceous species, giant and small, make up these unique landscape mosaics. Even the root systems of buck berry bushes can be over a thousand years old. We are dependent on the forests for each breath we take and the clean water they help provide. We, in turn, give them carbon dioxide, while we also create excessive amounts of industrial carbon that continually overburden the forests in their capacity to create oxygen via photosynthesis. Each tree has a built-in organic fractal system that exactly places each leaf in a noncompetitive, overlapping position on the limbs to absorb sunlight. It has been estimated that a big American elm can hold 6 million leaves. These unique biodiverse green factories help maintain our biodiverse bodies with a multitude of foods and provide a living pharmacy of beneficial medicines.

These magnificent solar-collecting ancient forests have been working in biological unison for millions of years, each tree helping its neighbors make and share the soils beneath them. The old-growth landscape soils are held together by millions of miles of roots (some microscopic), leaf and fallen-tree biomass, stable nutritional organic chemistry, interlocking bacteria, minerals, mosses, mold, fungus, worms, arthropod populations, and tons of minuscule insects. A five-gallon bucket of rich woodland soil might contain 50,000 springtails, 100,000 mites, plus many tens of thousands of other arthropods all adding up to millions of minute moving parts in even this small amount of decomposing matter. All these life-forms work together day and night to create healthy soils.

Our very lives and that of the forest are dependent on these sacred soils. You can see why it can take the forest hundreds of years to recover from the devastating consequences of clear-cutting. It must not only replace the loss of genetic stock, tied to the destruction of species and habitat, but also recover from the horrendous damage caused by soil erosion. The older and thicker the primeval layer of ground-laden biomass, the healthier the forests are. The soils make new forests; the forests in turn create microclimates along with the oceans. And, after all, climates reign supreme in regulating the living earth.

What incredible miraculous cycles these are that dictate how long we humans can exist on the planet. We know what happened to Easter Island when the forests were removed. When we save our mountains, we save ourselves, along with multi-trillions of beautiful organisms that form wilderness forests and aquatic habitats. The visionary inspiration variously provided by André Michaux, Aldo Leopold, my naturalist father, Bob Zahner, and Chris Bolgiano, whom Bob introduced to me, have helped shape a deep understanding of the ecological sacredness of the Southern Appalachians that the images in this book are meant to convey.

I have walked hundreds of miles into mountainous wild places in all seasons with large-view cameras in order to photograph the magnificent cathedrals of old-growth forests and wilderness landscapes. The Cherokee had marvelous names for the features of this territory, such as *Walasiyi—the place of the large green mythical frog*, referring to Mt. LeConte. The original inhabitants walked lightly on the land and understood its sacred green importance.

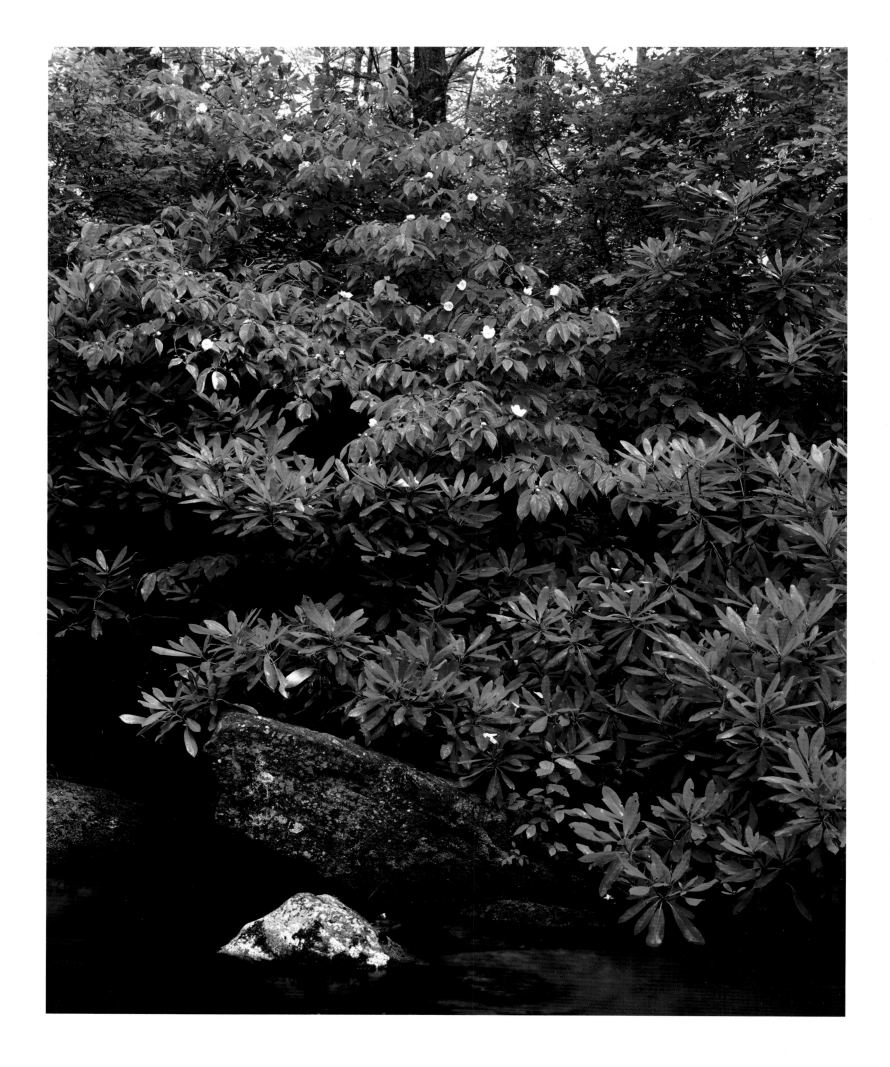

Mountain camellia, Overflow Wilderness Study Area, Nantahala National Forest, North Carolina
The mountain camellia, also called summer dogwood, is a small, rare, deciduous tree along wooded streams. This part of its range lies in the area proposed as the Bob Zahner Wilderness, in honor of one of the greatest champions of Southern Appalachian forests.

It was raining hard on the morning of June 16, 1787, when a Frenchman by the name of André Michaux led his two horses up the steep trail through the gap in the ridge far below where I stand today. His path was one made over millennia by migrating hooves and paws of eastern wood bison, deer, and elk, followed by their predators, red wolves and cougars, aided by local movements of black bears, foxes, raccoons, bobcats, and in earlier times, ground sloths, all following the course of greatest economy of effort. Native Americans adapted these trails to their own uses, initially for hunting and gathering forays, and later also for travel between villages for clan and council meetings.

In 1787 this trail wound through magnificent primeval forests, huge trees of many species, eastern hemlock, yellow birch, red maple, tulip tree, chestnut, black cherry, red oak, white pine, and silver bell, their canopies reaching over a hundred feet to form gigantic natural cathedrals. Michaux's journal records the landscapes, forests, plants, and weather encountered in ten years of journeying though the Southern Appalachian Mountains.

Now I see an asphalt road constructed along this same trail, a road leading to more than a dozen summer homes, the houses perched on steep slopes where a few decades ago no one would have dared build anything. The primeval forest is long gone and with it many of its original inhabitants, the mountain lion, red wolf, American chestnut tree, passenger pigeon.

From my vantage point on the crest of Whiteside Mountain overlooking the Chattooga River Valley, I am visualizing a two-hundred-year time warp, for below me I see vestiges of all the changes we have imposed on this landscape. A few tiny remnants of old forest endure, but there are many abandoned pastures and corn patches, now growing up in young pines, sassafras, and locust, reminders of early homesteads when the coves below were abounding with large families and their livestock.

A few key terms symbolize the past two hundred years, bringing me to the present view of this landscape: wagon road, cross-cut saw, mule team, sawmill, feral hog, "Trail of Tears," woods burning, timber baron, soil erosion, Winchester rifle, bear hound, national forest, electric utility easement, paved road, pickup truck, tourist, hydroelectric dam, clearcut, summer home, bulldozer, golf course, and, most recently, the hemlock woolly adelgid introduced from the Orient. All this, modern man's impact, some wounds healing, others fresh and opening, spread out across the mountain slopes, valleys, and ridges before me.

I see traces of old logging railroads, fire-scarred mountain slopes where regrowth forests are struggling to regain a foothold, and decaying ghosts of chestnut trees. The fact that these oldest remnants of past wounds are scarcely discernible today speaks for the remarkable resilience of our Southern Appalachian forested landscape. Today, as we drive or hike through the mountains, we have no concept of the primeval forest, of how it appeared to Michaux more than two centuries ago.

High up in the Cowee Mountains, I once found the decaying photograph of a middle-aged couple pasted to the wall of a crumbling, long-deserted homesteaders' cabin. I was a young man then, sixty years ago, and I have been haunted since by what I read in the eyes of the man and the woman in the photograph. Visions of a good life were dulled, hope for the future seemed gone, and all I could see was the grind of their struggle to exist. Their children would have none of this pioneering life and had left the mountain for the city long ago. The forest had already overgrown the garden and pasture, and only the huge English boxwoods survived in healthy condition on either side of what remained of the steps to the front porch. A large timber rattler had made a home in the disintegrating rock chimney.

These pioneers had tamed—nay, destroyed—the wildness of their mountain cove. Their ax and saw removed a few acres of forest, their livestock and woods burning ravaged another hundred, and their rifle killed most wildlife within several miles. A lumber baron offered them a pittance for their timber. Their plow eroded the soil, and in the end their eyes became as unresponsive as the land's ability to support them. This example encapsulates the struggle between natural and human history that played itself out in the Southern Appalachians early in the twentieth century. I used to think that nature had won many of these earlier struggles as old homesteads melted into the regrowth, but now I know that nature is no

Robert Zahner, Ph.D.

Introduction

match for today's bulldozer and acid rain. Not an acre of the primeval forest through which Michaux journeyed remains unaffected by human impact. Besides extirpating native species, modern man has introduced too many exotic species that overwhelm nature, including deadly pests like the woolly adelgid and the chestnut blight. Air pollution permeates even the most remote wilderness left, slowly deadening the life in soils and streams.

But I discovered 25 years ago that James Valentine is an optimist. Jim guided me on hikes to remarkable places. He rekindled my faith that perhaps all our mountain nature is not lost. He took me up to high ridges and down into cascading streams where few modern people ever visited. These were not the celebrated mountaintops and waterfalls of our tourist brochures, nor were they deep in backcountry wilderness areas. All we really wanted was to head out on walks where it's easy to lose the path, where we could find a bit of quiet solitude only a mile or two from town. Jim has a knack of making you realize that these simple places are indeed unique and extraordinarily beautiful.

Because of the rain and dense fog, Michaux was not aware of the towering cliffs above his trail, but he soon discovered that he was crossing over a divide that separated east-flowing streams from west-flowing ones. Today we call this the Blue Ridge Divide, and from it flow waters that give sustenance to millions of people in cities of the southeastern United States. Michaux had just written in his journal, " At noon we took a short halt to drink from a brook, where the water was the purest and best one could drink in America."

These streams that tumble down from our mountains merge to become the mighty rivers of the Piedmont and the Tennessee Valley. They still form picturesque waterfalls at the headwaters, but we no longer dare to drink from them. And within a few miles downstream, almost without exception, our streams are now instruments of modern technology.

For example, as I climb Whiteside Mountain, I pass the headspring of the Cullasaja River. Now from my vantage point on top of the mountain I can trace its valleys westward, and I count five dams and reservoirs in its first ten miles. In this short distance, the river picks up the sewage effluent from four golfing communities and a town of several thousand people. The native brook trout, sensitive to these changes, are long gone, replaced by the transplanted exotic rainbows.

Jim Valentine drew the theme for this book from Aldo Leopold's classic essay "Thinking Like a Mountain." An appropriate choice, as it conveys the consequences of man's intrusion on biotic communities. To think like a mountain means to consider the needs of all the plants and animals that make the mountain their home, including rain, air, streams, soil, humus, and microorganisms. Writing in the first half of this century, Leopold formed the ecological principles on which our modern science of conservation biology rests.

The preservation of "biological diversity" has become the goal of conservation biologists. The term is no longer limited to the diversity of just individual species; it encompasses all levels of life from genes to ecosystems, and all life processes from the pollination of flowers to the successful birth of bobcat kittens. This means that every species must retain the genetic ability to respond to environmental changes, and that diverse habitats across the landscape must provide pathways from mountain range to mountain range. In other words, biodiversity cannot survive in isolated, inbred patches: there must be provision, through interconnected biotic communities, for outbreeding of everything from gentians, salamanders, and brook trout to mountain winterberries and pileated woodpeckers.

Aldo Leopold often used the word "beauty" in reference to biotic communities. Was he referring to more than aesthetic beauty, perhaps to the miracles of life that come together to make the composition that Jim Valentine's photographs convey so clearly? What do we "see" when we look into the scene of a cool mountain brook flowing through a grove of old trees and streamside flowers? Is this simply a pretty picture to hang on the wall? Or do we imagine havens for unseen animals, deer mice stashing away acorns, nectar for a myriad of insects, deep green foliage producing the planet's oxygen? Jim's ability to recognize all this "beauty," and then to capture it through his camera lens, gives us the inspiration to protect, to preserve, to *save* this wild mountain heritage.

Mountain camellia, Overflow Wilderness Study Area, Nantahala National Forest, North Carolina Large, showy blossoms and colorful fall leaves make mountain camellias attractive to horticulturalists, but the plants are very difficult to grow. Poaching of this species—a dire threat to other Appalachian wildflowers and medicinal herbs—is not a problem because transplanting it is so predictably unsuccessful.

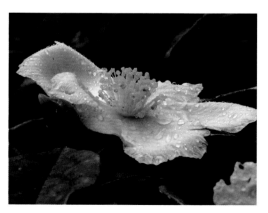

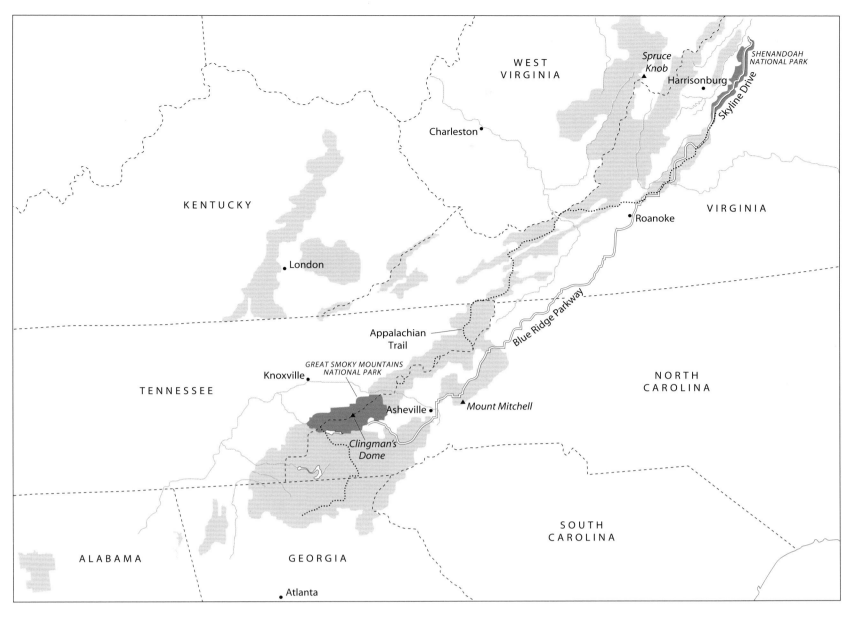

Even though no truly undisturbed place may be left in the Southern Appalachians, there is certainly the possibility of saving much of the next best thing—those fragments that to us appear at first glance to be pristine habitats full of natural life. Jim Valentine has spent most of his adult life searching for such places here in our mountains. With his book he is presenting photographic impressions of many of his findings. As Jim's artistry shows, there remains much of Leopold's "beauty" in our forests, streams, and landscapes.

Our task now is to ensure the preservation of these places, and protect them from the bulldozer, chainsaw, and urbanization. Perhaps we can then reintroduce in them some of the wild nature we have taken away, red wolves, peregrine falcons, brook trout, and the chestnut tree. And as a nation of informed people we must clean our mountain air and clean the rain that falls on our soils and into our streams.

The American experience has been to isolate ourselves from nature, to take away and not give back. In order to save our mountains, as this book demands, we must think like a mountain. It is clear that our course must change from man *versus* nature to man *and* nature. Restoring and protecting native habitats is man's challenge for the next century, but not just for saving nature—it is for saving ourselves.

As we turn the pages of this beautiful book, let us celebrate with Jim Valentine a few of the wild places he has discovered and is now sharing with us. Imagine that these are photographs not of a few remnants of nature, but of entire wild landscapes. Visualize pristine forests and clear streams covering entire mountain ranges, and even wolves and cougars free to roam from one range to the next. Eventually, as the Southern Appalachian wilderness continues to mature, our grandchildren and their children may again feel the same wonder of exploring truly wild places that André Michaux felt.

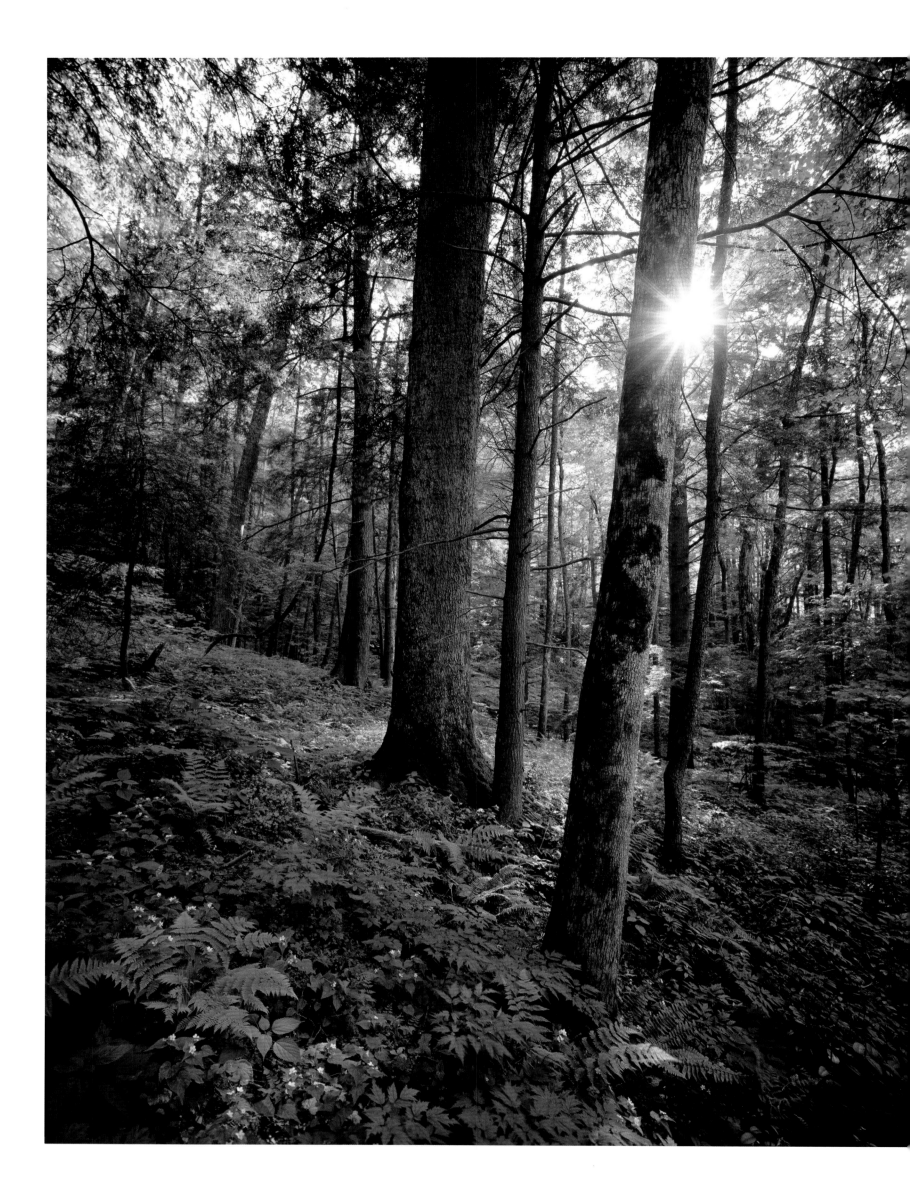

Appalachia is a state of mind and country. Loosely defined as the southern half of the Appalachian Mountain range, below the chilling effects of glaciers to the north, this legendary region is a globally ranked refuge for biodiversity. Trees are believed to have evolved in the sheltered, relatively undisturbed hollows of these southerly mountains over the last 200 million years. First came club mosses and horsetails, then palmlike cycads, then ginkgoes, hemlocks and pines, and finally the deciduous hardwoods for which Appalachia is most famous—oaks, hickories, maples, walnuts, chestnuts, cherries, beeches, birches, basswoods, and dozens more. One hundred species of trees and more than ninety species of shrubs are native to the Great Smoky Mountains National Park, which contains one of the largest blocks of temperate, old-growth forests remaining in North America.

The levels of forest understories are correspondingly rich. Appalachian wildflowers have drawn botanical interest since the eighteenth century and are today an increasingly popular tourism draw. Herbs and forbs, shrubs and small trees grade upward into a canopy dominated by massive crowns of old trees, many of which produce nuts or fruit. Natural forest disturbances tend toward the small-scale, such as blowdowns by fierce winds, fires from lightening strikes, and insect infestations. Generally, only a few acres of trees die, enough to allow sunlight to germinate light-dependent seeds. Elsewhere, trees slowly prune themselves by shading out competitors and dropping lower limbs.

Across rocky ridge tops, along moist northern slopes and dry southern exposures, the Appalachian forest is a shifting mosaic of plant communities. Each stand of trees expresses nuances of soil, climate, and the history of human use. Mountain soil is unevenly fertile, with productive floodplains and scattered limestone valleys attracting intensive human agriculture. Climate is temperate, even subtropical south of 40 degrees latitude. Rainfall is generally ample, although local variance runs from nearly tropical lushness to semiarid slopes where prickly pear cacti thrive. Here live plants and animals—and peoples—like none other on earth. New species are still being discovered. This unique diversity of life invests Appalachia with mystery and grandeur better conveyed by images than words.

(OPPOSITE) *Bitternut hickory (center), 35.8 inches in diameter at breast height, Sugarlands, Great Smoky Mountains National Park, North Carolina/Tennessee*
The "hickory smoked" flavor of pork often comes from bitternut hickory wood. Aptly named, the nuts are generally unpalatable to most wildlife, although many other kinds of hickories as well as oaks, chestnuts, walnuts, and hazelnuts produce highly favored fruit. Bitternut hickories have exceptionally dense root systems that help grip soil tightly against erosion. Canada violets, fancy wood ferns, and a white ash in the foreground appear to thrive in the same soil.

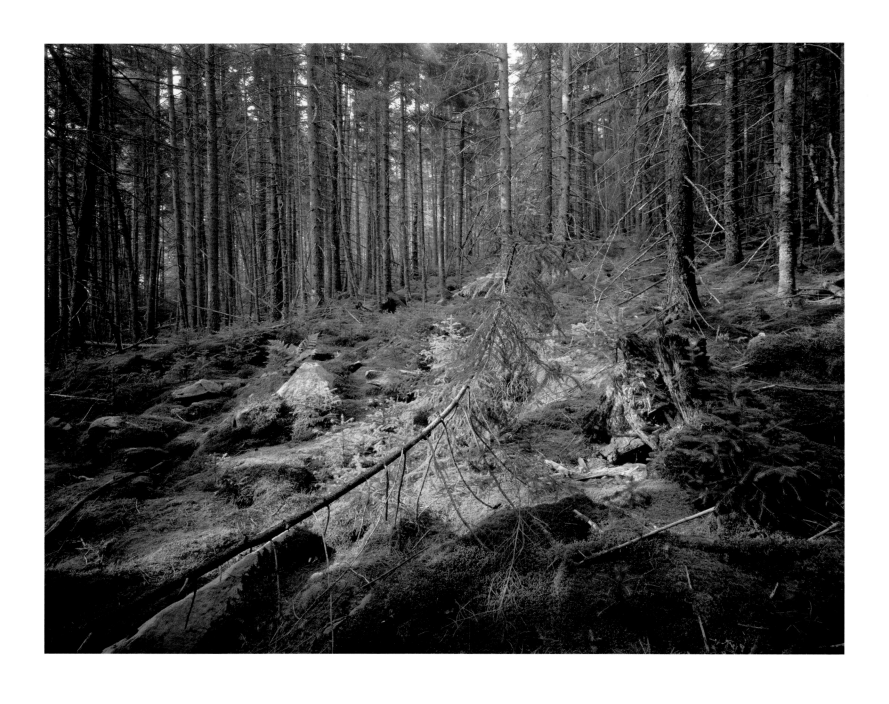

Gaudineer Scenic Area, Monongahela National Forest, West Virginia
Sunlight pours into a canopy gap left by a windthrown red spruce. The fifty acres
here of virgin red spruce are a remnant of the hundreds of thousands of acres of
spruce-fir forests that originally covered high-elevation ridges. A surveyor's error
before the Civil War allowed this strip of trees to escape logging.

Short Hill Mountain, Natural Bridge, Virginia
Of the many images of Appalachia embedded in the American mind, surely the
most glorious is the autumnal forest. The palette of colors on Short Hill Mountain
paints a complex picture of forest communities found nowhere else on earth.

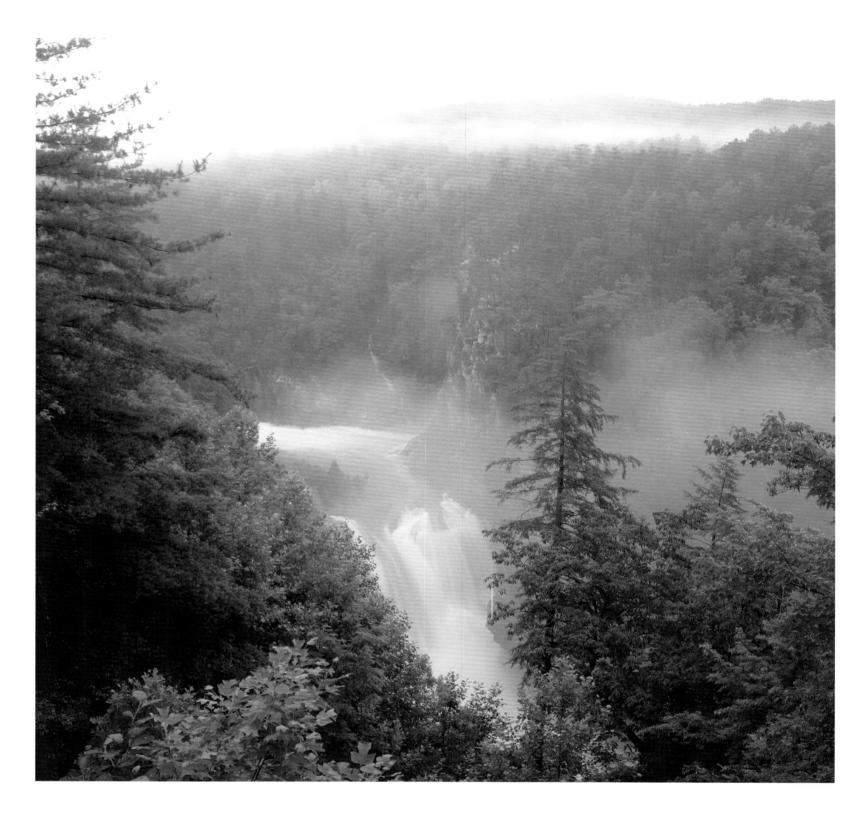

Tallulah Falls, Tallulah Gorge State Park, Tallulah Falls, Georgia
The roar of the falls cutting through two miles of canyon could be heard for miles
before 1913, when a hydroelectric dam was built upstream to power Atlanta's streetcars.
The dam still redirects most of the Tallulah River to an electricity-generating plant,
but Georgia Power releases water on a schedule for recreational use.

(OPPOSITE) *Flat Top Mountain, Cohutta Wilderness, Chattahoochee National Forest, Georgia*
Birches and ferns appear bathed in a primeval mist. But forests here—like most Southern
Appalachian forests—were logged and burned in the early twentieth century during a holocaust
of timbering. Only a few remnants of the original Great Forest remain.

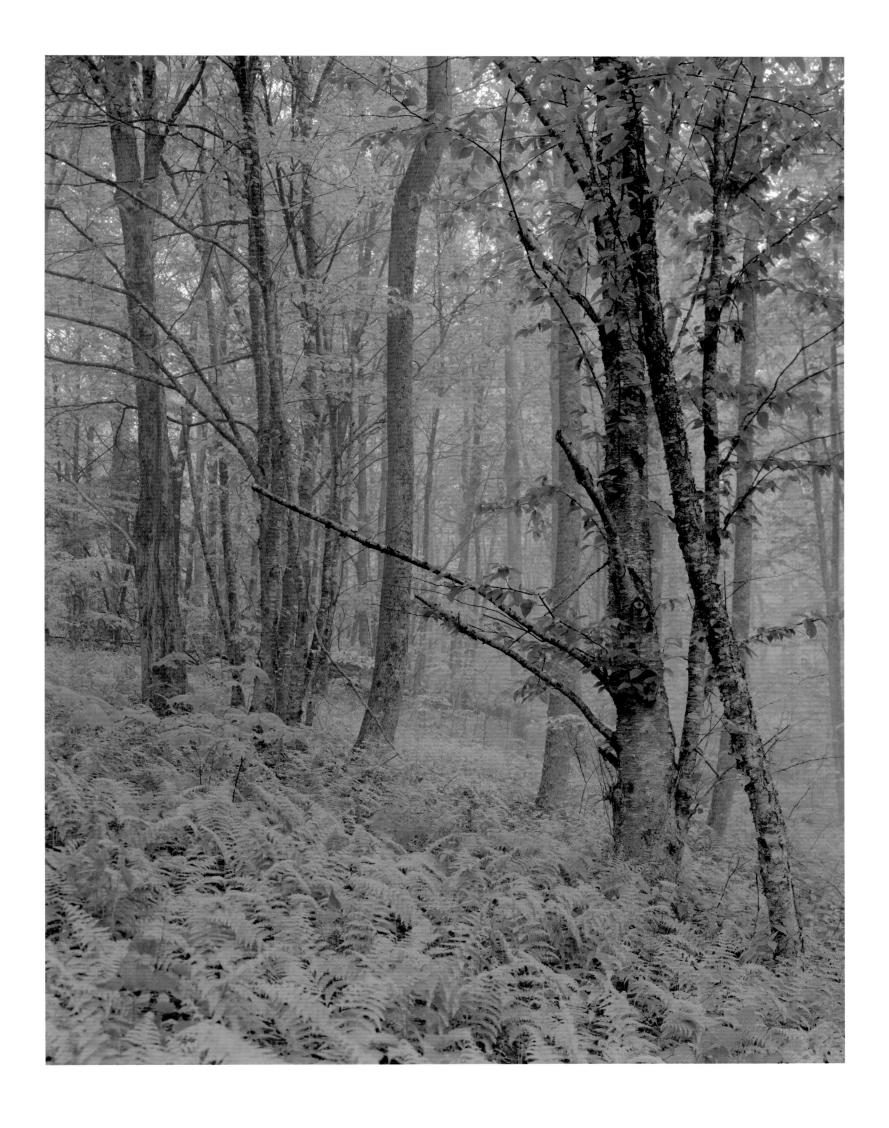

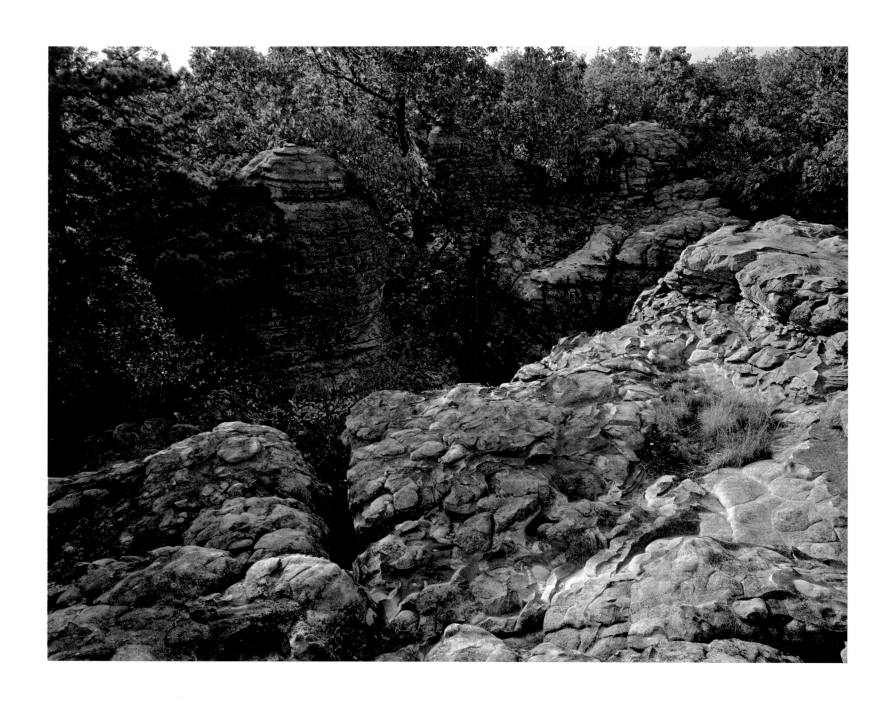

Pigeon Mountain, Crockford-Pigeon Mountain Wildlife Management Area, Georgia
The passenger pigeons that once roosted here by the millions were extinct by 1914, but
golden eagles that had been extirpated were reintroduced and now sometimes nest in the
craggy heights. Some of the large sandstone rocks appear to have been shaped by human
hands, but are not claimed by the Cherokee. In 1900, anthropologist James Mooney wrote:
"There is a dim but persistent tradition of a strange white race preceding the Cherokee,"
known as the "moon-eyed people" because they could not see in daylight.

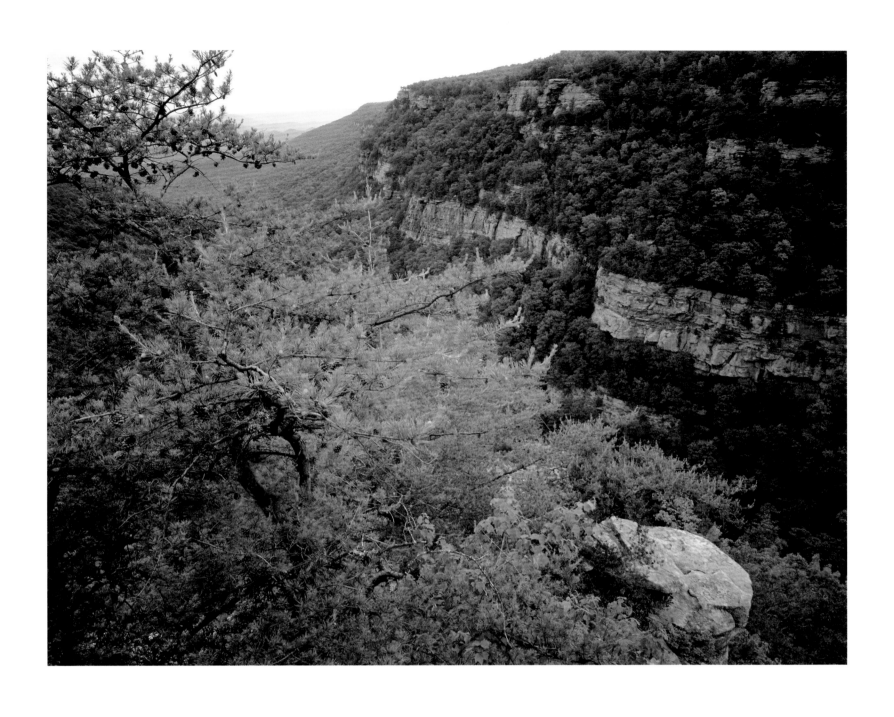

Cloudland Canyon, Rising Fawn, Georgia
The names say it all: a rugged canyon with rimrock views over the seemingly endless
Cumberland Plateau, near a town named after a Cherokee princess. This high perch is
a good spot for watching warblers and other neotropical birds because it lies beneath
one of the world's great migratory routes, the Appalachian flyway.

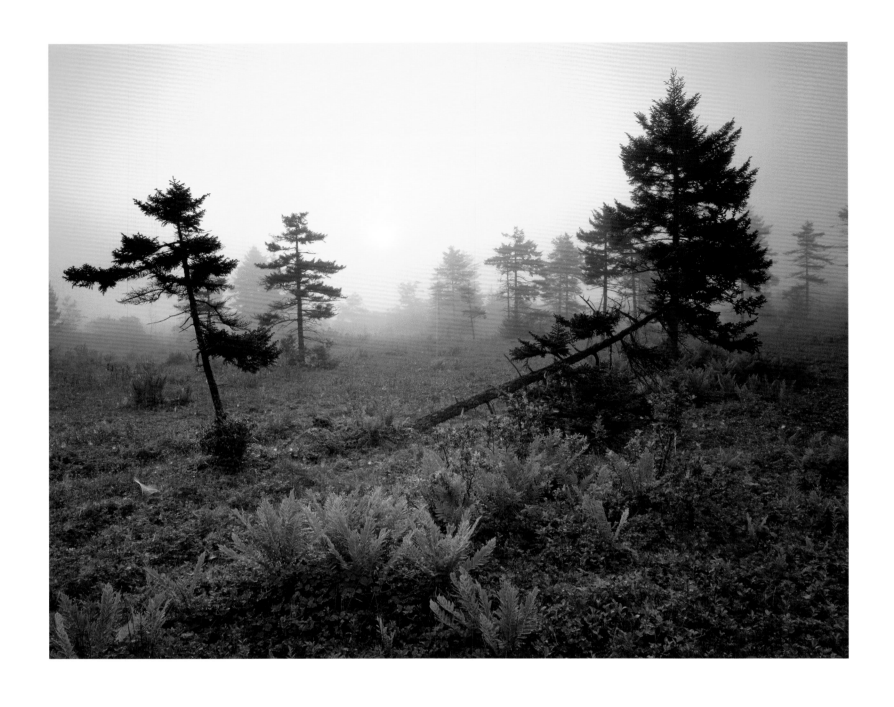

Cranberry Glades Botanical Area, Monongahela National Forest, West Virginia
This series of acidic wetlands at an elevation of 3,400 feet most closely resembles the muskegs of much farther north: boggy depths of sphagnum moss and partially decayed plants, resembling peat. Northern species such as cranberries and various mosses moved southward in the cooling effects of glaciers in Pennsylvania, then retreated upslope as the lowlands warmed. The Glades are now the southernmost edge of many cold-adapted species.

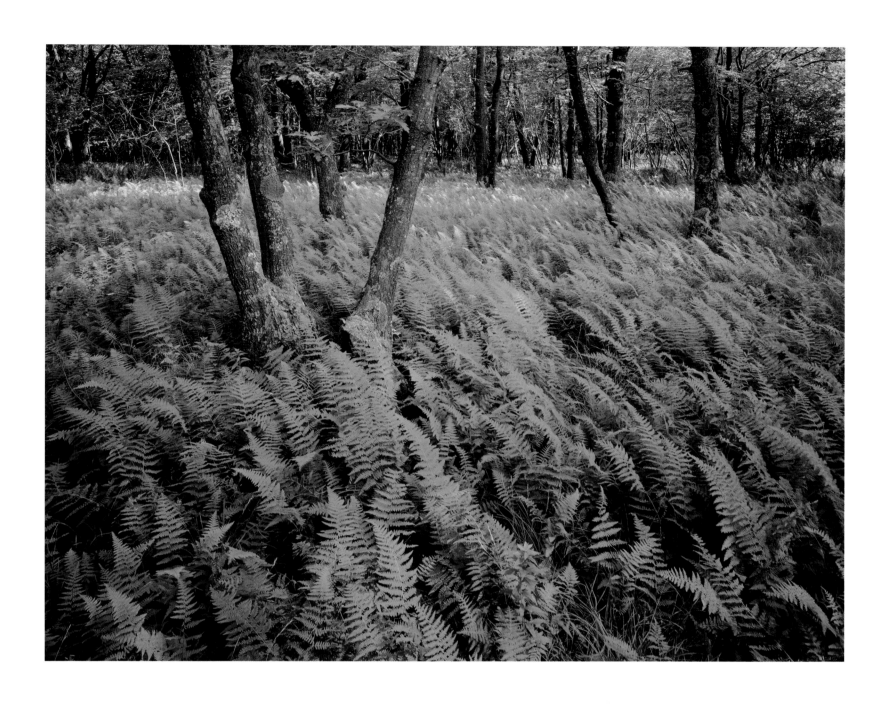

Ferns, Dolly Sods Wilderness Area, Monongahela National Forest, West Virginia
New York ferns (*Thelypteris noveboracensis*) and hayscented ferns (*Dennstaedtia punctilobula*)
are similar and often confused. Both spread in huge thickets that seem to epitomize the
deep, undisturbed woods, but they can actually reveal a legacy of land abuse. Logging and
subsequent wildfires in the early twentieth century destroyed the upper layer of organic
soil and exposed a mineral layer that few other plants can tolerate.

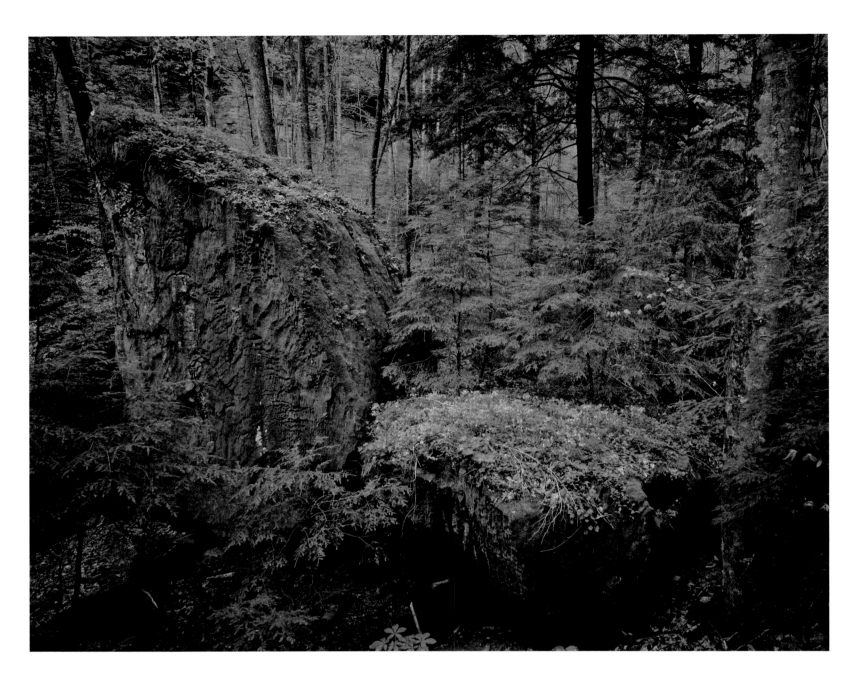

Sipsey Wilderness, Bankhead National Forest, Alabama
Phlox and other flowers bedeck boulders in scattered stands of unlogged trees
on steep slopes. Old growth here includes oaks, hickories, beeches, birches, poplars,
and hemlocks. Hemlocks and some species of moss reach the southernmost end
of their range here, as did, in centuries past, the Cherokee Nation.

(OPPOSITE) *Red maple, 27 inches in diameter at
breast height, Pisgah National Forest, North Carolina*
Red maples thrive on a wider range of soils, moisture,
and elevation than any other tree in the East. Foresters
sometimes disparage red maple as a "soft" wood,
but birds and mice dine on the seeds, deer browse the
twigs, and people love its fall color.

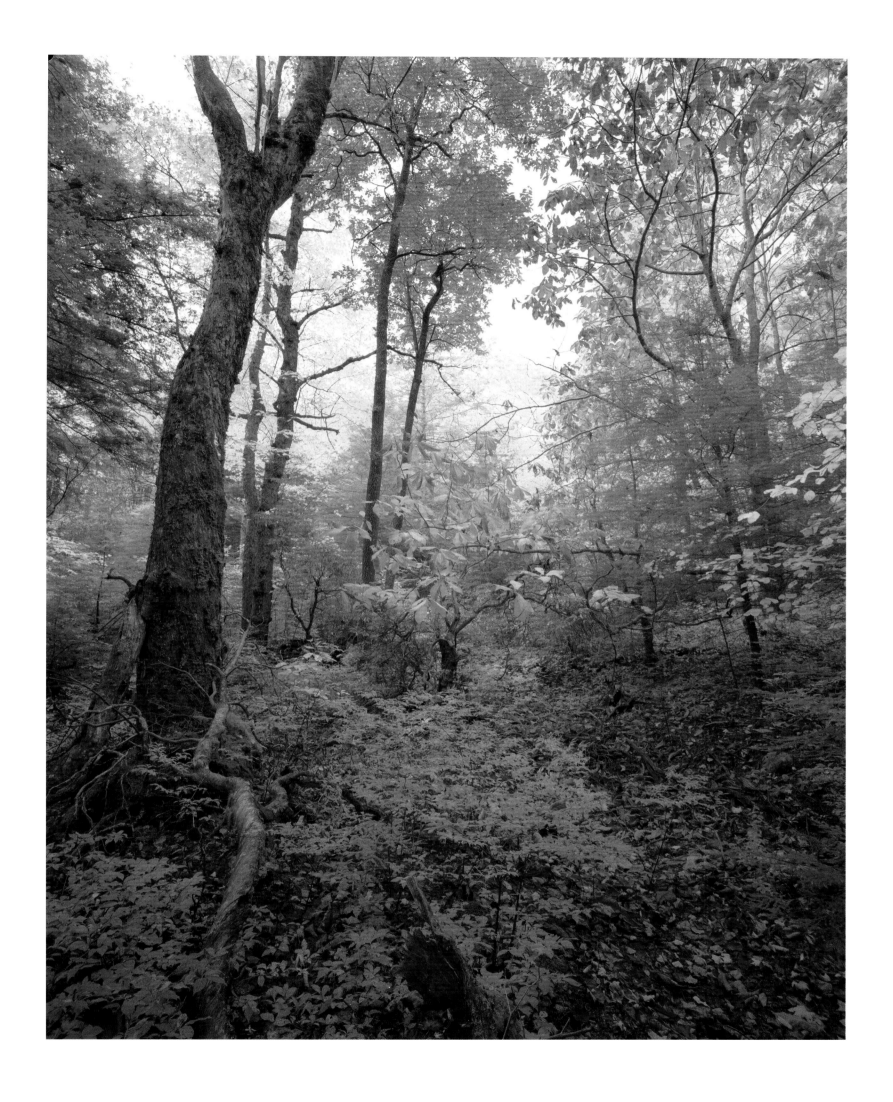

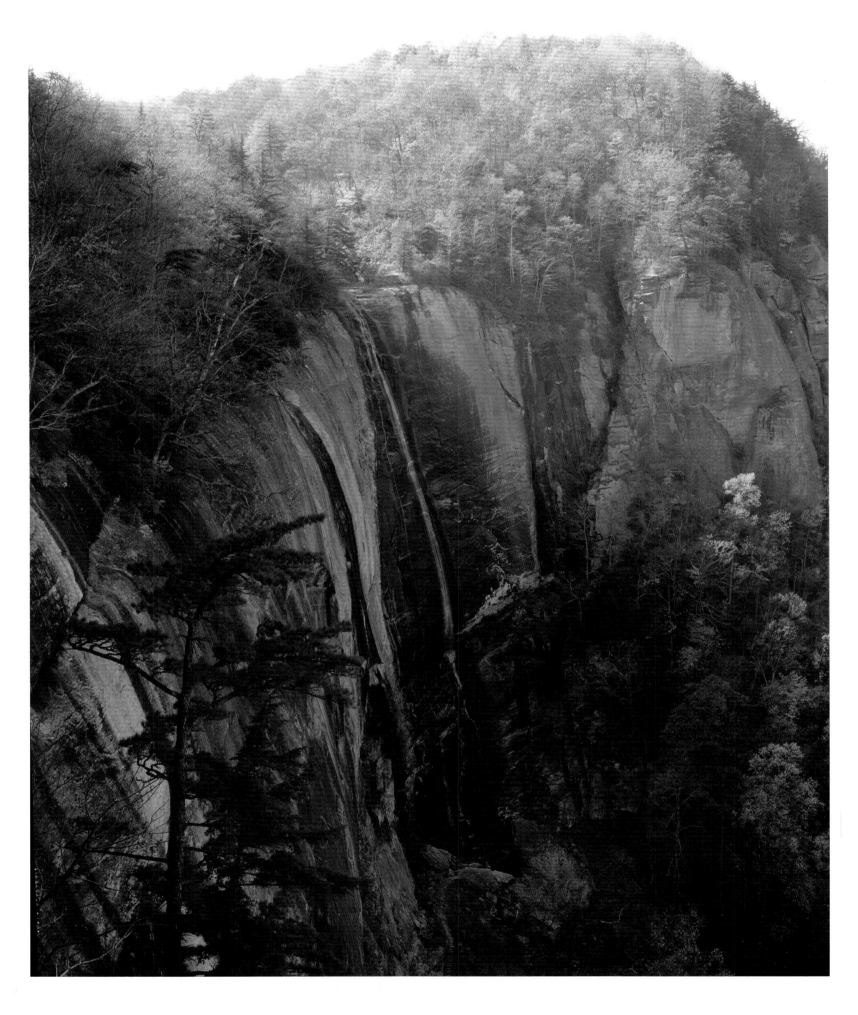

Hickory Nut Falls, Chimney Rock State Park, North Carolina
One of the highest waterfalls in the East at 404 feet, Hickory Nut Falls was privately owned and developed as a tourist destination starting in the late 1800s. By 2005, subdivisions so threatened the fourteen-mile gorge that a coalition of groups and individuals mounted a successful campaign to create a park to protect dozens of rare plant and animal species found here.

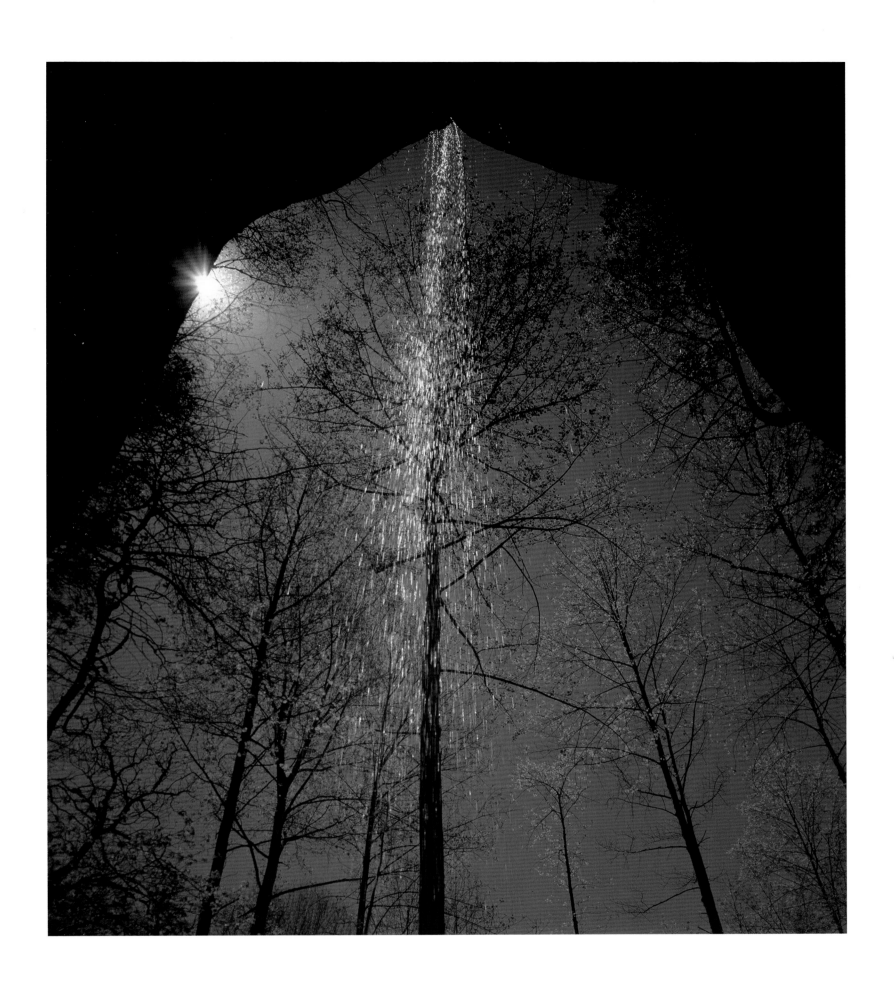

Natural Bridge, Rockbridge County, Virginia
Seen from the creekbed below, water plunges over the roof of what formerly was a cave, which now serves as a bridge for State Route 11. Once owned by Thomas Jefferson, who called it "the most Sublime of nature's works" and hosted many famous guests in a log lodge nearby, it remains in private hands. Fences block the view of the canyon from the road above, but visitors may purchase a ticket to get to the bottom.

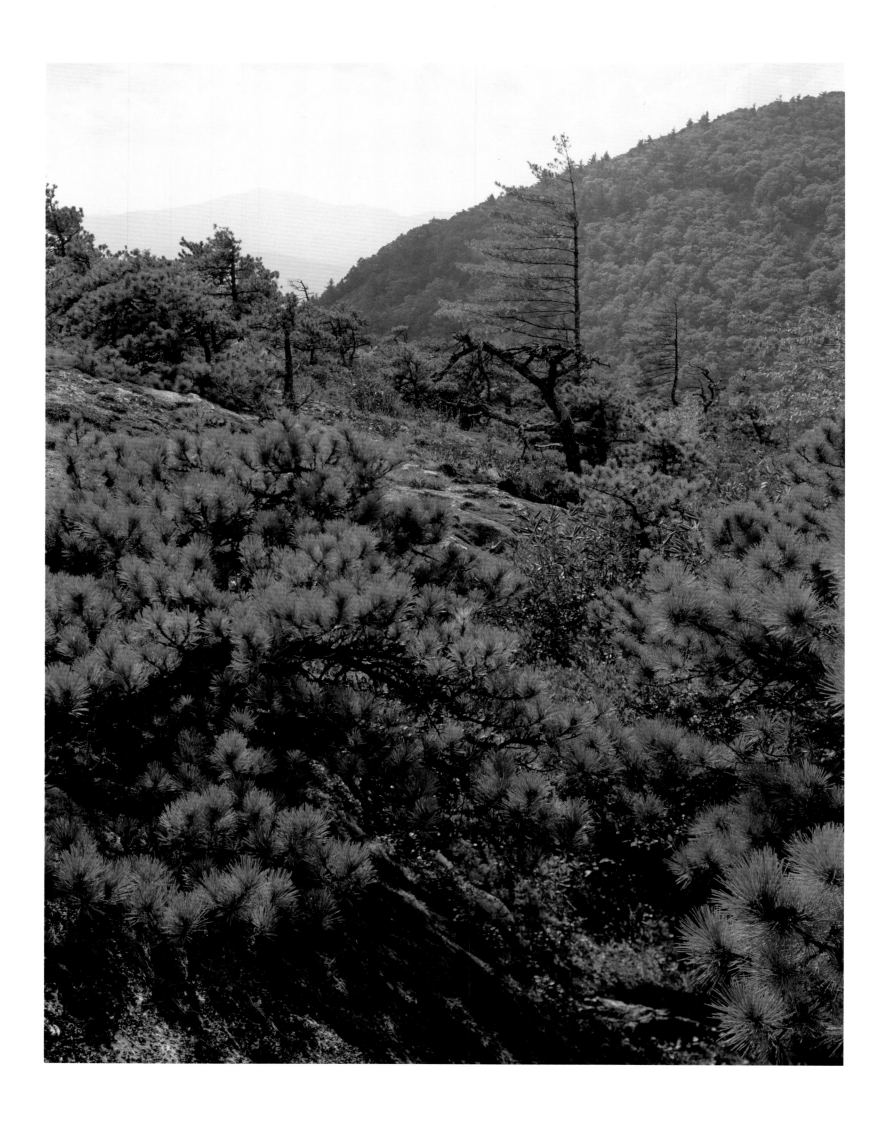

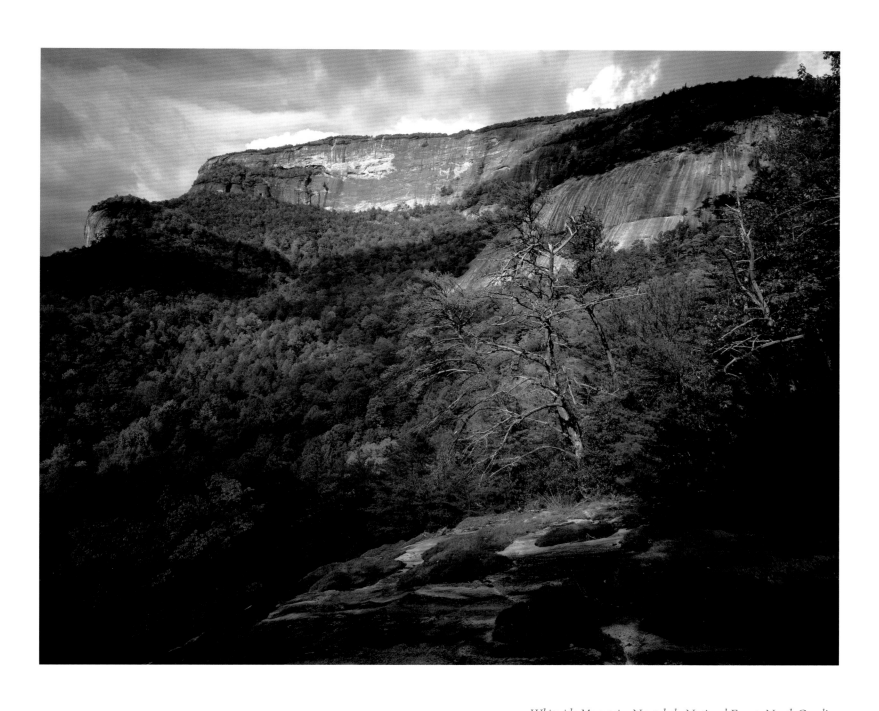

Whiteside Mountain, Nantahala National Forest, North Carolina
The 750-foot cliffs at Whiteside are among the highest and sheerest rock faces east
of the Mississippi River. The rock is roughly half a billion years old, and Whiteside
is believed to be one of the most ancient mountains in the world.

(OPPOSITE) *Fodderstack Mountain, Nantahala National Forest, North Carolina*
Dwarfed but centuries-old pitch pines could tell stories not only about weather but also about circumpolar
ancestors of eons ago, when the continents were still fused together. Some Southern Appalachian plants have close
relatives in Asia, and the biologist who inventoried Fodderstack Mountain in 1992, Dr. L. L. Gaddy, wrote that
"the closest analogue I have yet to find is Yellow Mountain, a pine-dominated granitic dome in eastern China."

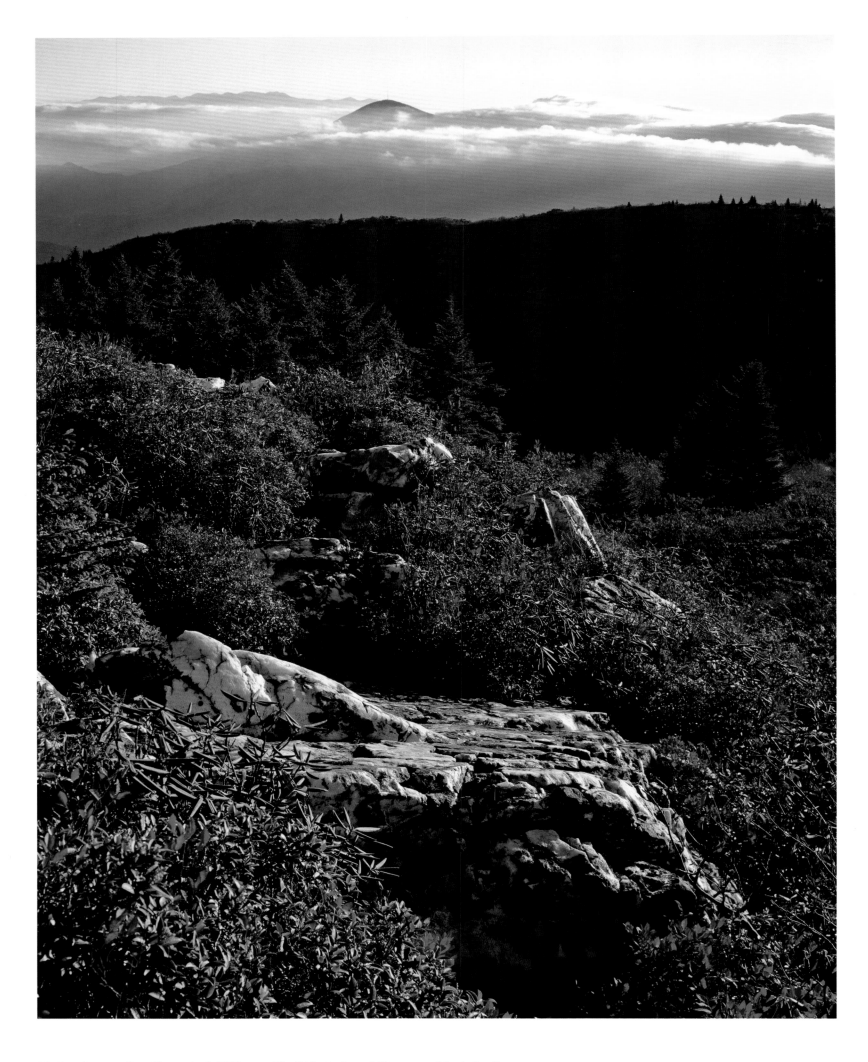

Mt. Pisgah, as seen from Shining Rock Wilderness, Blue Ridge Parkway Milepost 408, North Carolina
Sunrise promises a new day at Mt. Pisgah, where in 1898 the first school of forestry in America explored
the new idea of perpetuating rather than destroying forests. Named for its white quartz, Shining Rock
was one of the original components of the Eastern Wilderness System, begun in 1973.

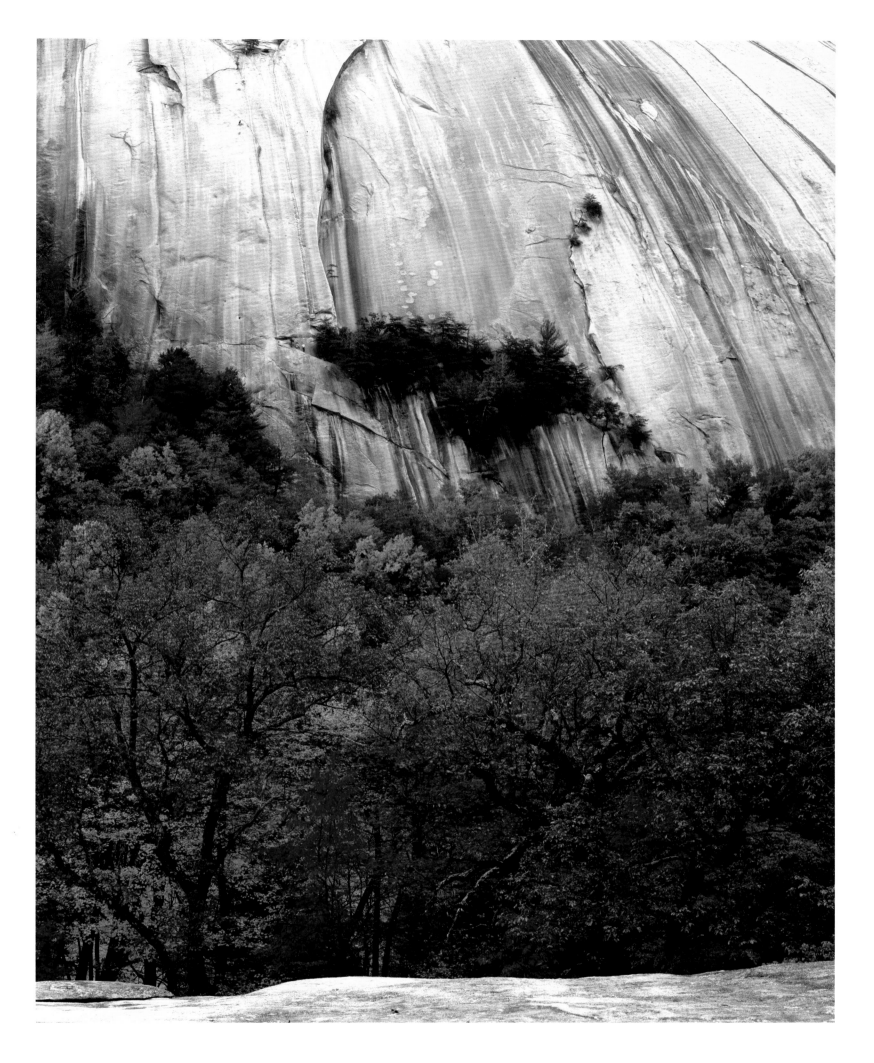

Stone Mountain State Park, Roaring Gap, North Carolina
The 600-foot granite dome at Stone Mountain dwarfs rock climbers. It is
considered one of the best examples in North Carolina of a monadnock, a
small mountain that rises abruptly from the surrounding plain.

Fungus, Cataloochee, Great Smoky Mountains National Park, North Carolina/Tennessee
Beneath the visible fruiting body, many nearly invisible fingers of fungi hold forest soils together as they break down dead plant tissue into reusable nutrients. The hundreds, perhaps thousands, of species of uncharismatic bacteria, fungi, and invertebrates that live in every cubic foot of soil are the foundation of forest life, the "little things that run the world," as E. O. Wilson famously referred to them. The rich soil in the Cataloochee Valley, formed from the surrounding 6,000-foot-high peaks, attracted both Cherokees and white settlers before becoming part of the Park in the 1930s.

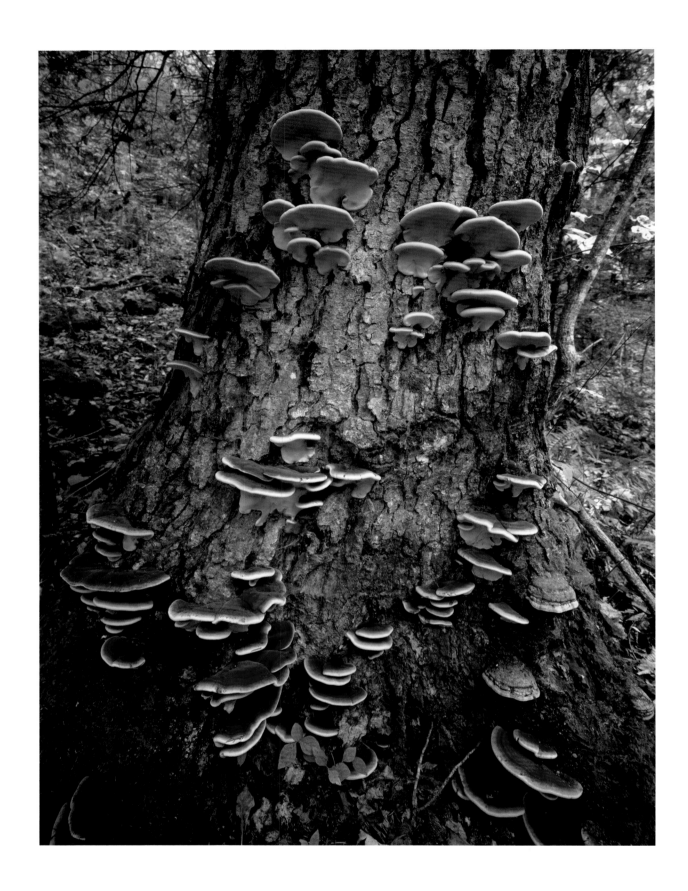

(OPPOSITE) *Tulip poplar, 56.4 inches in diameter at breast height, Cataloochee, Great Smoky Mountains National Park, North Carolina/Tennessee*
"This is the king of the Magnolia family," wrote Donald Culross Peattie in his 1948 classic, *A Natural History of Trees of Eastern and Central North America*, "the tallest hardwood tree in North America." At 154 feet tall, this poplar doesn't quite meet the 200-foot height Peattie mentions, but it's still growing.

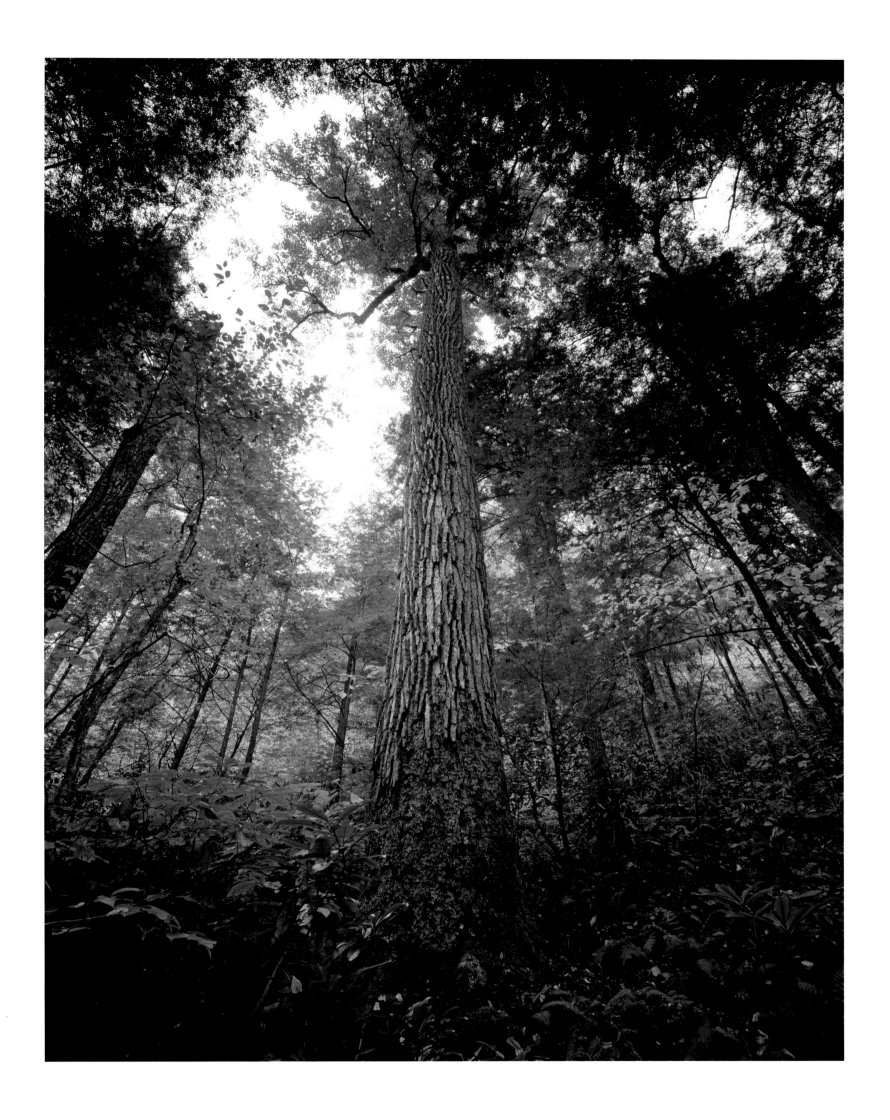

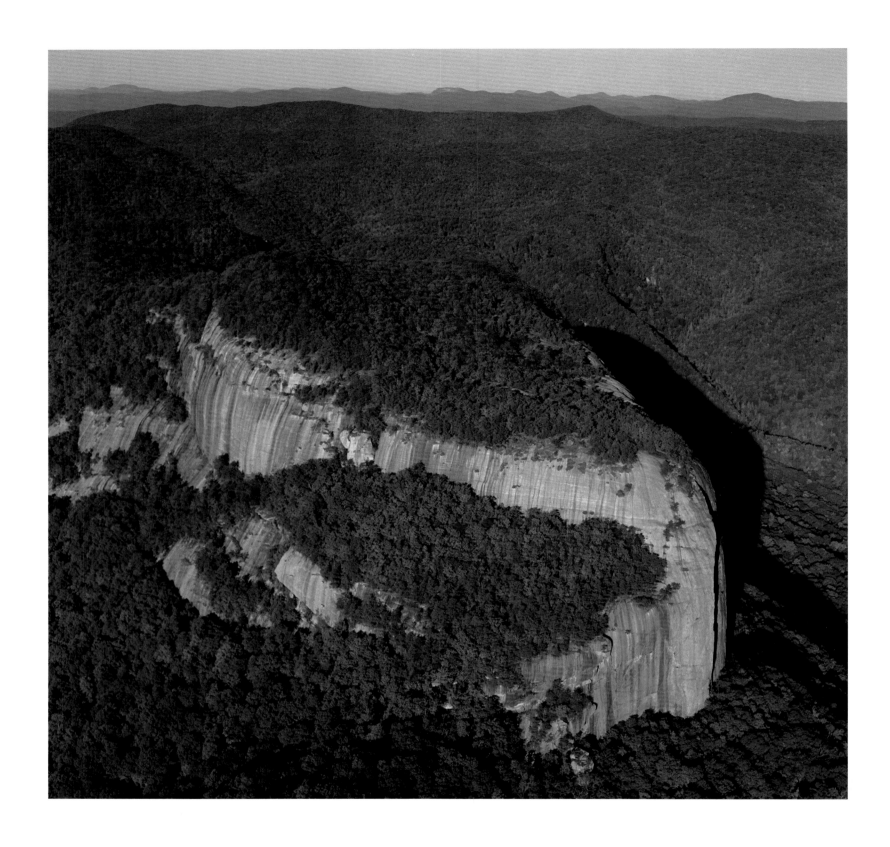

Table Rock State Park, South Carolina
On the eastern edge of the Blue Ridge Mountains, Table Rock provides spectacular views
that have drawn tourists since the 1840s. Nearly a century later, the Civilian Conservation
Corps, a federal jobs-creation program during the Great Depression, built the facilities
still used here and in many other state parks and national forests throughout the Southern
Appalachians. In the 1960s, the seventy-six-mile Foothills Trail was established between
Table Rock and Oconee State Parks.

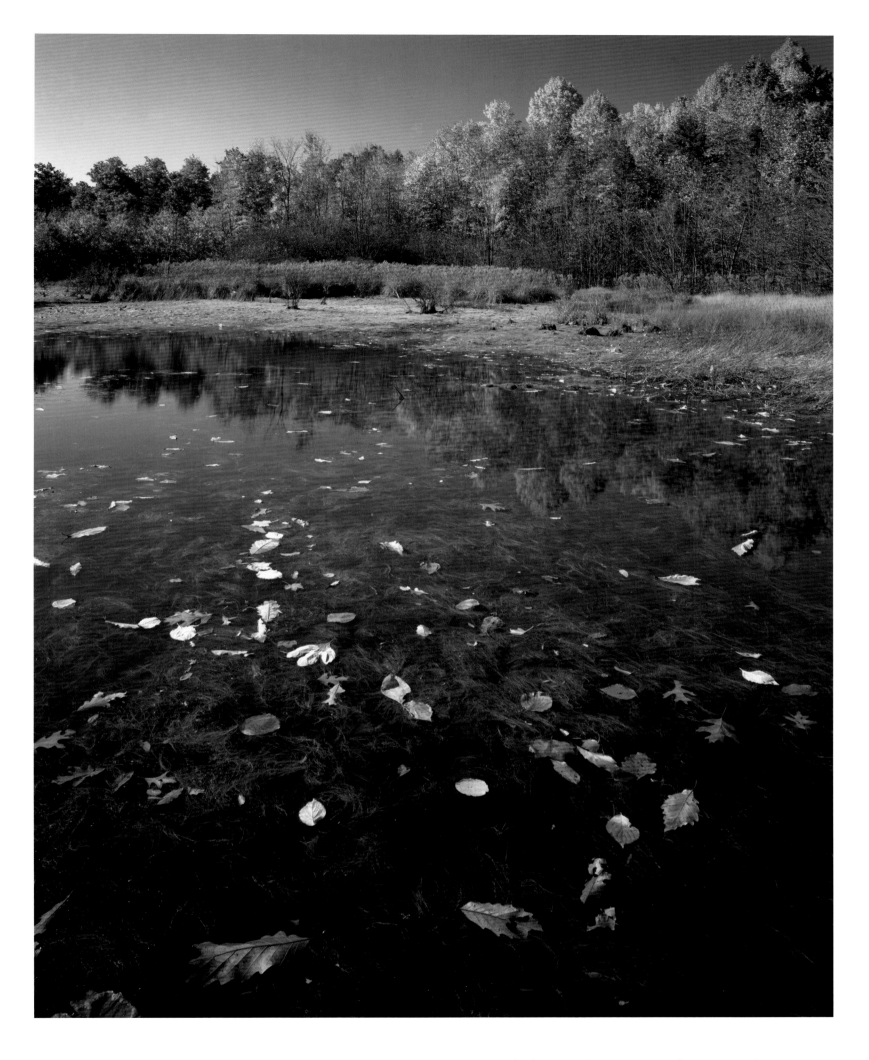

Maple Flats Natural Area, George Washington National Forest, Virginia
Natural sinkhole ponds form part of a wetland complex that dates back
15,000 years or more. Nearly one hundred species of northern bog and
coastal plain plants live here, relicts of a colder, wetter time.

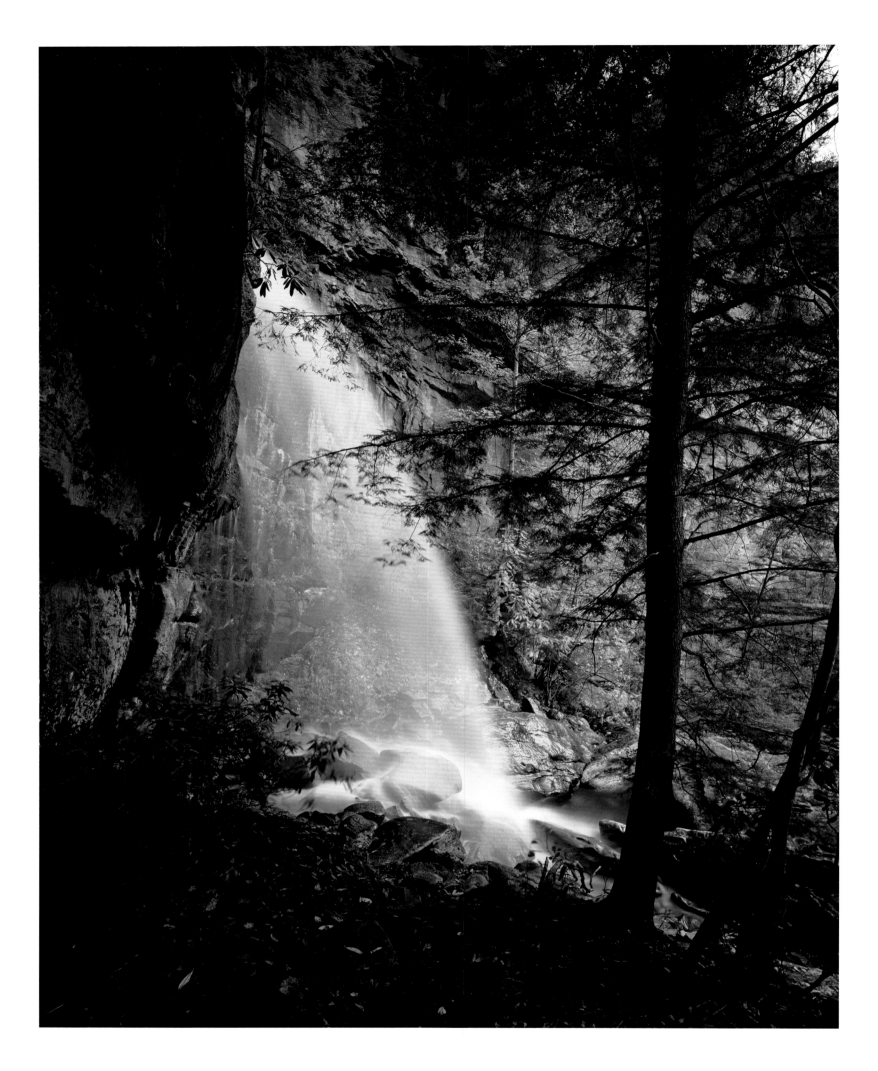

Bad Branch Falls State Nature Preserve, Kentucky
Named for its unexpected twists and sharp turns, the boulder-lined Bad Branch creates pools and riffles that harbor rare fish. It has also carved a narrow canyon whose shaded depths protect more than thirty species of rare plants and animals, one of the largest concentrations in the state. The land is managed as a partnership between The Nature Conservancy and the Kentucky State Nature Preserves Commission.

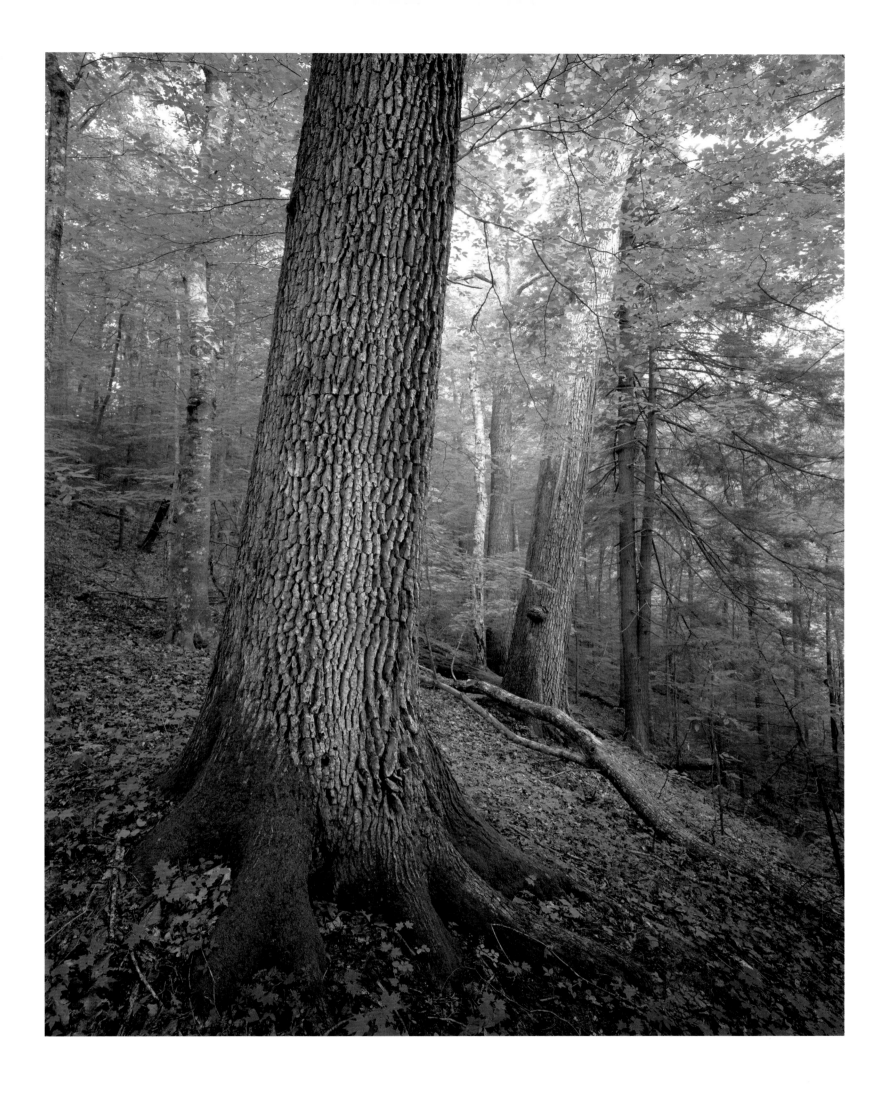

Lilley Cornett Woods, Appalachian Ecological Research Station, Eastern Kentucky University, Letcher County, Kentucky
Although parts of this preserve were grazed by livestock and periodically burned, altering the soil and the understory, a small section of forest was never logged. Nuances of past disturbances influence every aspect of forest growth.

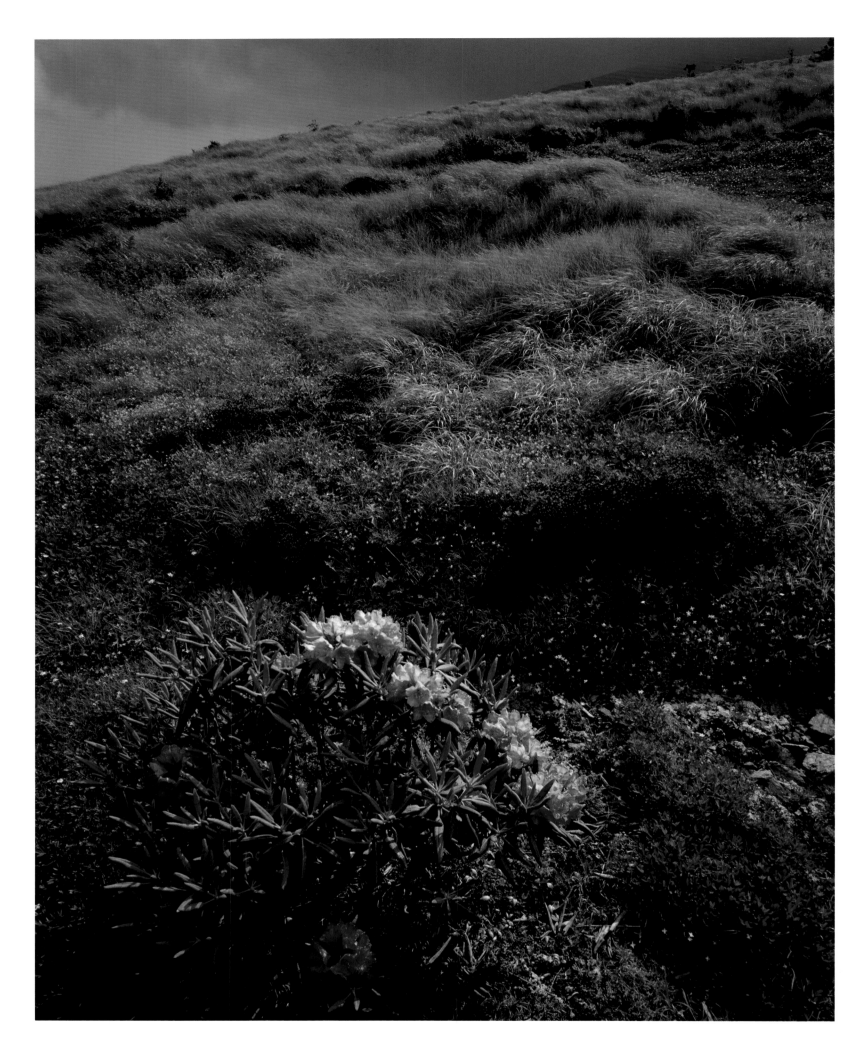

Carver's Gap, Roan Mountain, Pisgah National Forest, North Carolina
Is the one Catawba rhododendron shown here a forerunner of others moving out
from the forest to take over this ridge of sedges and grasses? Scientists do not know
how the two kinds of balds, grassy and heath, originated.

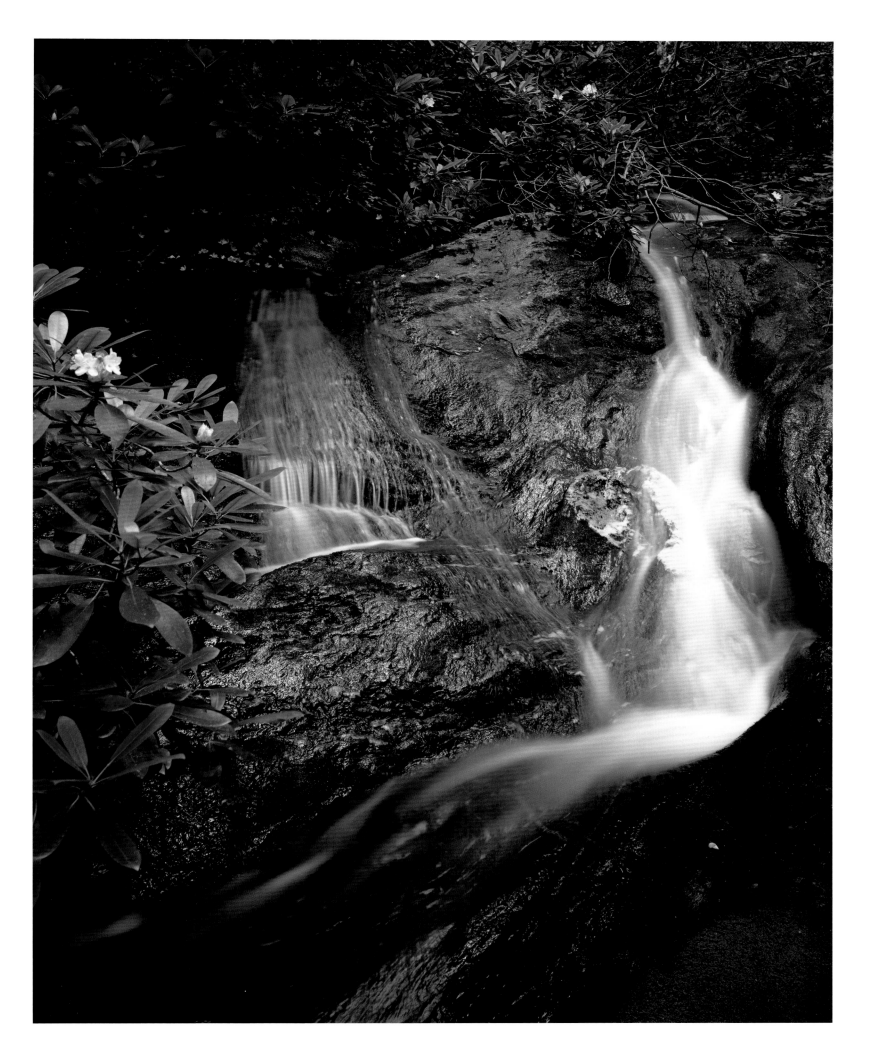

Wildacres Falls, Wildacres Retreat, Little Switzerland, North Carolina
White noise from whitewater can help meditating visitors clear their minds. A 1,600-acre, high-elevation enclave, Wildacres Retreat is not open to individual travelers but serves nonprofit groups conducting educational, cultural, or artistic programs.

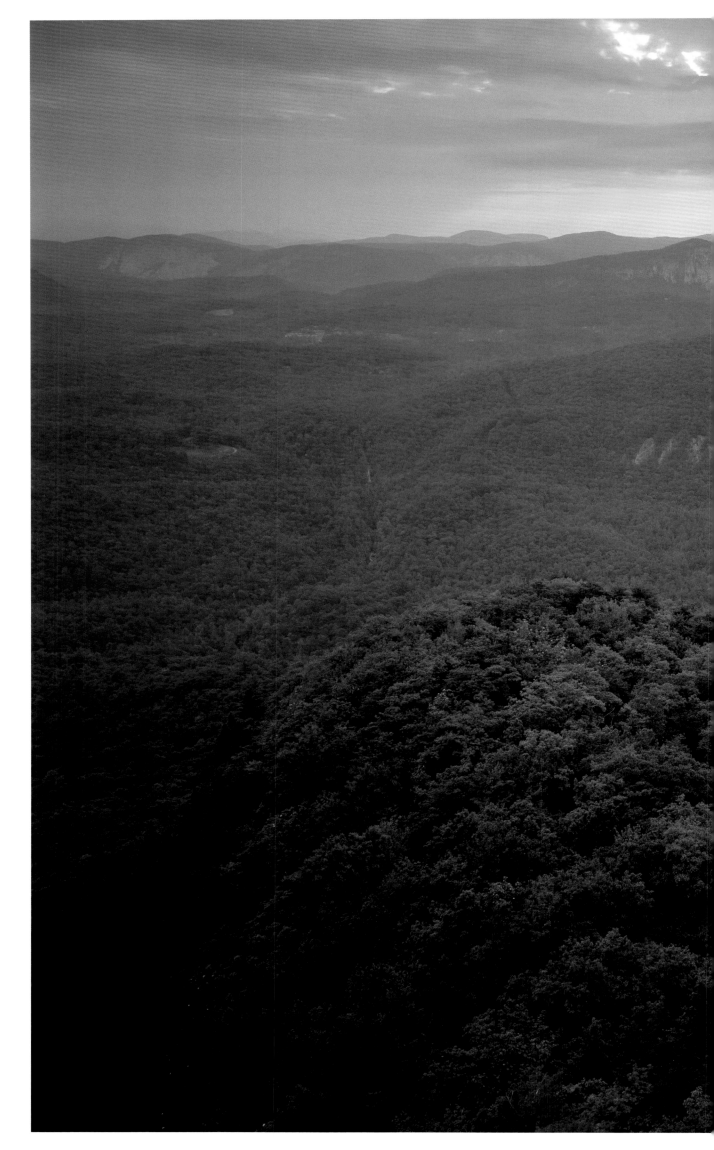

View from Whiteside Mountain, Devil's Courthouse, Nantahala National Forest, North Carolina
First, horse-drawn carriages and, then, shuttle buses once carried tourists to the summit of Whiteside for the views of Chimneytop Mountain, Rocky Mountain, Timber Ridge, and other surrounding landmarks. To minimize congestion and pollution, the U.S. Forest Service turned the road into a trail when it purchased the mountain in the 1970s.

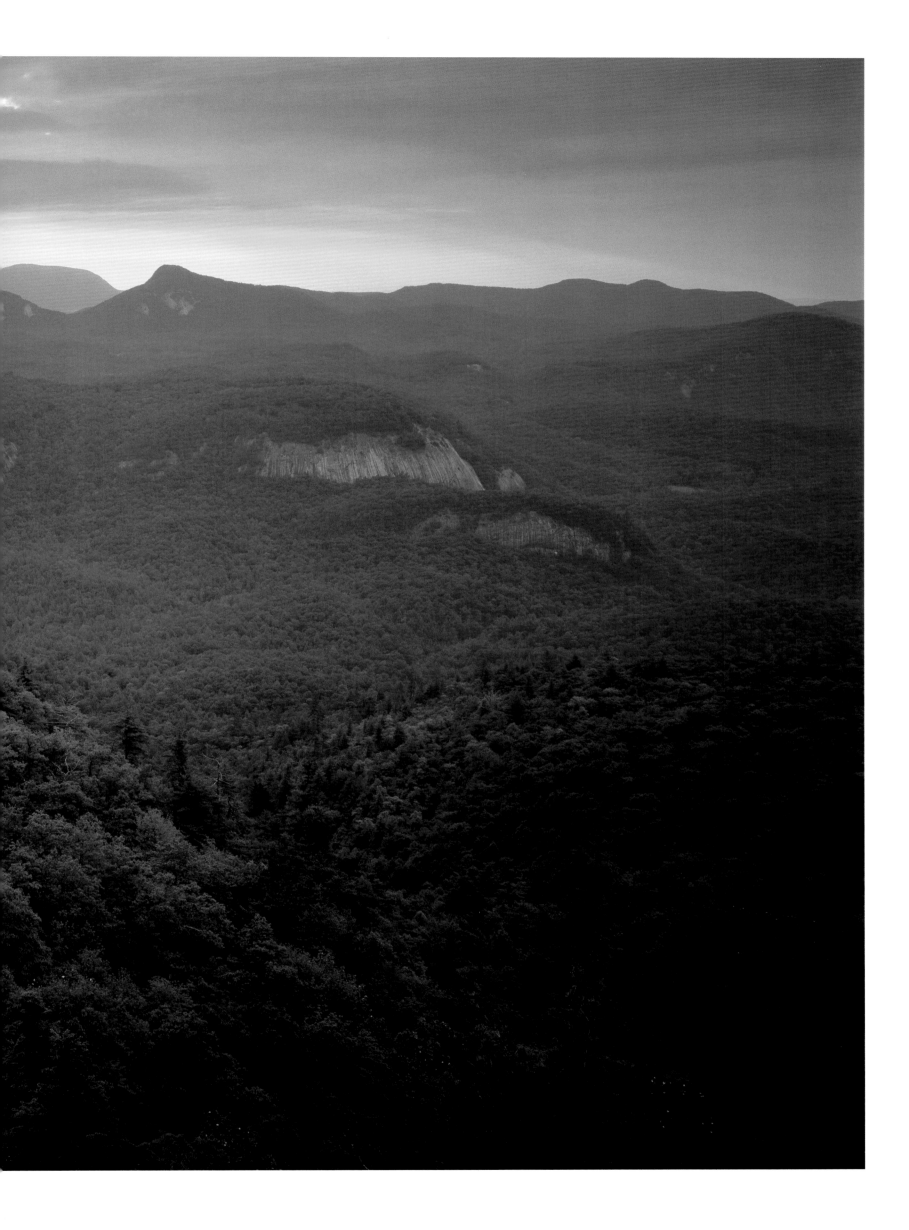

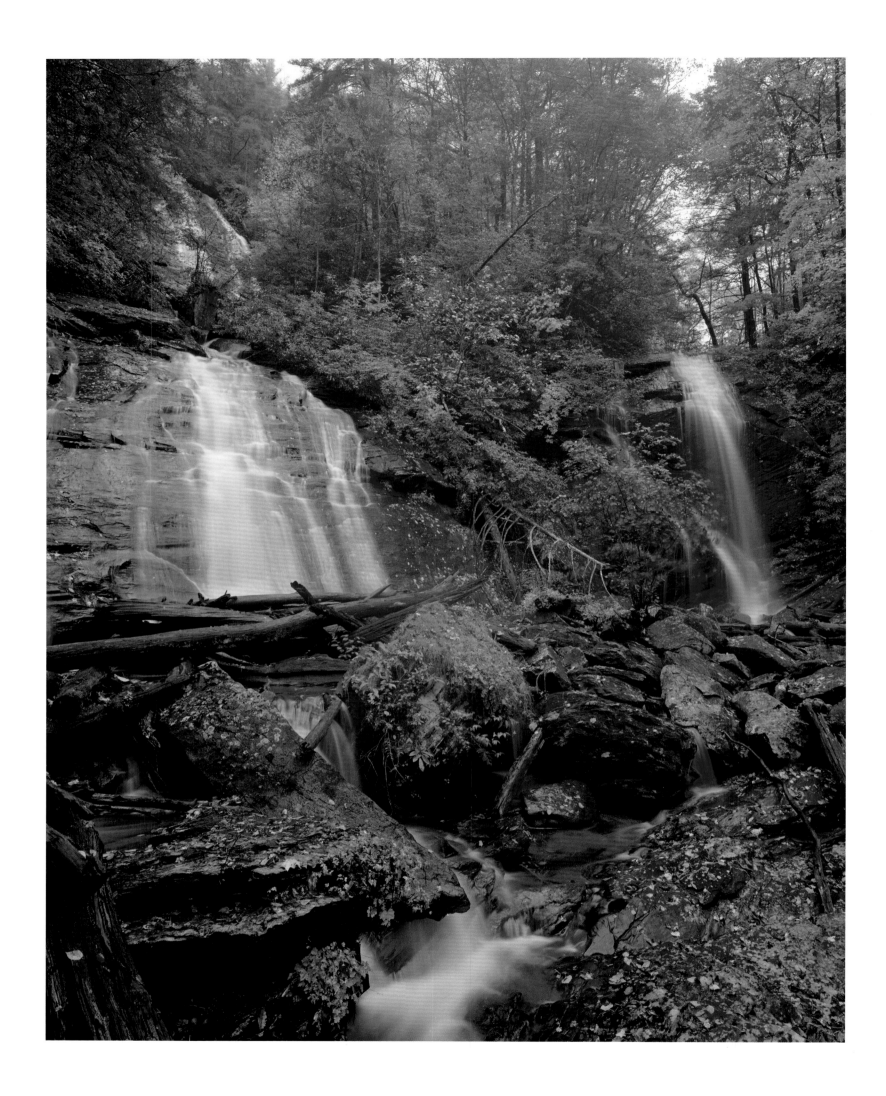

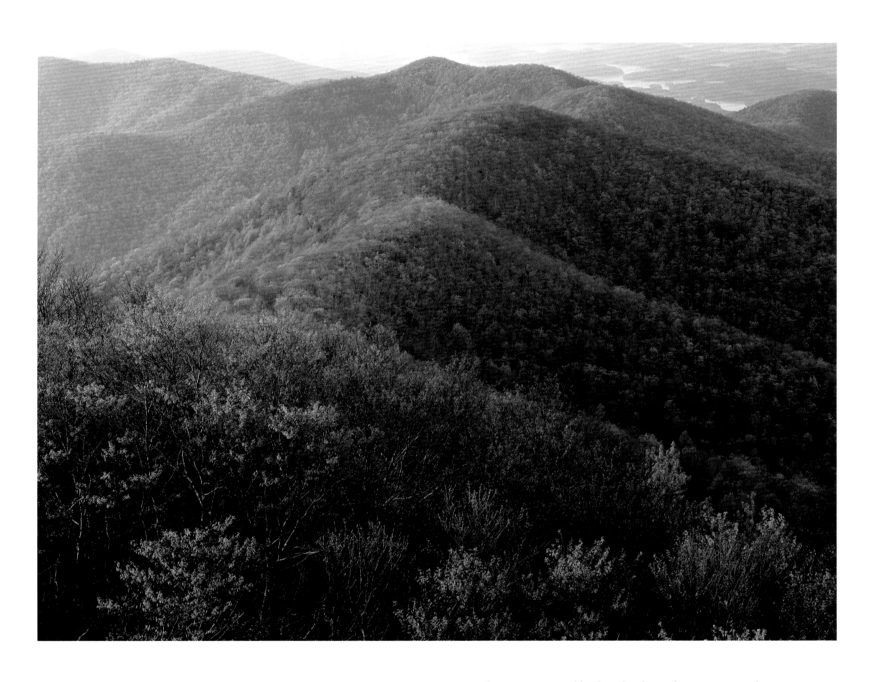

View from Brasstown Bald, Chattahoochee and Oconee National Forests, Georgia
There's no brass here. The name was mistakenly translated from a Cherokee word that actually meant "place of fresh green"—an accurate description of early spring at Brasstown Bald.

(OPPOSITE) *Anna Ruby Falls, Chattahoochee National Forest, Georgia*
Named for the daughter of a former owner, the falls are formed by two creeks coming together. The pines and poplars that dominate the 1,600-acre Anna Ruby Falls Scenic Area were some of the first trees to recolonize the area after heavy logging a century ago.

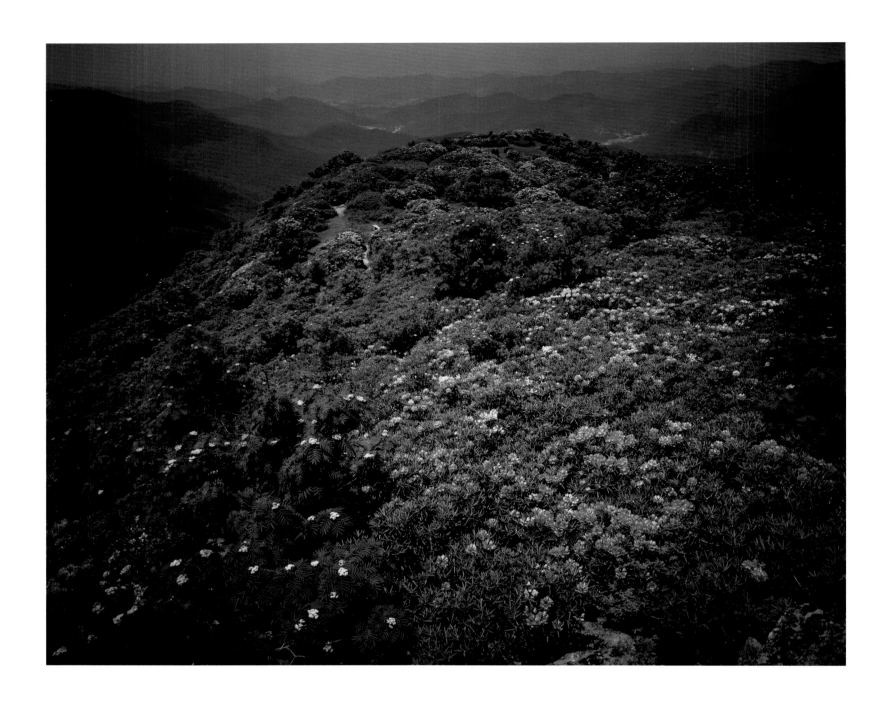

Rhododendrons, Craggy Gardens, Blue Ridge Parkway Milepost 364, North Carolina
About a dozen species of rhododendrons and azaleas grow in the Southern Appalachians.
Some tolerate shade and thrive in the forest understory, while others take advantage of
the full sun available on balds.

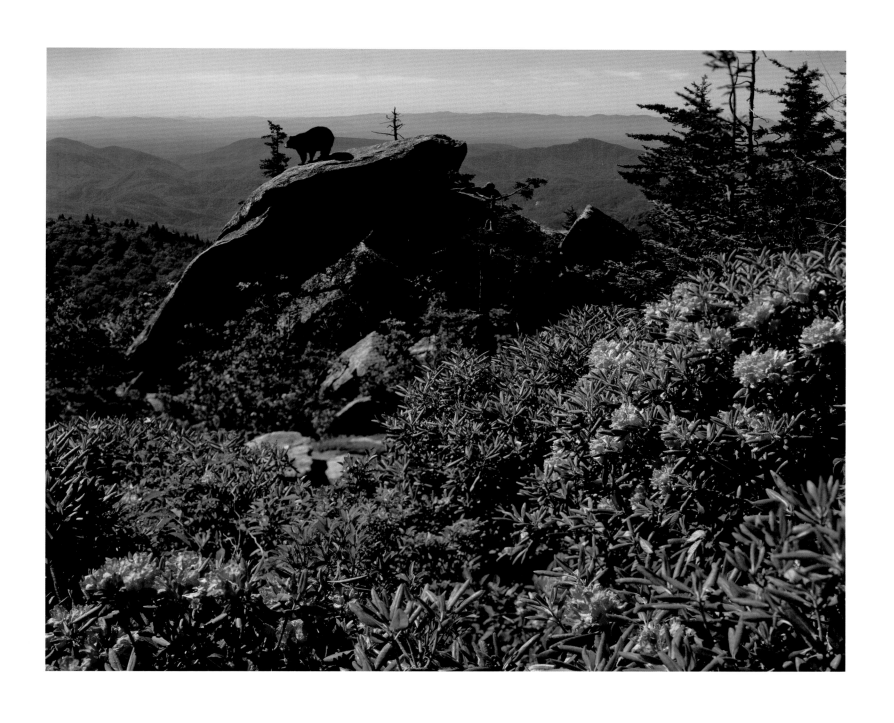

Grandfather Mountain, Blue Ridge Parkway Milepost 305, North Carolina
Rising abruptly from the valley floor to 5,946 feet, Grandfather Mountain supports
sixteen distinct ecological communities. It is the only privately owned property in the
United Nations' global network of biosphere reserves. Black bears, the success story of
Southern Appalachian wildlife management, have found a haven here.

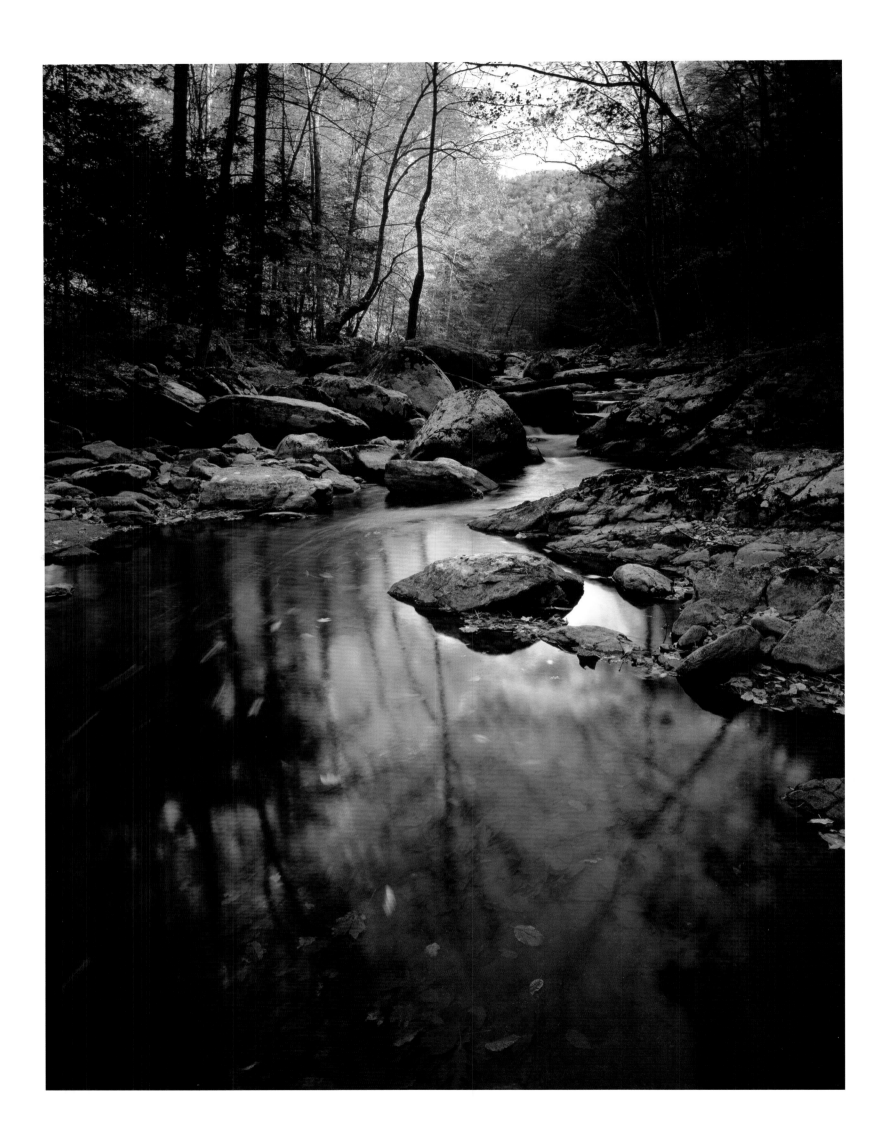

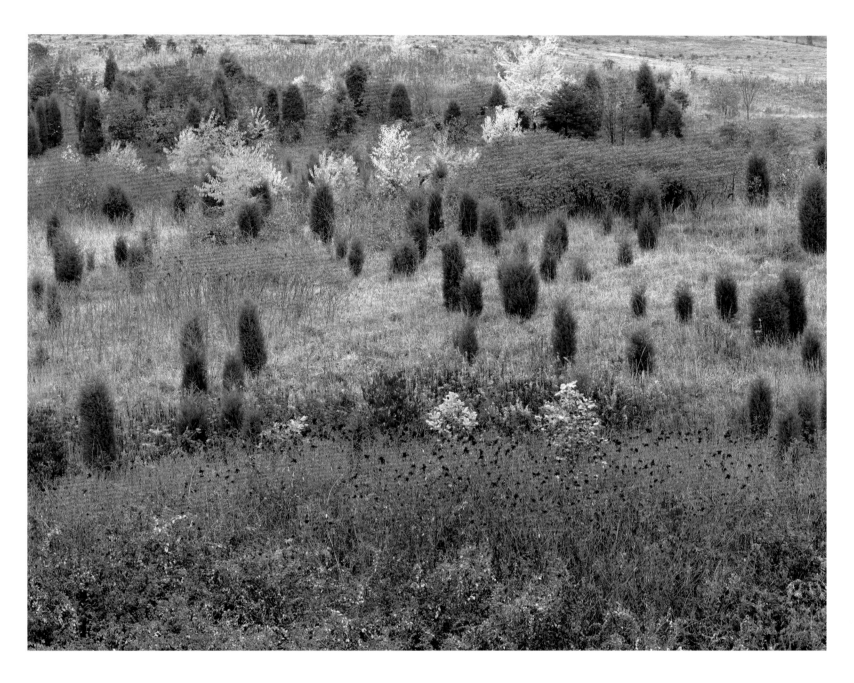

Crab Orchard, Tennessee
Eastern red cedars begin the slow succession from field back to forest. Fields were
first cleared here shortly after Daniel Boone hewed the Wilderness Road through
Cumberland Gap in 1775. The cedar was the sacred tree of the Cherokee because of
its evergreen nature, its fragrance, and the red color of its heartwood.

(OPPOSITE) *Bottom Creek Gorge Preserve, The Nature Conservancy, Virginia*
Darkening light hides colorful native fish in these headwaters of the Roanoke River: orangefin madtoms,
bigeye jumprocks, and riverweed darters. Old-growth hemlocks, whose shade helps keep water temperatures
cool enough for fish, were inaccessible to loggers but not to the hemlock woolly adelgid, one of many
nonnative pests killing trees in Southern Appalachian forests.

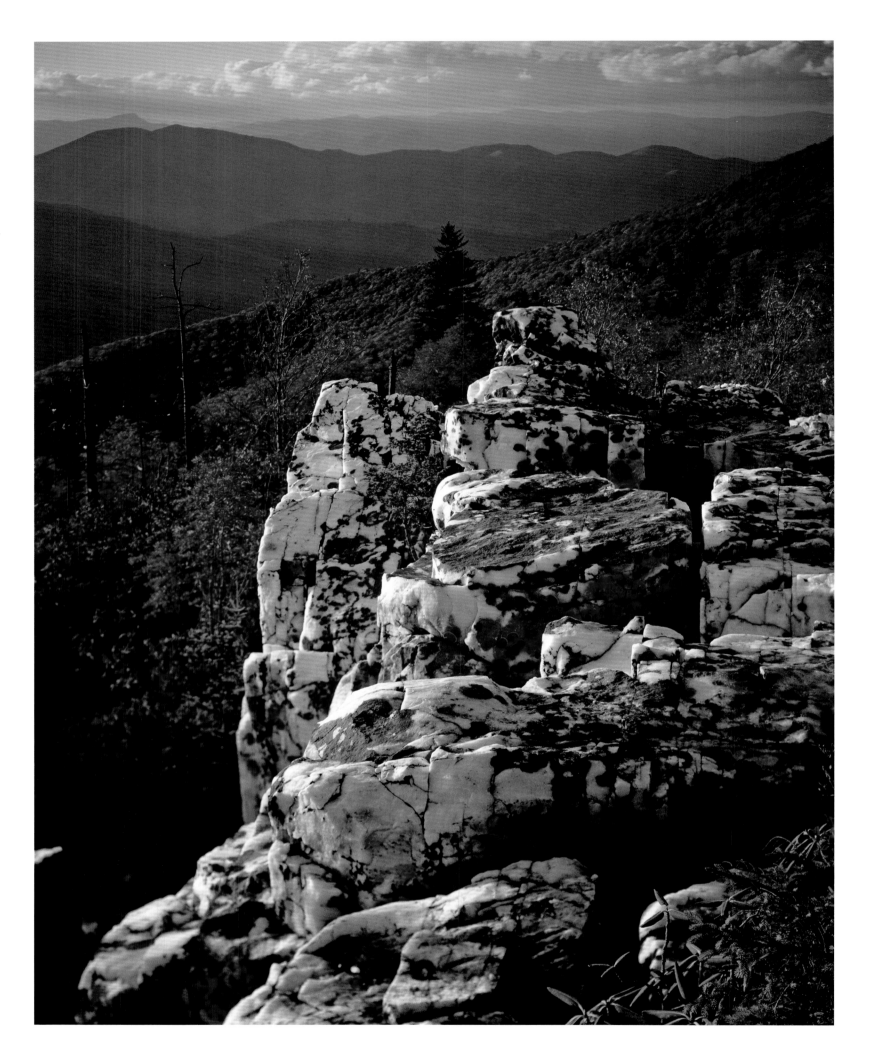

Shining Rock, Shining Rock Wilderness, Pisgah National Forest, North Carolina
Here is where the Creator chose to put Kanati and Selu, the first man and woman. It was challenging terrain, with many of the surrounding mountains reaching elevations of more than 5,000 feet, but the First Couple thrived and generated the prosperous, cosmopolitan Cherokee tribe.

"Just as a deer herd lives in mortal fear of its wolves, so does a mountain live in mortal fear of its deer," wrote famous conservationist Aldo Leopold in his 1949 essay, "Thinking Like a Mountain." As a young forest ranger in New Mexico, he shot one of the last wolves there because he had been trained to see them as enemies. Then he watched "every bush and seedling browsed" until "the starved bones of the hoped-for deer herd, dead of its own too-much, bleach with the bones of the dead sage."

Wolves were long gone from the Southern Appalachians when Leopold wrote; so were cougars and most of the black bears, and other "varmints" like falcons, eagles, and hawks were well down the road toward disappearance.

Today, deer are a major problem, costing millions of dollars annually in collisions, spreading Lyme disease, and eating the landscape, including the saplings that are supposed to make the next forest.

Yet overabundant deer are only one sign of an ecosystem out of balance. The Southern Appalachians are under assault by invasive pests and diseases, sprawl and subdivisions, air and water pollution, and, in places, too much attention.

It is a testament to their resilience, itself dependent on biodiversity, that the forests of the Southern Appalachians still offer so much life. Resilience, plus the Weeks Act of 1911, which addressed the worst abuses occurring at the time. This legislation authorized the U.S. Forest Service to purchase land for national forests in river headwater areas that had been so heavily logged since the Civil War that few tree roots remained to soak up rainfall, causing massive flooding downstream. The Forest Service purchased roughly nine million acres and planted millions of trees. In the 1930s, three national parks were established that further protected land and wildlife.

The not-quite-continuous band of public lands in Appalachia makes it possible to think like a mountain, or rather, like mountains: long ranges running roughly from southwest to northeast, with river courses carving and connecting them into a bioregion of linked watersheds. Each range, from the Blue Ridge to the Alleghenies to the Cumberland Plateau, has its own origin and geology, but all of them give meaning to the saying "as old as the hills."

Thinking like mountains in twenty-first-century Appalachia means managing the public lands to restore as much as possible of what's been lost, with top predators as emblems of fully functioning ecosystems.

Heartening efforts are under way. Restoration of healthy forests, the basis of animal life, is becoming a scientific discipline. A visitor to the cliffs of Whiteside Mountain can once again watch a peregrine falcon, one of the fastest birds on earth, from above. Cougars, believed extirpated by about 1900, are now very occasionally confirmed by physical evidence. Wolves may even make their way, slowly, tentatively, down the Appalachian chain from New England, as coyotes have already done. There are deer enough for all.

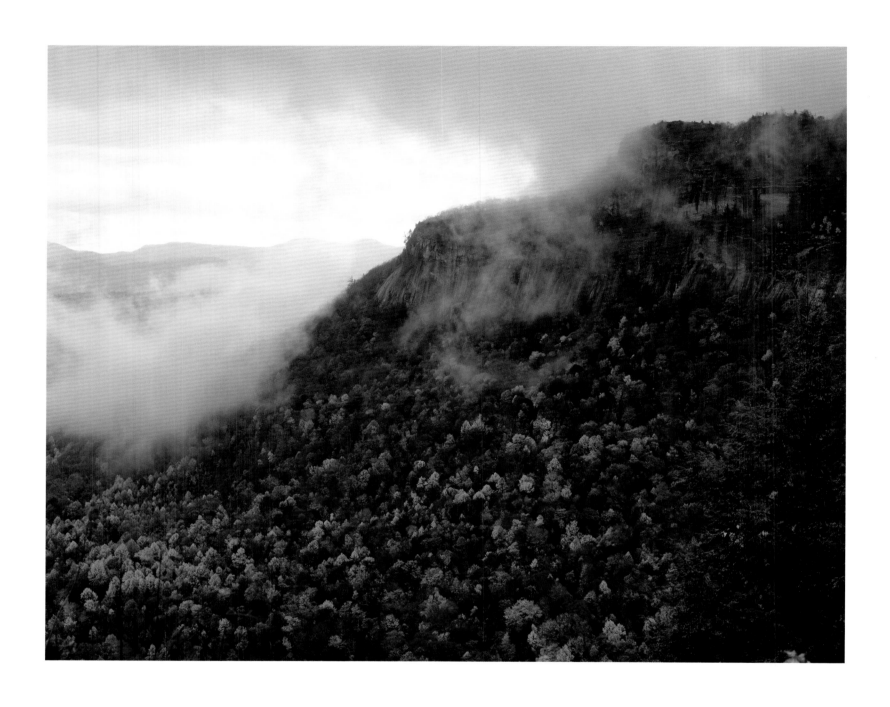

Devil's Courthouse, Whiteside Mountain, Nantahala National Forest, North Carolina
"Deserving a far more benevolent name," wrote Bob Zahner, a forester, scholar, and writer
who spent most of his life near Whiteside, "the Devil's Courthouse is a broad, gently sloping
surface facing west to a raised rock 'pulpit,' where sits a presiding spirit or life force."

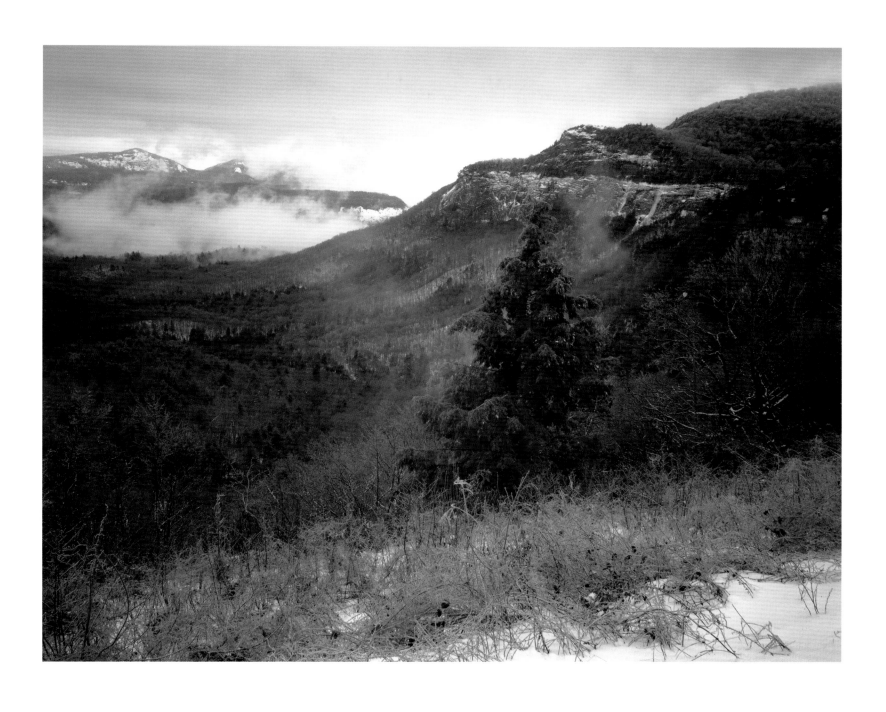

Devil's Courthouse, Whiteside Mountain, Nantahala National Forest, North Carolina
To the Cherokee, Whiteside's cliffs looked like sheets of ice. Their presiding force was not so benevolent:
this was the home of Spearfinger, a monster who stabbed and ate human livers, and who tried to build a rock
bridge between mountains. Lightning struck and sheared off the bridge, leaving bare rock exposed.

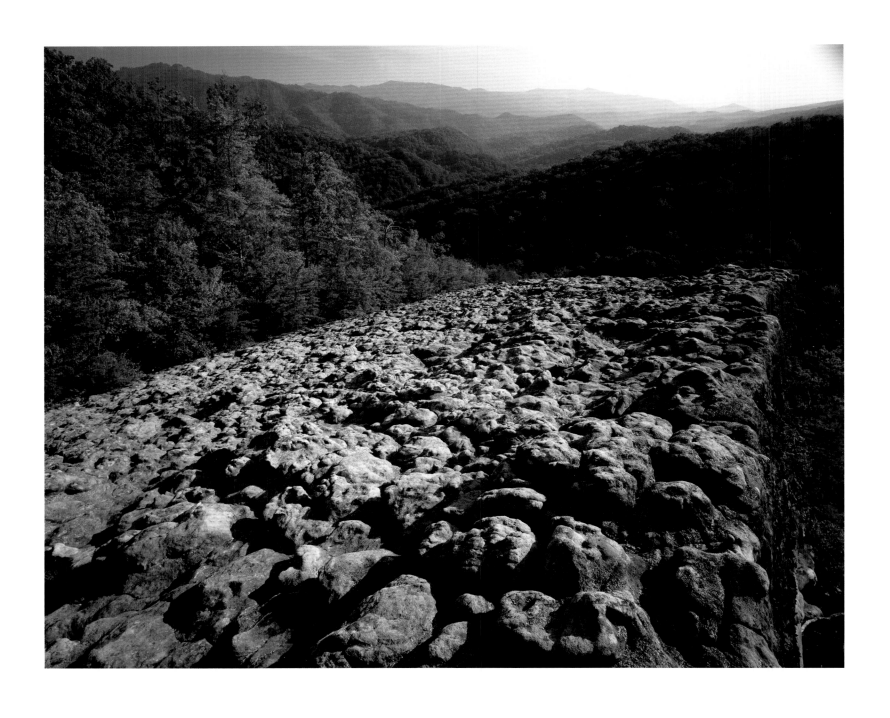

Blanton Forest State Nature Preserve, Harlan County, Kentucky
The signs say "Knobby Rock" while local people say "Knotty Rock," but,
by any name, this sandstone outcrop is gnarly terrain. From it, the view takes
in some two thousand acres of relatively undisturbed woods.

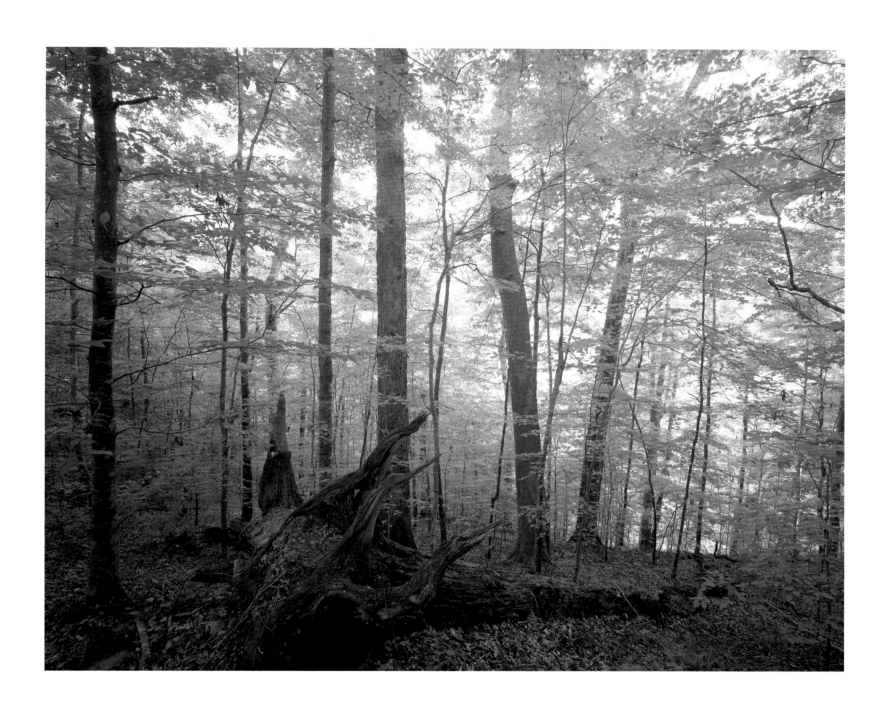

Lilley Cornett Woods, Appalachian Ecological Research Station,
Eastern Kentucky University, Letcher County, Kentucky
Left to its natural patterns, the forest renews itself through small gaps
formed by the death of single or small groups of trees, killed by wind
or lightning, disease or insects, or infirmities of age. Dead trees are
themselves a resource, providing habitat for numerous small creatures.

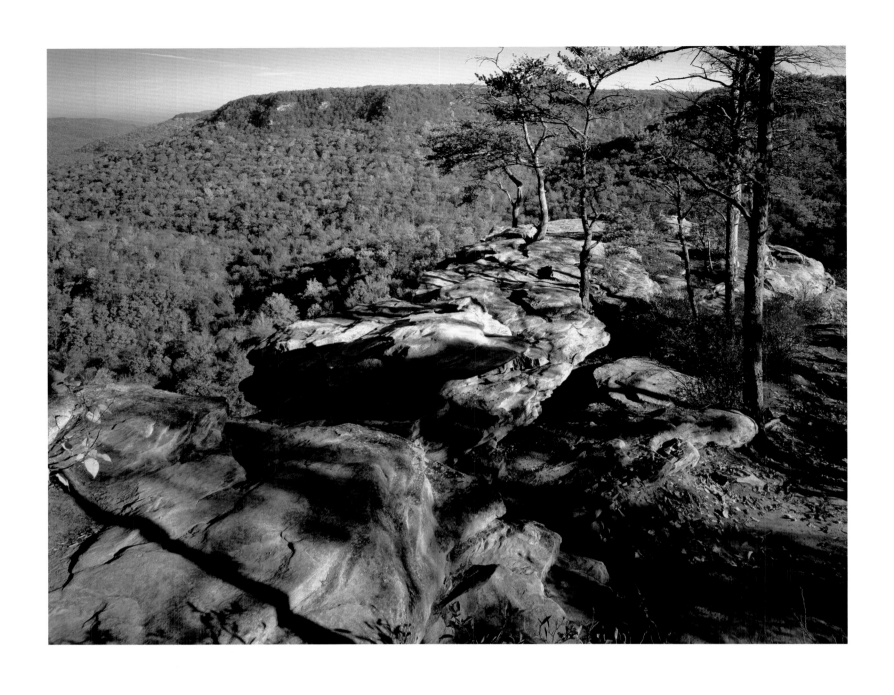

Savage Gulf State Natural Area, South Cumberland State Recreation Area, Tennessee
Named after the family that once owned part of these 15,000 acres, the western edge of the Cumberland Plateau
is rugged enough to deserve the description. Cliffs, gorges, waterfalls, and underground streams create many habitat
niches, which, with groves of both hardwood and short-leaf pine old-growth, add up to a huge biodiversity count:
one-third of some 2,300 plant species native to Tennessee can be found here.

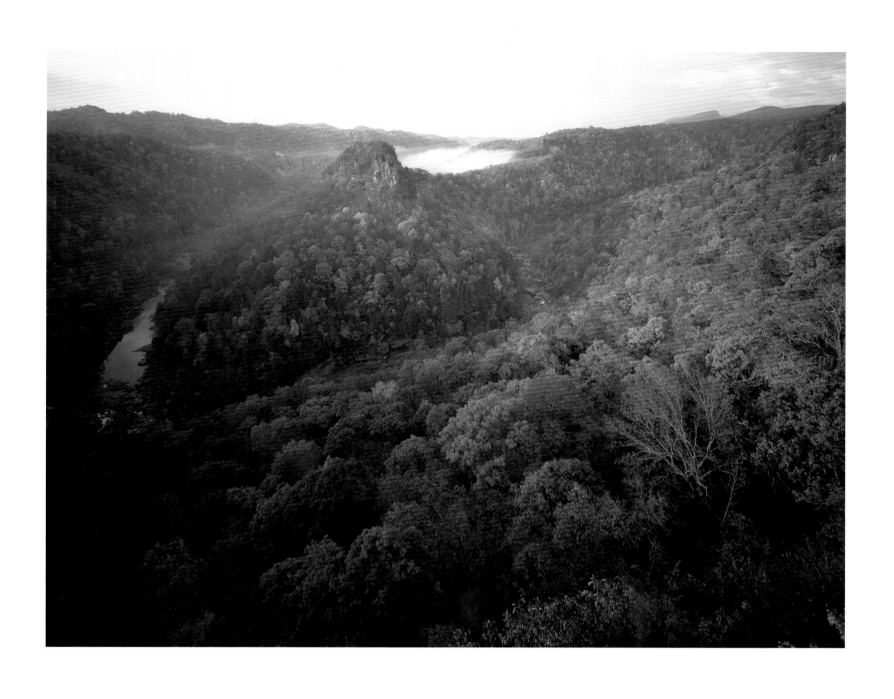

The Towers, Breaks Interstate Park, Virginia/Kentucky
Five miles long and 1,600 feet deep, the Breaks of the Russell Fork River rivals Linville Gorge in North Carolina as the deepest gorge in the eastern United States. The Russell Fork cuts through the 125-mile length of Pine Mountain, as Daniel Boone discovered in 1767 on his trail-blazing way into Kentucky. The forests Boone saw were much different than the forests today.

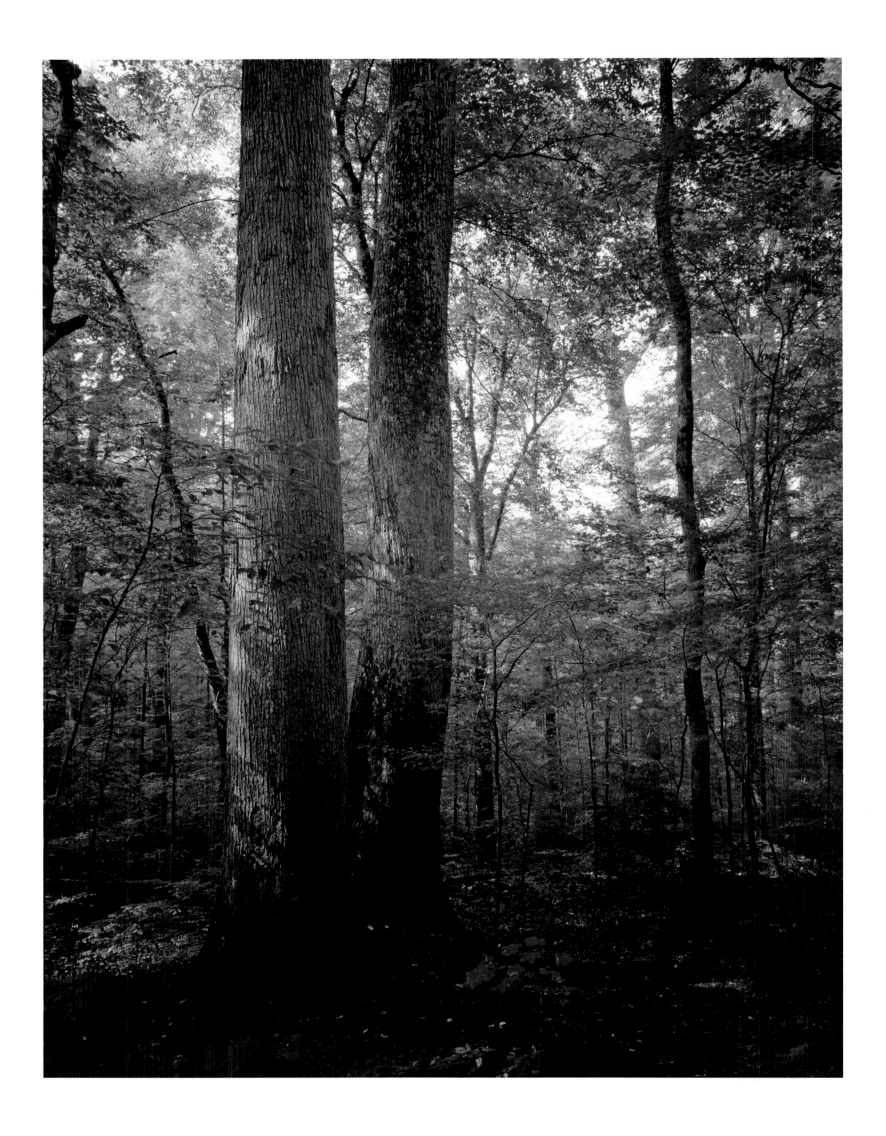

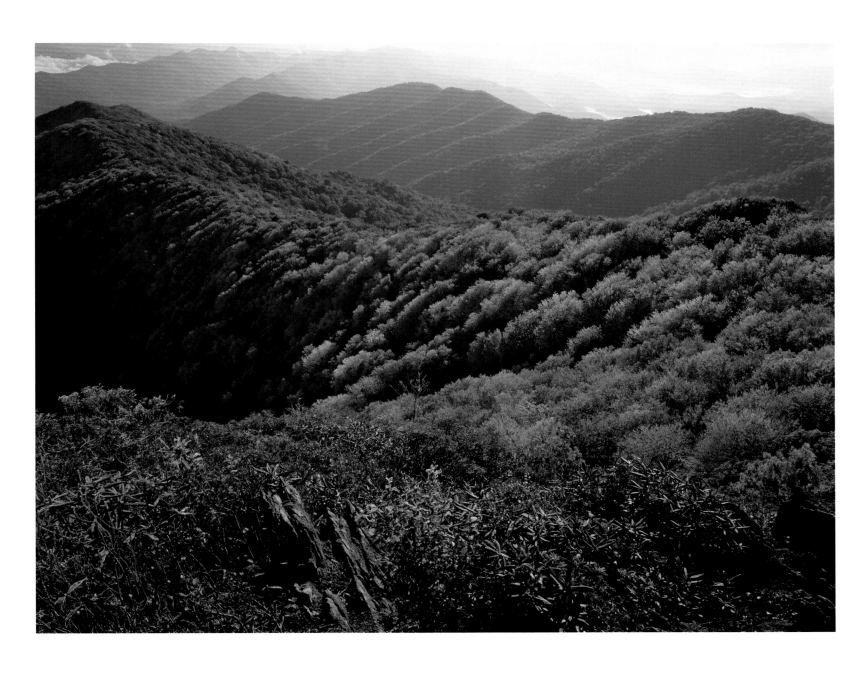

Hangover Lookout, Joyce Kilmer–Slickrock Wilderness,
Nantahala National Forest, North Carolina/Cherokee National Forest, Tennessee
Balds over 5,000 feet high show the chilling effects of early fall frosts. Beyond the well-
trodden path through Joyce Kilmer Memorial Forest, but less marked by feet or signs,
are sixty more miles of trails across this 17,394-acre federally designated Wilderness.
Nearly 6,000 acres preserve old-growth forests of red and white oaks, basswood, beeches,
sycamores, and hemlocks, although woolly adelgids are ravaging the hemlocks.

(OPPOSITE) *Poplars, Joyce Kilmer Memorial Forest, Joyce Kilmer–Slickrock Wilderness,*
Nantahala National Forest, North Carolina/Cherokee National Forest, Tennessee
"I think that I shall never see/A poem lovely as a tree," wrote poet and journalist
Joyce Kilmer, who never actually visited this area. But he must have been thinking
of trees like these. Many are four hundred years old and grow out of soil that is
far, far older and teeming with microscopic life.

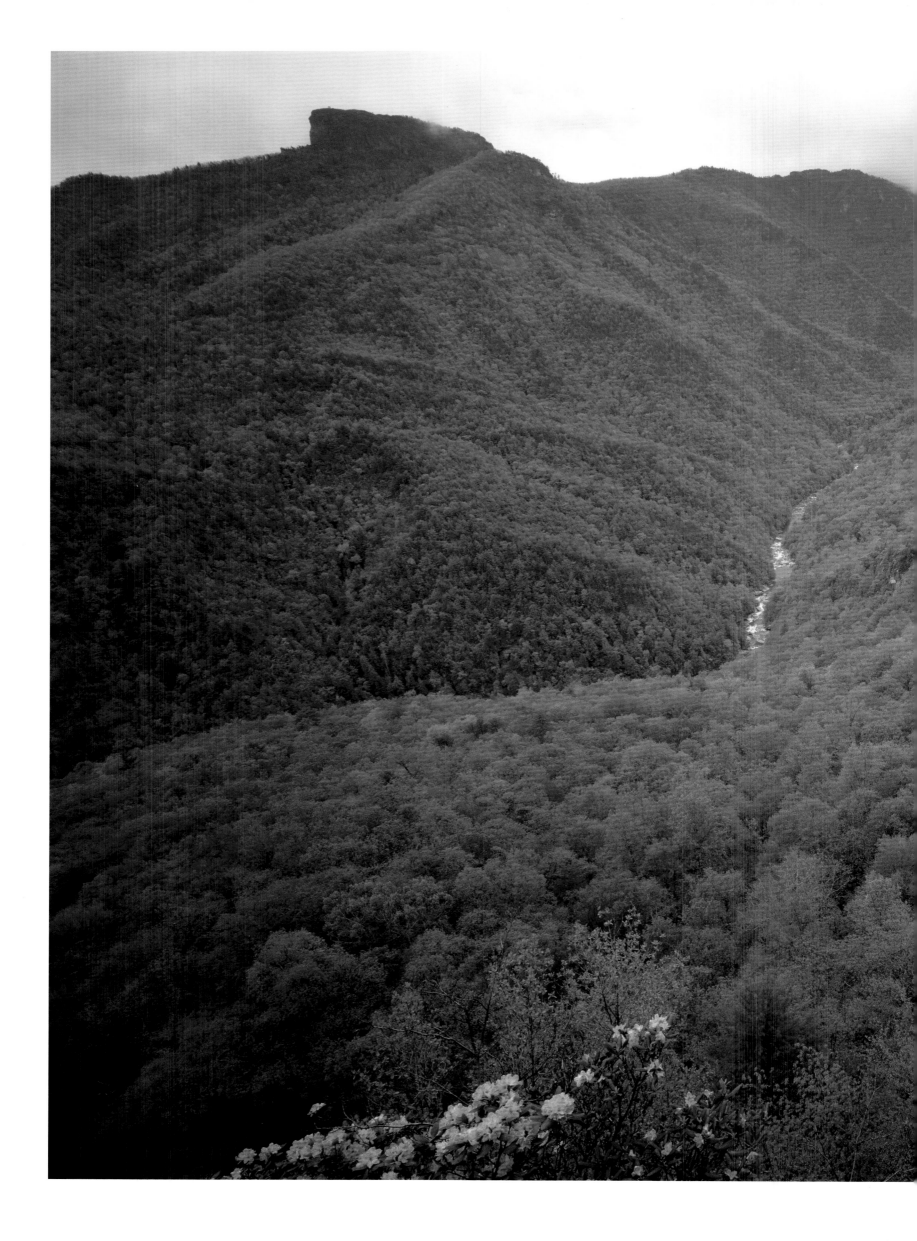

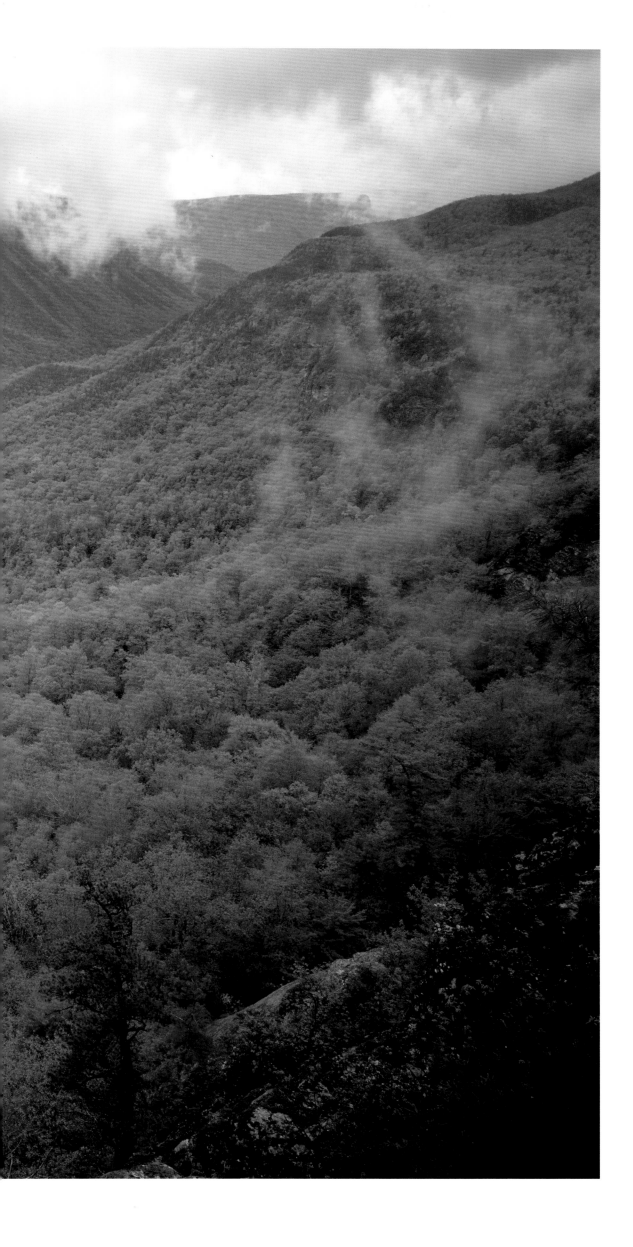

Linville Gorge Wilderness,
Pisgah National Forest, North Carolina
Called "the Grand Canyon of North
Carolina," Linville Gorge is twelve miles
long and roughly 1,400 feet deep. It is so
craggy that loggers could not reach every
stand of trees, and about 10,000 acres of
the original Great Forest survive here.

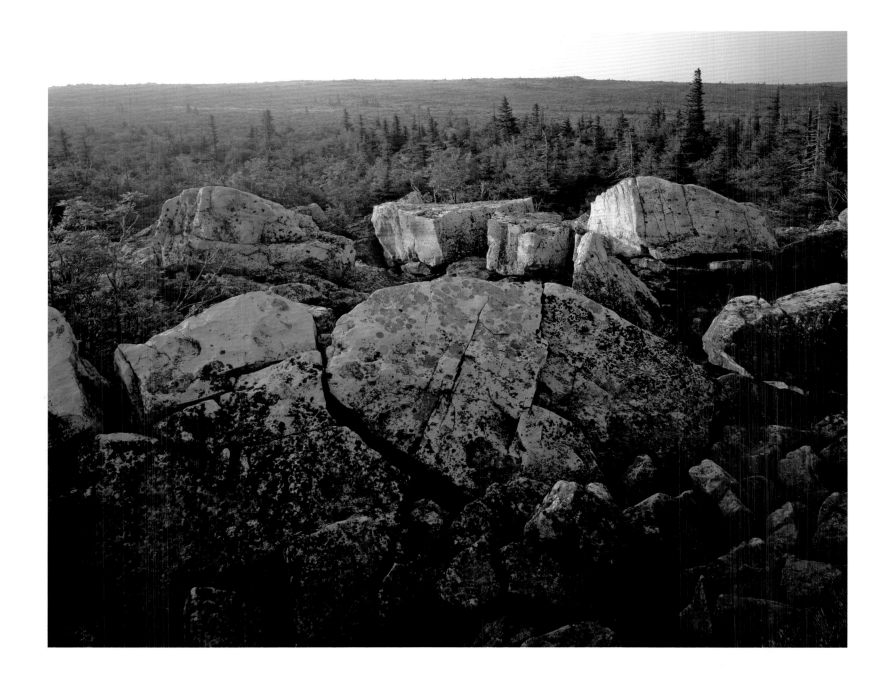

Dolly Sods Wilderness, Monongahela National Forest, West Virginia
This tundralike area on a 4,000 foot-high plateau was used to train soldiers for mountain
fighting in World War II. Unexploded shells are still occasionally found.

Humpback Mountain, Blue Ridge Parkway Milepost 6, Virginia
It may look forbidding, but Humpback Mountain provided food, medicines, and building materials for mountain settlers: wild nuts, berries, and herbs were plentiful in season; game was abundant in the early years of settlement; and there was wood for every use imaginable.

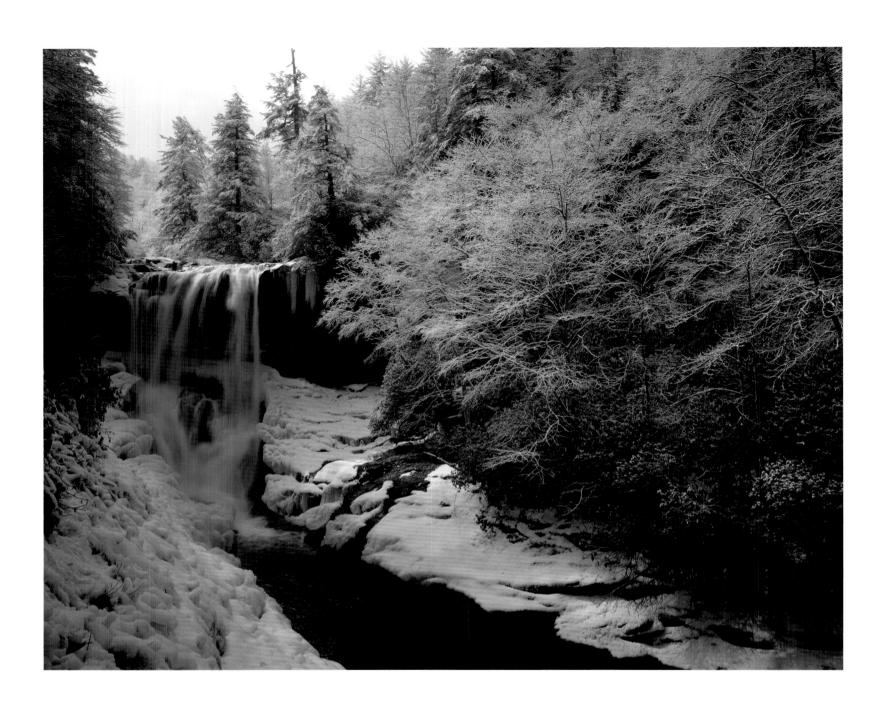

Dry Falls, Cullasaja River, Nantahala National Forest, North Carolina
Dry Falls offers the rare opportunity of walking behind a curtain of falling water. When freezing temperatures help keep the water flow at a low level, visitors can walk beneath the overhanging cliff and stay dry. But even when temperatures plunge below zero, the grottoes behind the falls remain warm enough to sustain a fern species from the West Indies, whose spores must have blown in on a wind from the south.

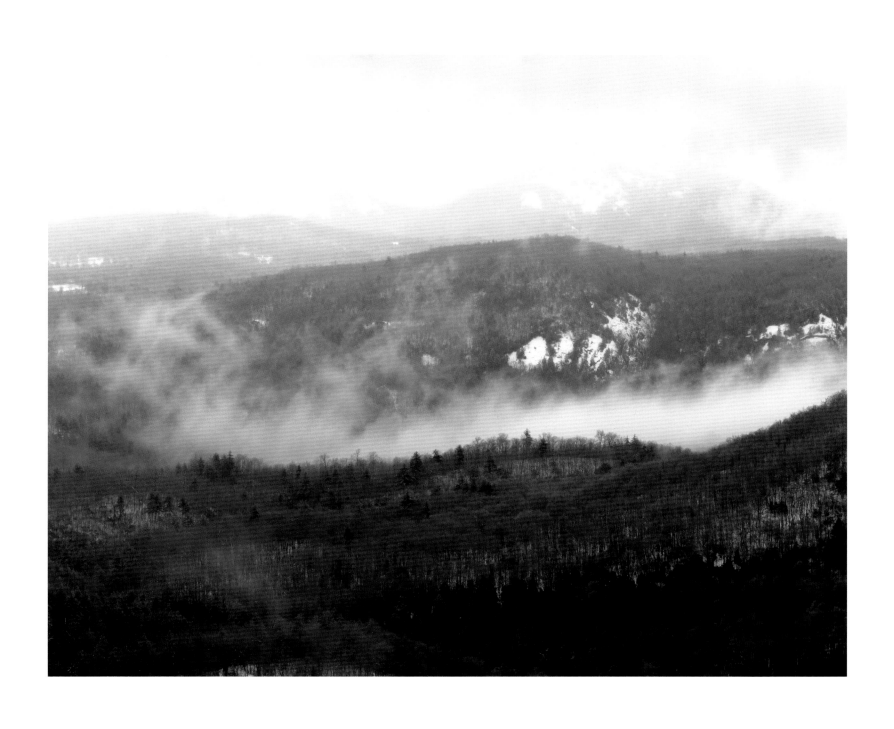

Rocky Mountain, Chimneytop Mountain, and Timber Ridge,
Jackson and Transylvania Counties, North Carolina
If the climate warms as predicted, the cold-adapted plants and
animals that can live only at high elevations will lose their home.
Without contiguous habitat corridors, seeds and animals won't
be able to move in response to climate change.

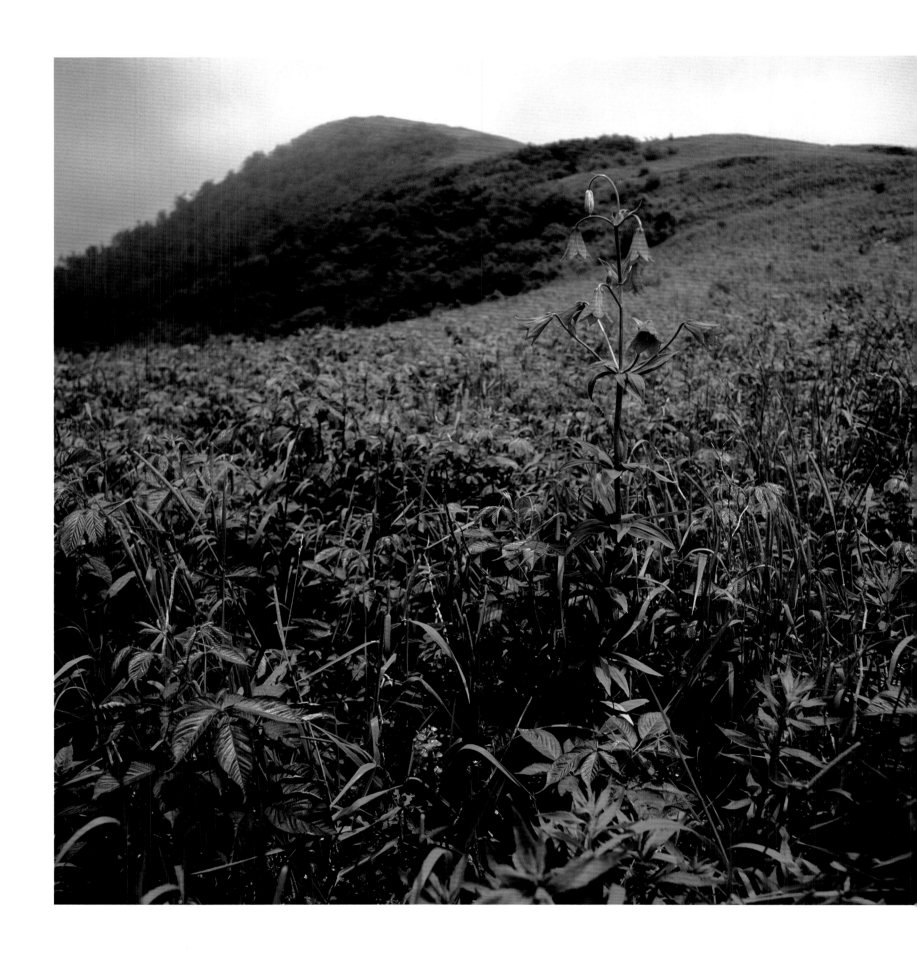

Gray's lily, Pisgah National Forest, North Carolina
Generally about three feet tall, Gray's lily has been known to reach eight feet. It grows only in a few high meadows, balds, and bogs, where wild hogs love to root it out, as do poachers. Lilies and orchids belong to large, widespread families believed to have a common ancestor. The ancestors of the wild hogs in this region came from Europe in 1911, when they were imported for hunting.

Why do some Southern Appalachian mountains lack trees at their summits? None of them is above the tree line; even the highest have spruce-fir forests. No visible ecological fence bars trees from growing on balds, and, in fact, many balds are constantly invaded by woody species that must be grazed, cut, or burned to keep the bald open.

Grazing and burning figure prominently in origin theories. Some ecologists speculate that during the age of glaciers, when severe cold stopped tree growth at the highest elevations, mammoths and mastodons were attracted to the tundralike fields that resulted. The giant grazers perpetuated the open conditions; and after the megafauna disappeared, the balds were grazed by bison, elk, deer, and livestock.

Or maybe lightning was drawn toward the highest mountaintops, where it lit forest fires and created openings that attracted grazers both wild and domestic. Native Americans and settlers alike had long traditions of using fire to create meadows, further blurring our record of the past.

Yet many balds are old enough to have developed unique species and communities. The heath balds are dominated by rhododendrons and other ericaceous shrubs like blueberries, all belonging to a plant family whose typically bell-shaped blooms are spectacular affirmations of Southern Appalachian biodiversity. Grassy balds are most common on south and west aspects and are dominated by mountain oat grass and sedges, sometimes with a sparse scattering of trees or shrubs around a completely grassy center.

As the federal government set about repairing environmental damage on public lands in the early twentieth century, livestock were removed from balds and fires were put out. Grassy balds tended to be overtaken by blueberries, rhododendrons, serviceberry and hawthorn or conifer trees, unless these were cut. Heath balds were less subject to invasion, although various woody species slowly crept in from the surrounding forest.

The Cherokee, whose nation covered most of the Southern Appalachians when white settlers arrived, believed that immortal spirit people called the Nunnehi lived in townhouses in the highlands, especially the balds. The Nunnehi cleared the balds so that eagles could hunt rabbits there. They were a sociable people and very fond of music and dancing, and their drumming was often heard on the balds almost up to the time of the Trail of Tears.

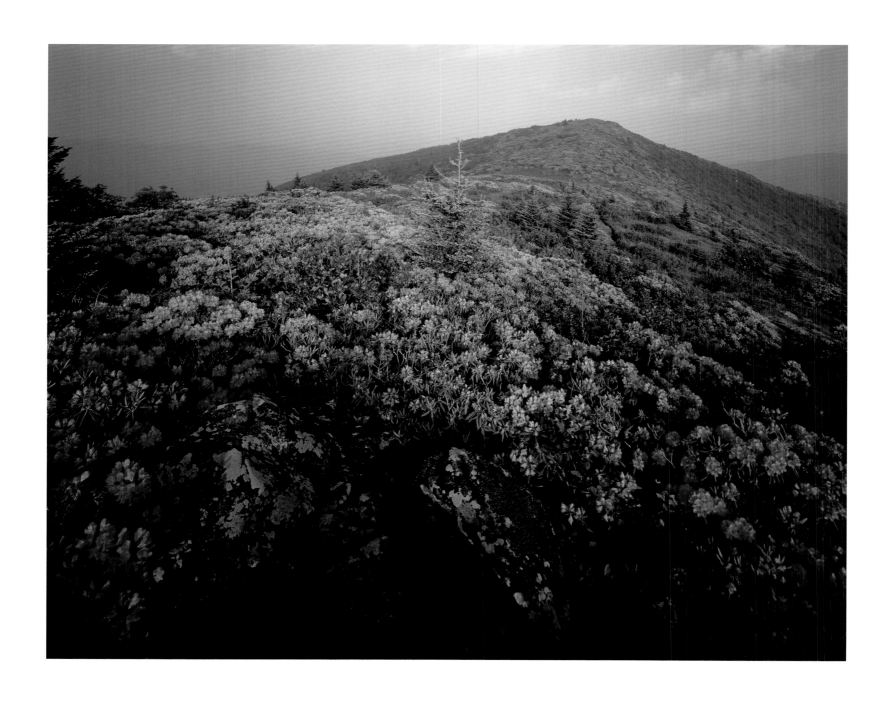

Catawba rhododendrons, Roan Mountain, Pisgah National Forest, North Carolina
Rhododendron species are widely distributed around the world, but Catawba rhododendrons grow
only in the heights of the Southern Appalachians and on bluffs in the North Carolina piedmont and
coastal plain, where they represent relicts of an earlier distribution. They dominate heath balds.

Flame azaleas, Roan Mountain, Pisgah National Forest, North Carolina
"The epithet fiery, I annex to this most celebrated species of Azalea . . . which [is] in general of the colour of the finest red lead, orange and bright gold, as well as yellow and cream," wrote explorer and botanist William Bartram in 1791. "The clusters of the blossoms cover the shrubs in such incredible profusion [on] the hillsides, that . . . we are alarmed with the apprehension of the hill being set on fire."

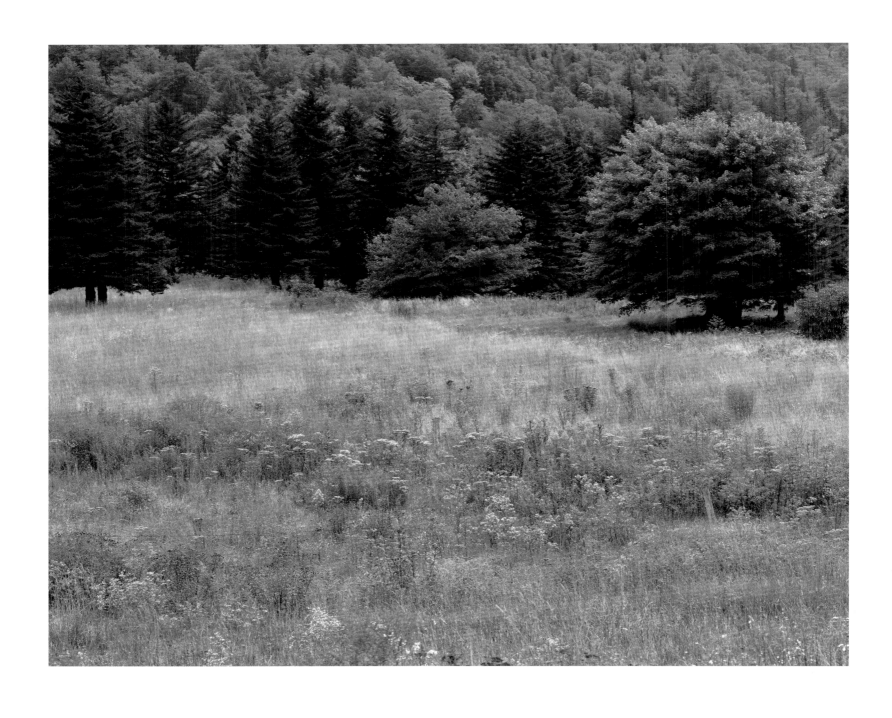

Blue Ridge Mountains, Ashe County, North Carolina
This remote meadow includes goldenrod, swamp asters, sneezeweed, boneset, and other
field flowers against a backdrop of turning maples and evergreen spruce. Old fields, known
to have been created by humans, host plant communities very different from those of
balds, whose origins have faded into the mists of Blue Ridge time.

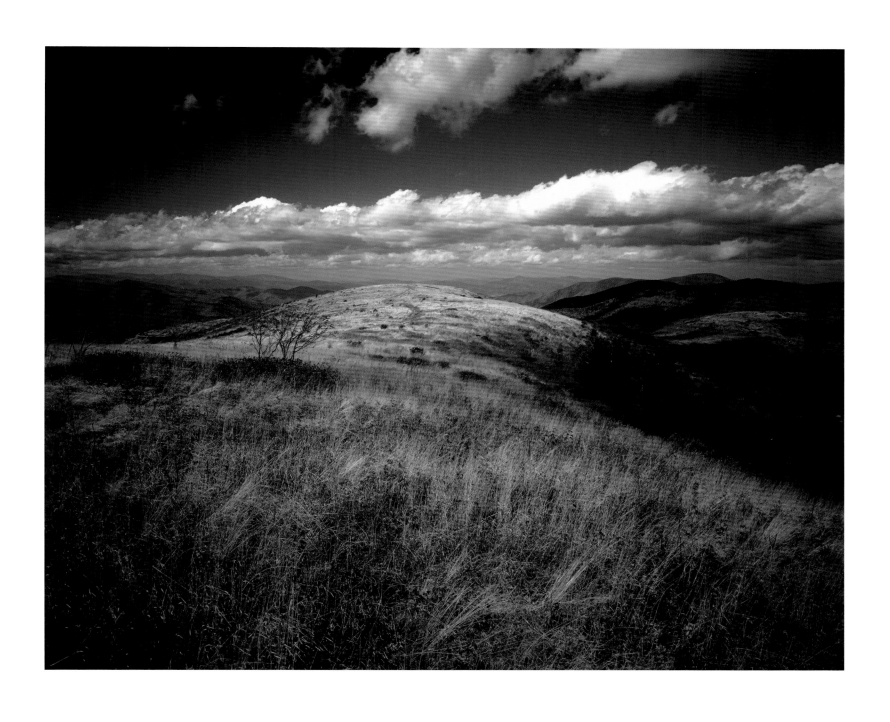

Mountain oat grass, Shining Rock Wilderness, Pisgah National Forest, North Carolina
Mountain oat grass dominates many of the grassy balds of the Southern Appalachians,
often growing densely enough to prevent tree seedlings from taking root.

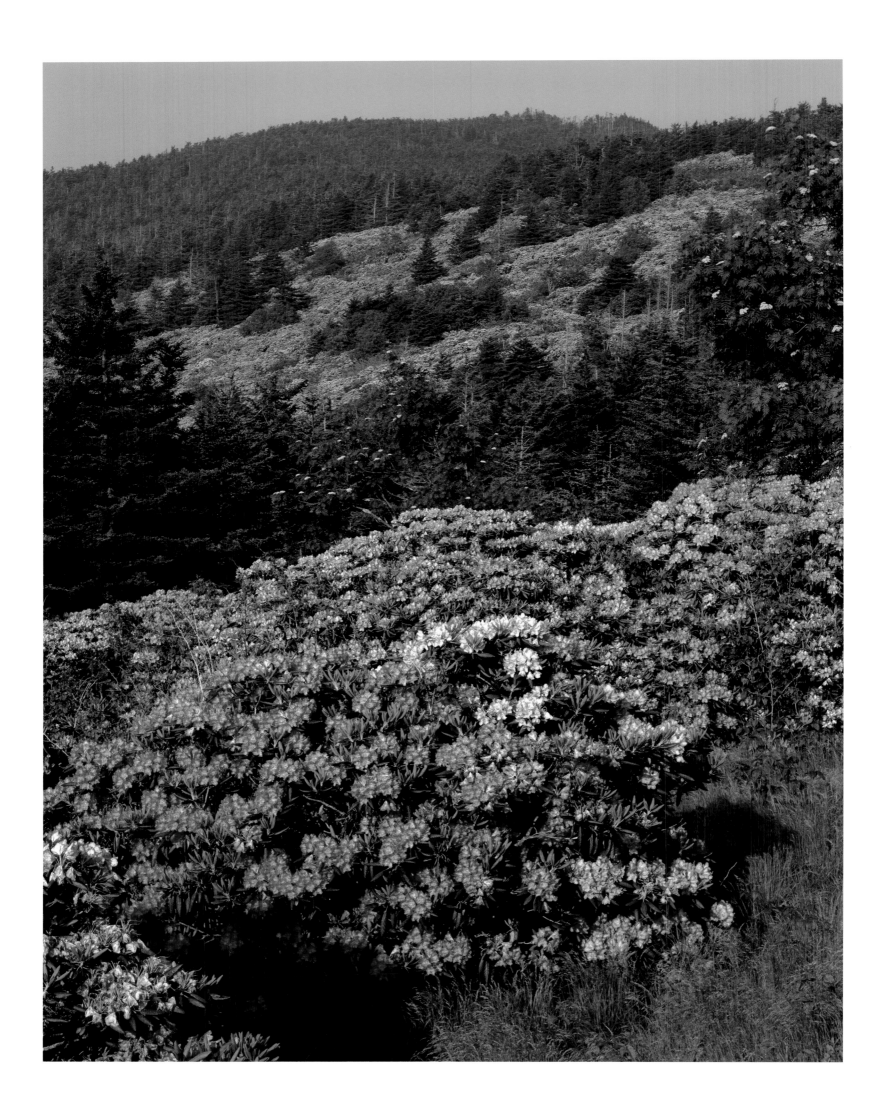

Roan Mountain, Pisgah National Forest, North Carolina/Cherokee National Forest, Tennessee
The conjunction of spruce trees, rhododendrons, and grasses embody the enigma of balds.
Scientists speculate that some unknown combination of climate change, lightning or human-set
fires, and grazing animals created both grassy and heath balds in the midst of lush forest.

(OPPOSITE) *Catawba rhododendrons, Roan Mountain Gardens, Pisgah National Forest,*
North Carolina/Cherokee National Forest, Tennessee
Two national forests converge at the state border along Roan Mountain. Both were
among the first national forests to be created after the Weeks Act of 1911 authorized
the U.S. Forest Service to purchase, for restoration, lands where forest cover had been
destroyed by logging and by repeated fires ignited by steam-powered equipment.

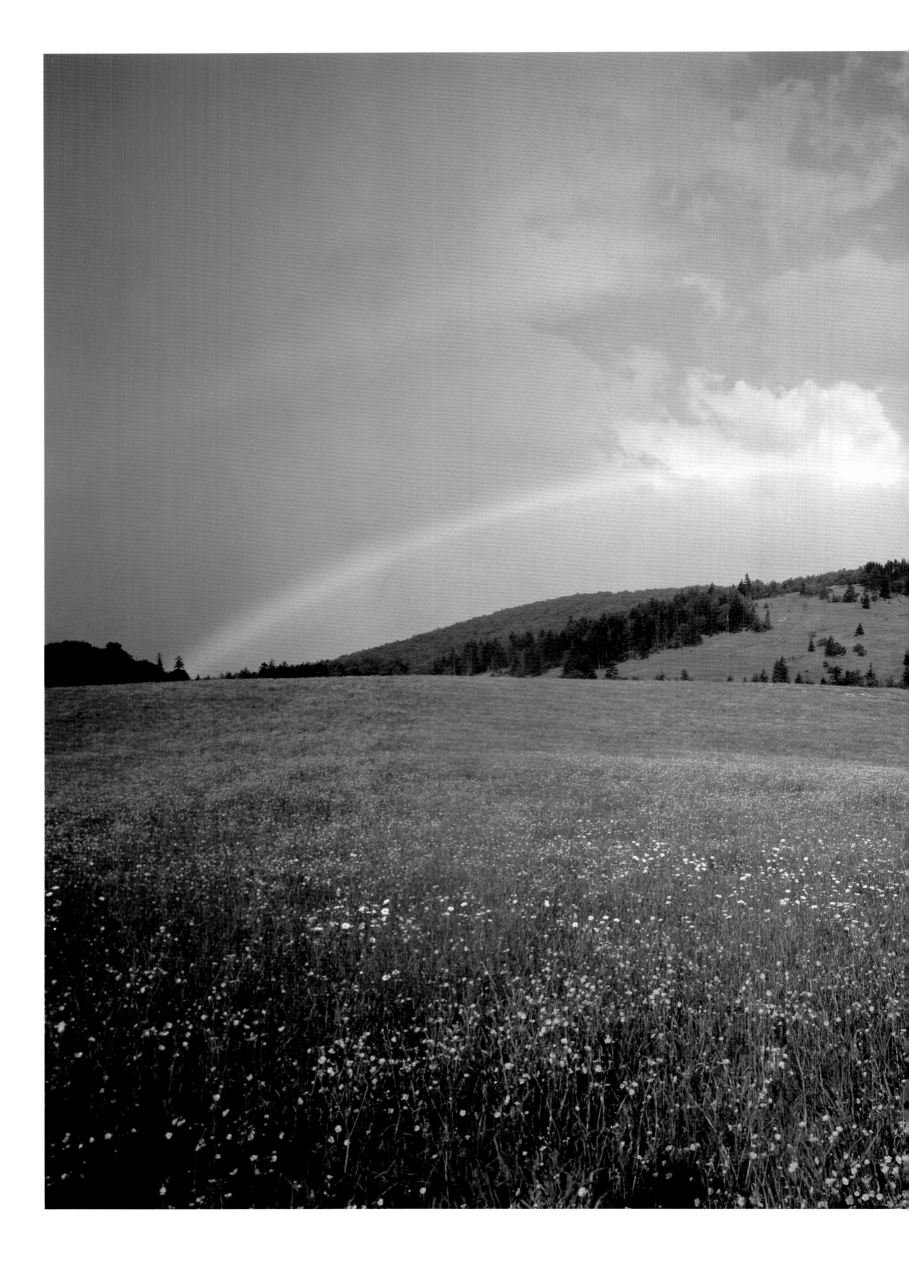

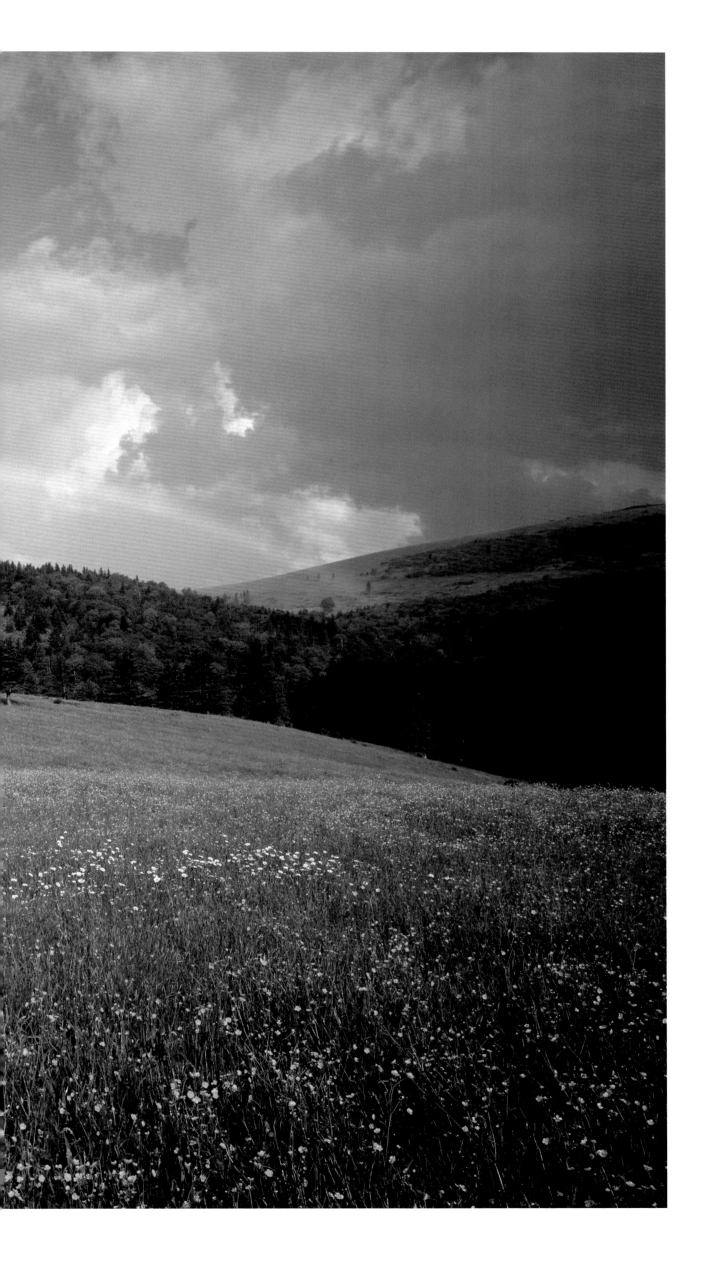

Blue Ridge Mountains,
Ashe County, North Carolina
Pastures cleared many years
ago mimic the look of balds.
Just as with many balds, bram-
bles and trees slowly begin to
move in from the edges.

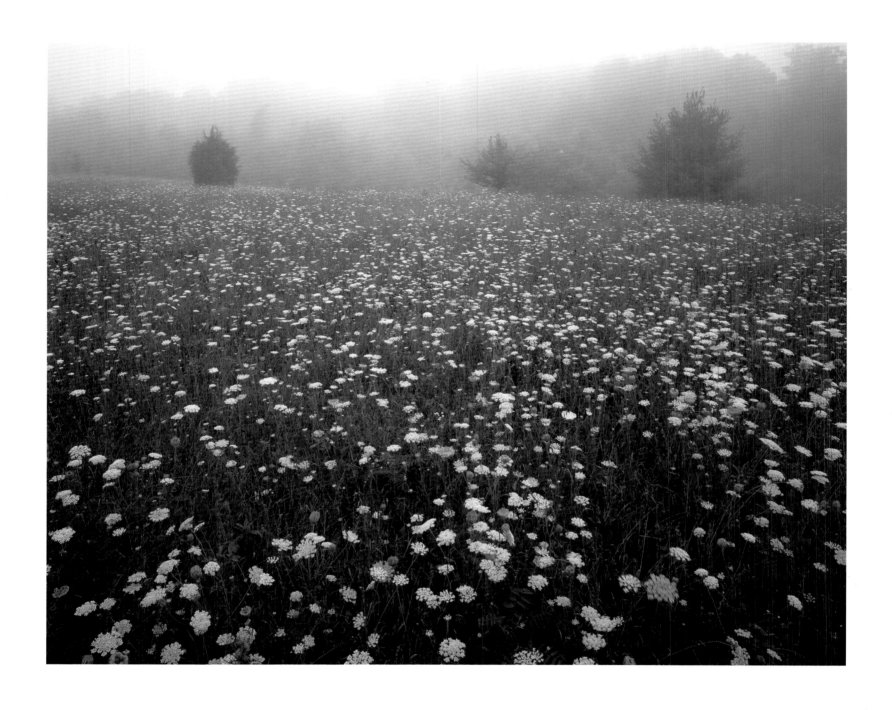

Queen Anne's lace, West Virginia
Brought from Europe by the earliest settlers for its medicinal qualities, which include
anti-inflammatory properties, this beloved but invasive wildflower has spread across most
of North America. The Cherokee, who knew the medicinal use of some seven hundred
native plants, soon learned to make an infusion of it to treat swelling.

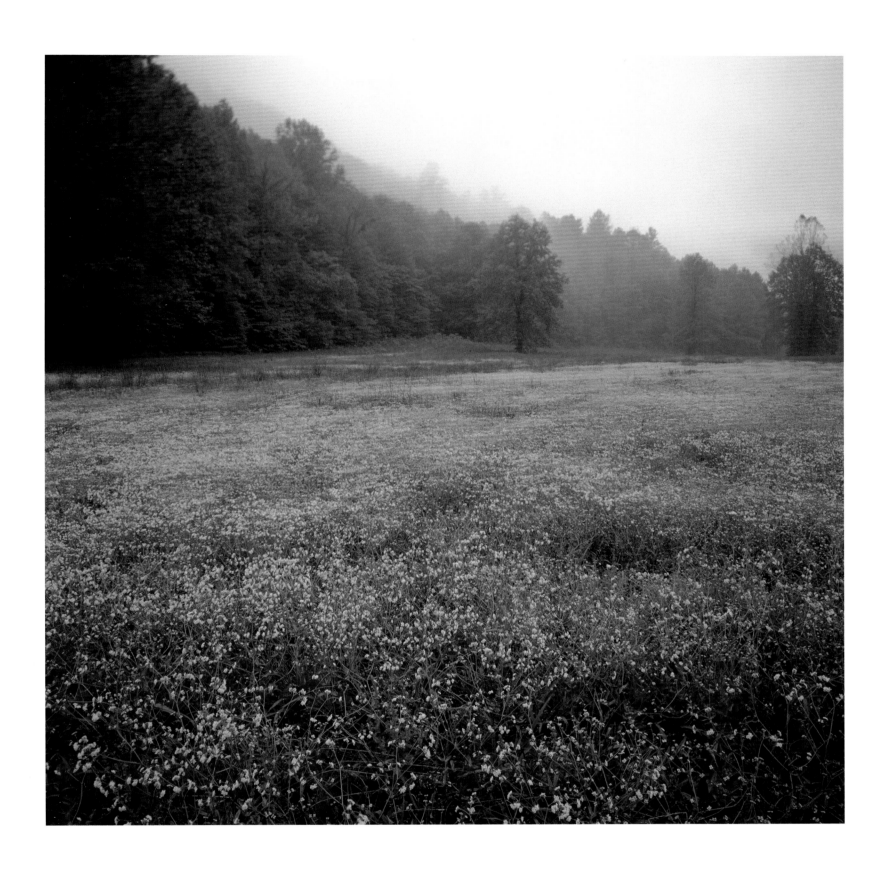

Cherokee, North Carolina
One of the Cherokee names for the Great Smoky Mountains was "Land of Blue Smoke," referring to the frequent fog rising after rains and the natural haze from vast, breathing forests. Descendents of Cherokees who escaped the forced movement westward on the Trail of Tears in 1838 today populate the town of Cherokee and the Qualla Boundary, the land trust for the Eastern Band of Cherokee Indians.

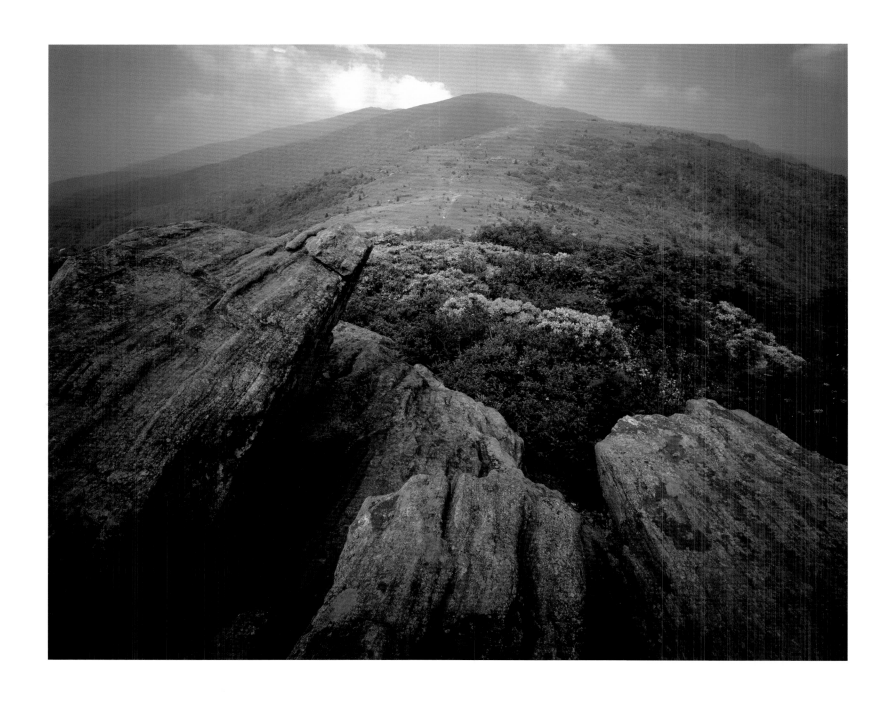

Roan Mountain, Pisgah National Forest, North Carolina/Cherokee National Forest, Tennessee
Acres of blooming rhododendrons make Roan Mountain a favorite stop along the 2,175-mile
Appalachian Trail, seen here in the middle distance. The shelter at Roan High Knob (elevation
6,285 feet) is the highest on the Trail.

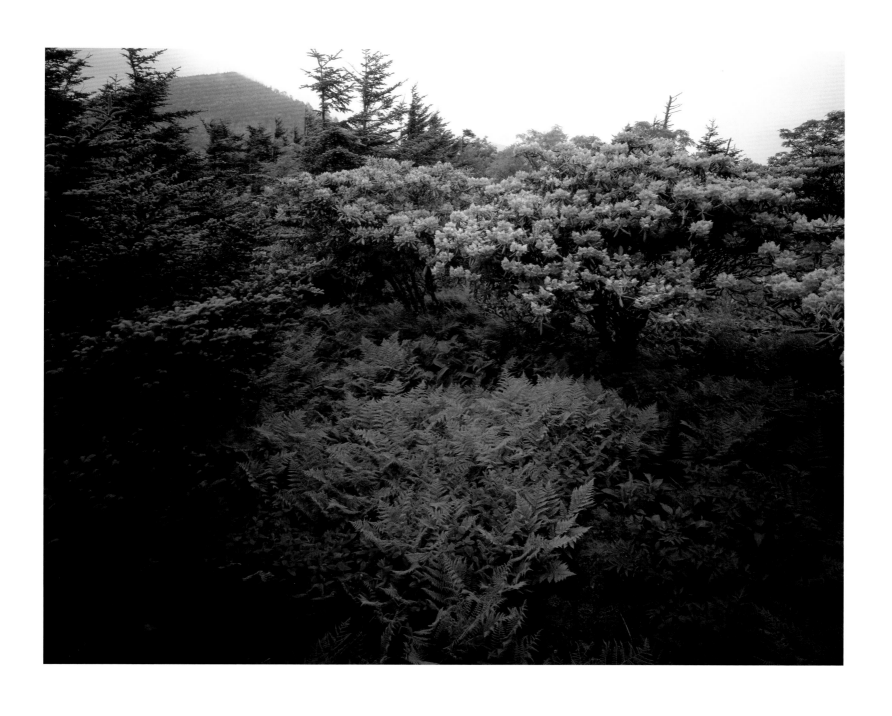

Mt. Mitchell State Park, Blue Ridge Parkway Milepost 355, North Carolina
The beauty of Mt. Mitchell—and its fame as the tallest peak in the eastern United States at
6,684 feet—prompted many North Carolinians to express alarm at the imminent destruction
of its natural character by logging. In 1915, it became North Carolina's first state park.

Ragworts, Blue Ridge Parkway Milepost 355, North Carolina
Wildflowers bloom from March through October along the 469-mile long Parkway, America's
favorite summer drive. As it meanders along the high crests of Virginia and North Carolina, the
Parkway passes through a multiplicity of climate zones, vegetative communities, geological features,
and cultural sites, encompassing much of the complexity of Southern Appalachian life.

Crabtree Meadows, Blue Ridge Parkway Milepost 339, North Carolina
Black-eyed Susan, butterfly weed, beard tongue, gentian, and approximately 1,300
other species of wildflowers bloom along the Parkway. More than fifty threatened
and endangered plant species claim the Parkway as critical habitat.

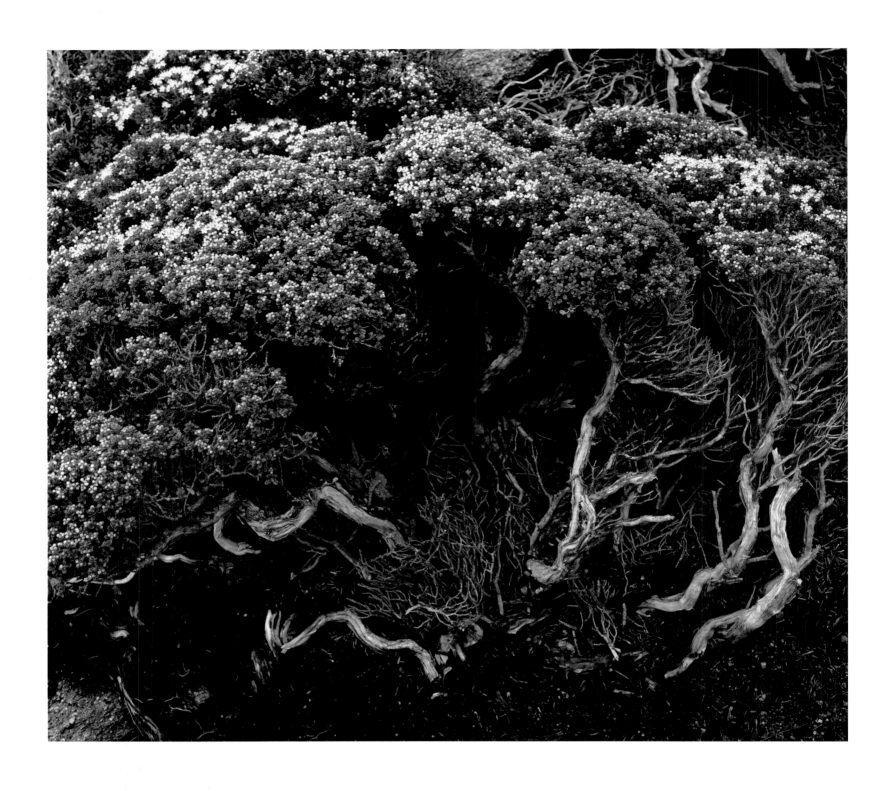

Sand myrtle, Grandfather Mountain, Blue Ridge Parkway Milepost 305, North Carolina
True to its name, sand myrtle grows along the sandy Carolina coasts and in the New Jersey
Pine Barrens, as well as in parts of the Southern Appalachians. An evergreen shrub related
to mountain laurel, it prefers rocky outcrops at moderate to high elevations.

The last snow on northern slopes is melting, but new leaves on deciduous trees remain tightly furled, still unconscious of the coming spring. Hours of sunlight warm the forest floor day after day. Last fall's leaves form comforting if decomposing layers of nutrients. Now! Cry the spring ephemerals. Rejoice!

And so they do: hepaticas, spring beauties, trout lilies, trilliums, fire pinks, columbines, bleeding hearts, jack-in-the-pulpits, violets, and hundreds more species seize the time between winter and spring to bloom in a celebration of life's possibilities. They sprout, flower, and fruit before the canopy leafs out overhead and shades out most of the sun. By June, spring ephemerals have died back aboveground and gone dormant belowground.

What the flowering ephemerals are really doing, just like the later-blooming bee-balms, lady slippers, lilies, asters, goldenrods, sunflowers, and many others, is trying to attract pollinators. It's the same old story: sex, of a sort. Attracting an insect to deliver or carry pollen is a dance through the ages between form and function. Orchids in particular have complex relationships with pollinators, sometimes based on deception as the bee works into a flower to find no reward, but exits with legs laden with pollen grains.

Little is known about native Southern Appalachian insect pollinators except that there may be lots of them. The All Taxa Biodiversity Inventory at Great Smoky Mountains National Park lists 765 species of Hymenoptera, an order of insects that includes bees, wasps and their relatives. About two dozen of those species were unknown to science before the inventory began a decade ago. Three dozen species of moths and butterflies of the 1,871 species so far inventoried are new discoveries as well.

In addition to pollinators, wildflowers need large predators that feed on deer. Overabundant deer are eating many flowers into rarity.

People consume some of them, too, for medicinal purposes. The shy, elusive American ginseng plant has a close relative in China, where dried roots were sometimes worth their weight in gold (Western science is now confirming some healthful properties of ginseng). Harvesting and selling ginseng to China helped finance frontiersmen like Daniel Boone, and today still provides income for many Appalachian people. But ginseng has declined throughout its range.

The Cherokee believe that, long ago, animals felt threatened as humans multiplied and killed them with ever more powerful weapons. The animals retaliated by bringing diseases to people, but the plants felt pity for humans and furnished a cure for each new sickness. To reciprocate the benevolence of plants, Cherokee medicine people passed by the first three plants before digging the fourth, to prevent overharvesting.

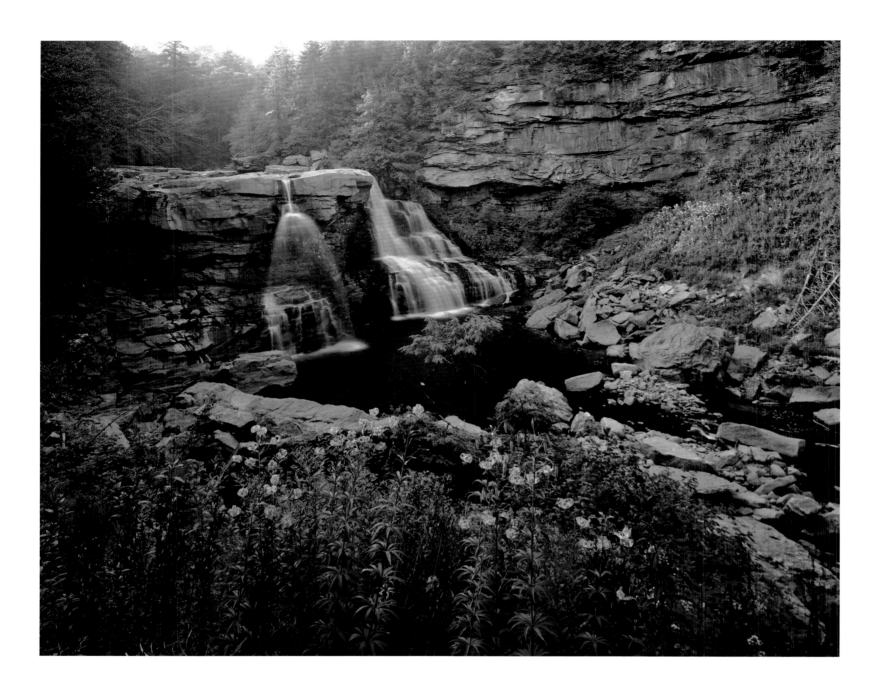

Turk's cap lilies, Blackwater Falls State Park, West Virginia
Turk's cap lilies bloom from June to August and are pollinated primarily by
several species of swallowtail butterflies. For half a century, Blackwater Falls
State Park has been the starting point for the annual West Virginia Wildflower
Pilgrimage, which draws hundreds of pilgrims including some from Europe.

(OPPOSITE) *Carolina lily, Highlands, North Carolina*
The only fragrant native lily east of the Rocky Mountains, this is
the state wildflower of North Carolina. It grows selectively in the sandy
soils of the Southeast. (Photograph by J. Manson Valentine)

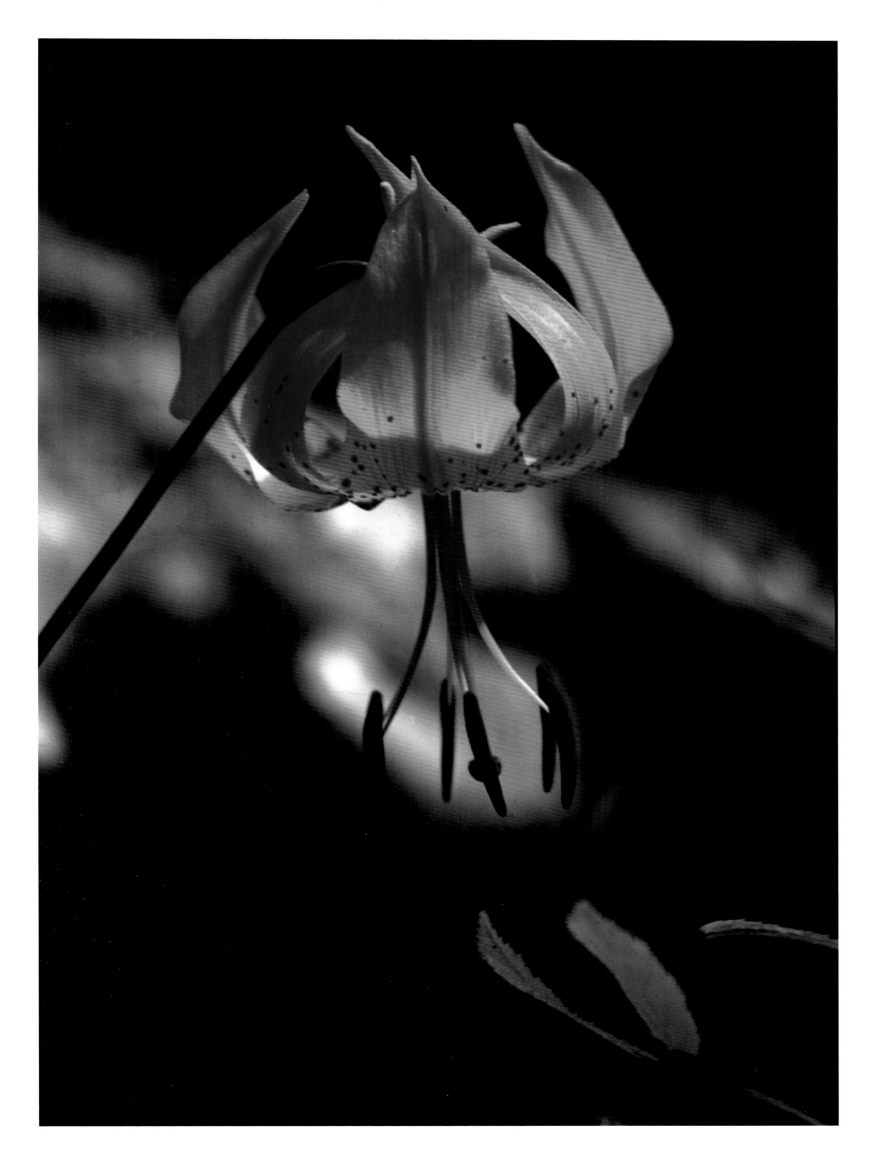

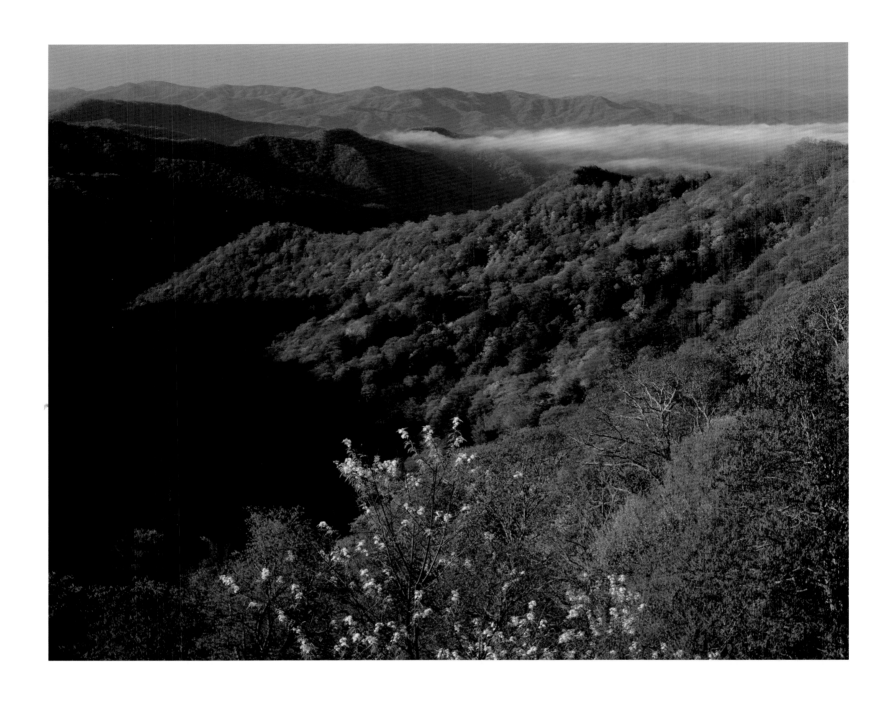

Serviceberry, Great Smoky Mountains National Park, North Carolina/Tennessee
By June, thrushes and other nesting songbirds seek out sweet, juicy serviceberries,
the earliest tree fruits available. Some 100,000 acres of mountainside were purchased
for the Park just before loggers reached them in the 1930s; they now are the largest
remnant of the original Great Forest in the eastern United States.

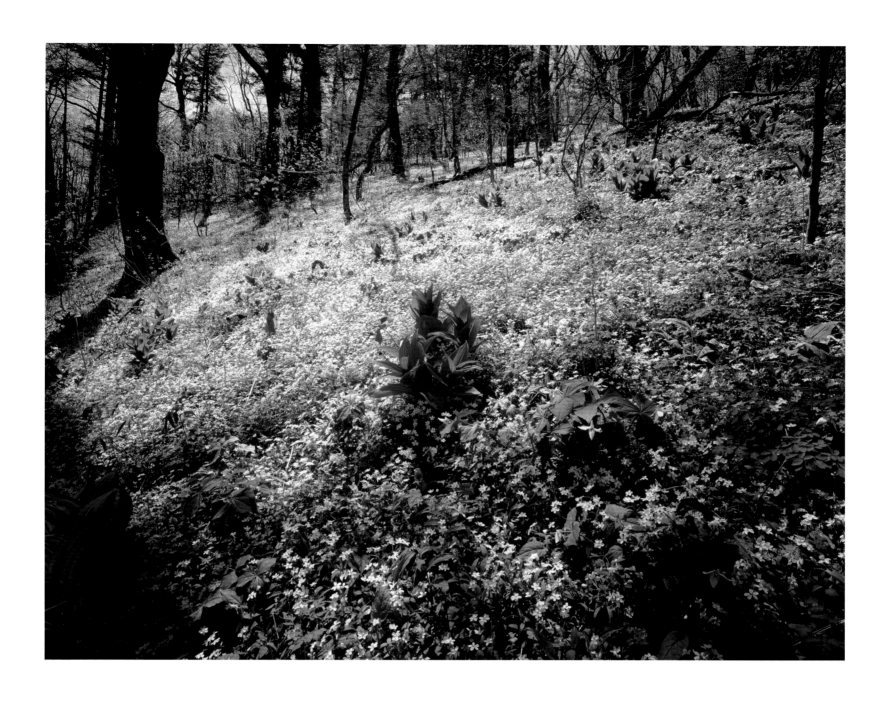

Spring beauty, trout lily, skunk cabbage, Great Smoky Mountains National Park, North Carolina/Tennessee
Depending on temperatures, spring beauties may begin as early as February to carpet parts of the forest floor with white. Peeking over them are yellow trout lilies, which can grow into large colonies hundreds of years old. The variously striped or spotted, green to purple leaves of skunk cabbage poke well above both of them (if you poke the plants, they'll emit the odor for which they're named).

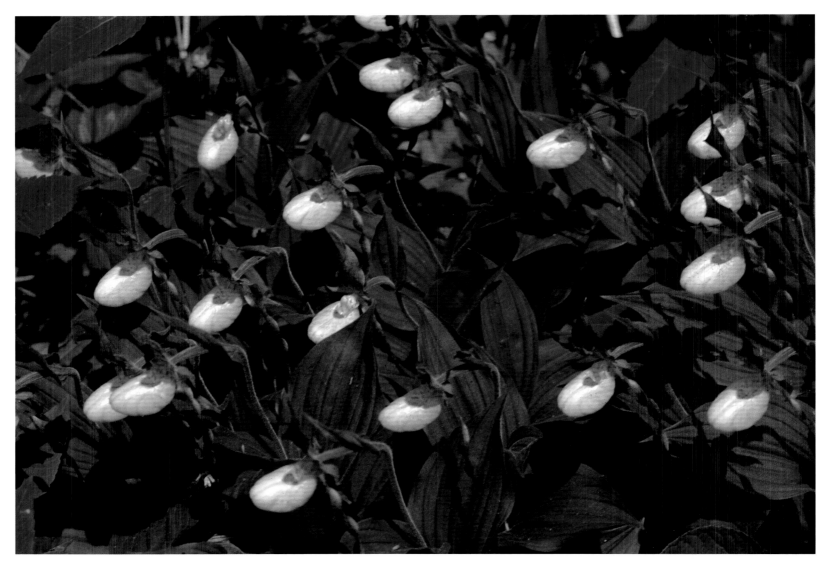

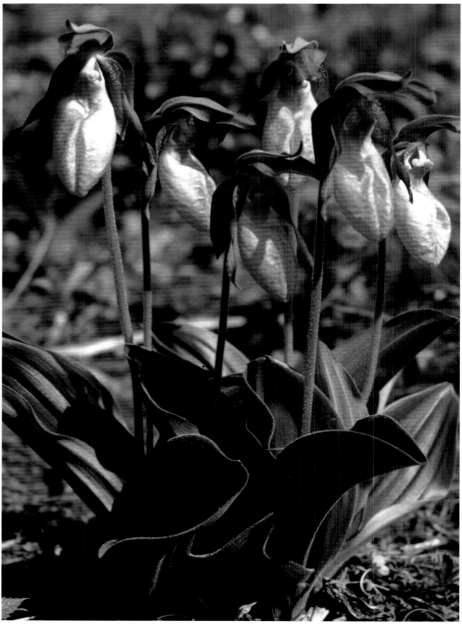

(ABOVE) *Yellow lady slippers, Highlands, North Carolina*
More than fifty species of orchids are native to the
Southern Appalachians, of which lady slippers are probably
the best known. Much sought after by horticulturalists
and gardeners, this perennial herb is threatened or
endangered in most states throughout its range. Cherokees
and mountain people made a sedative tea from the roots.
(Photograph by J. Manson Valentine)

(BELOW) *Pink lady slippers, Highlands, North Carolina*
Pink lady slippers are generally found in acid soils
near pine trees. As with many orchids, their pollination
is a complex procedure requiring specific agents.
(Photograph by J. Manson Valentine)

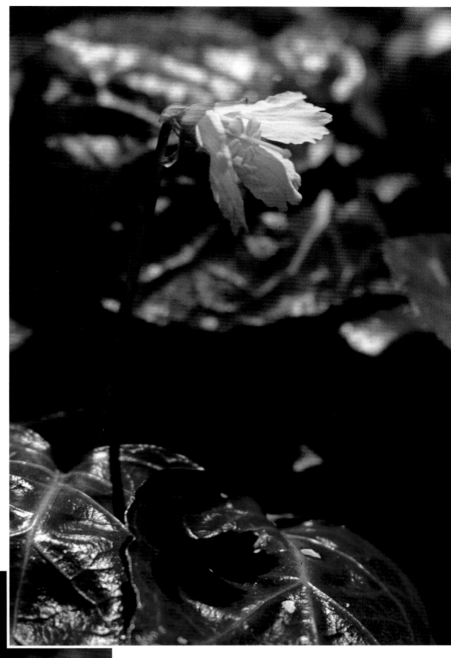

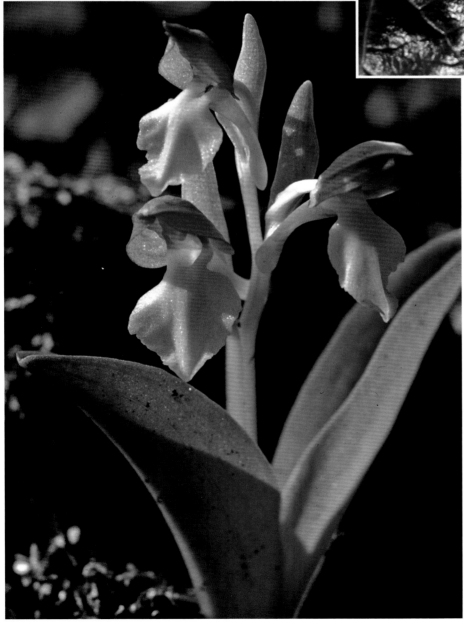

(ABOVE) *Oconee bells, Highlands, North Carolina*
André Michaux, the traveling French botanist who
originally described many Southern Appalachian plants,
collected and pressed this wildflower in 1787. It then
eluded botanists in the wild for nearly a century and
now is considered the rarest of Appalachian wildflowers.
(Photograph by J. Manson Valentine)

(BELOW) *Showy orchid, Highlands, North Carolina*
Two pink to purple upper petals form a hood over a
white lip. Orchids have three petals, one of which often
looks quite dissimilar to the other two because it has
evolved to deal with a particular type of pollinator.
(Photograph by J. Manson Valentine)

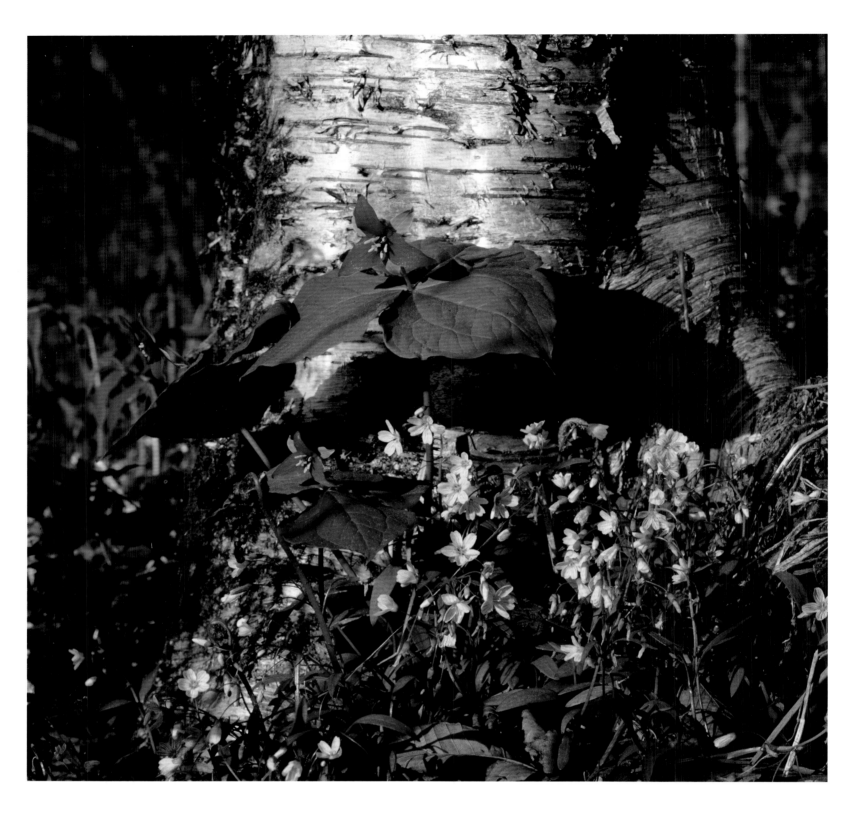

(ABOVE) *Trilliums, Great Smoky Mountains National Park,*
North Carolina/Tennessee
Approximately ten species of trilliums grow in the
Southern Appalachians, several of which are commonly
called wake robins. Their habit of hybridizing makes
identification difficult. Members of the lily family,
trilliums are distinguished by three leaves at the top
of the flower stalk.

(BELOW) *Large-flowered trilliums, Asheville, North Carolina*
This largest and showiest of the Southern Appalachian
trilliums is frequently cultivated in gardens. As the flower
ages, it turns from white to pink.

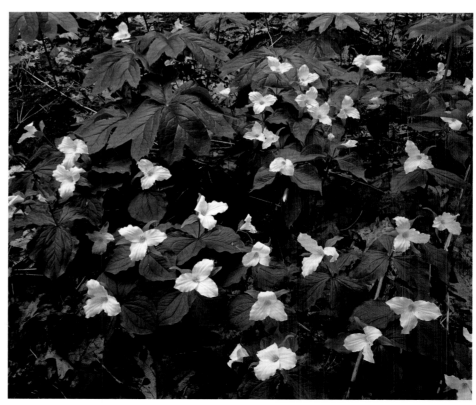

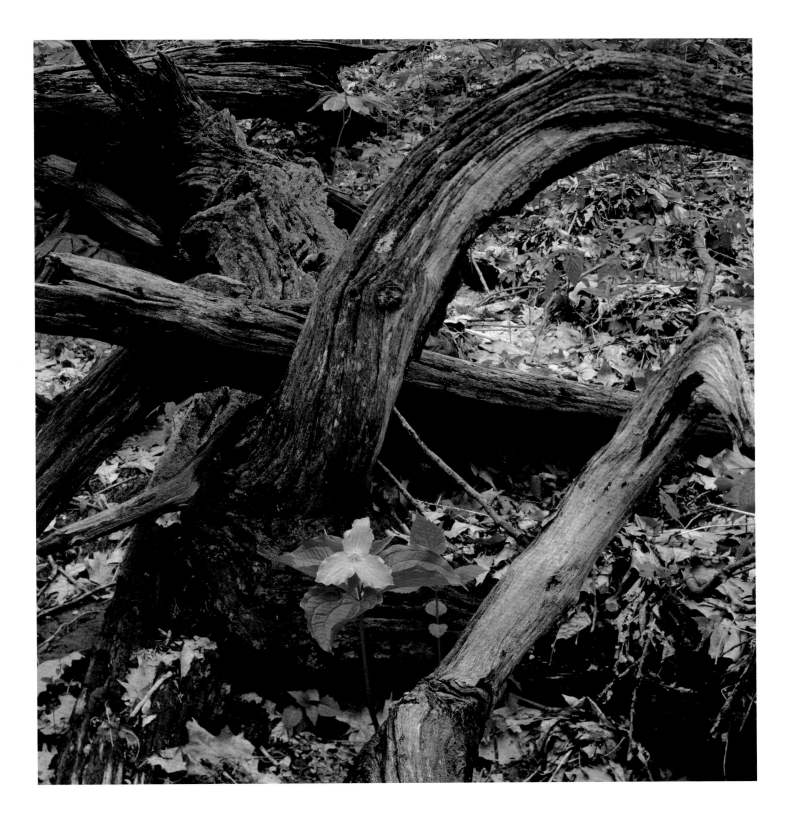

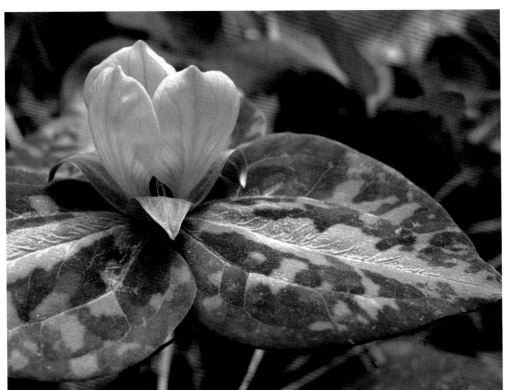

(ABOVE) *Large-flowered trillium,*
Mt. Mitchell State Park, Blue Ridge Parkway
Milepost 355, North Carolina
The leaves of this and several other species of trilliums were used medicinally for women's ailments, although other parts of the plants are poisonous to humans. But not to deer, who will eat them down to the ground. This trillium has evaded deer long enough to turn from white to pink with age.

(BELOW) *Toadshade trillium, Highlands, North Carolina*
Said to smell like bananas, these flowers range in color from green to maroon to yellow, with variously mottled leaves. (Photograph by J. Manson Valentine)

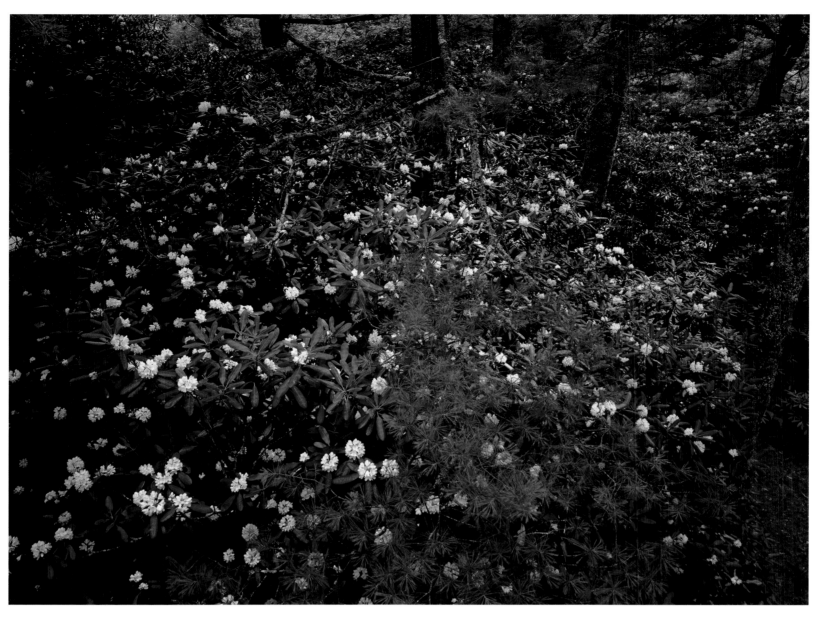

(ABOVE) *Rosebay rhododendron, Highlands Biological Station, Highlands, North Carolina*
More abundant at lower elevations than the Catawba, this rhododendron can grow to 30 feet high. Cherokees used the wood to make pipes and spoons, and infused the leaves to make a tea for heart trouble. (View from Valentine House Dormitory in recognition of a gift by James Valentine.)

(BELOW) *Mountain laurel, Highlands Biological Station, Highlands, North Carolina*
Mountain laurel prefers dry, rocky slopes and sometimes takes them over. "A 'hell' or 'slick' or 'woolly-head' or 'yaller patch,'" wrote Horace Kephart in his 1913 book, *Our Southern Highlanders*, "is a thicket of laurel or rhododendron, impassable save where the bears have bored out trails."

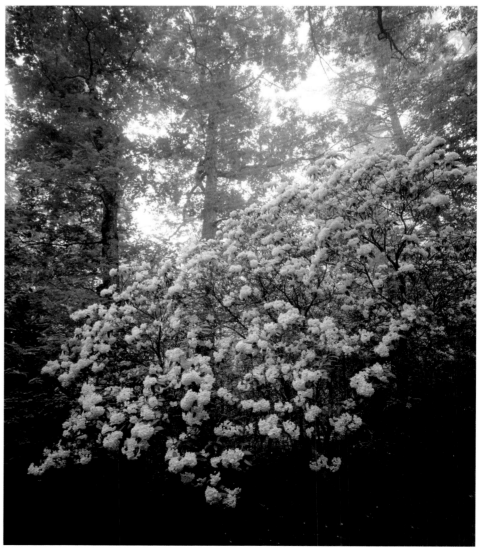

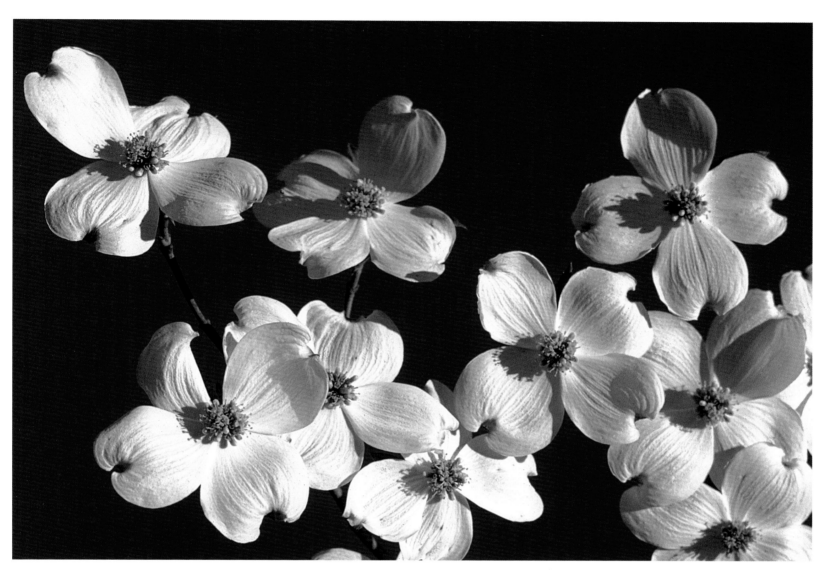

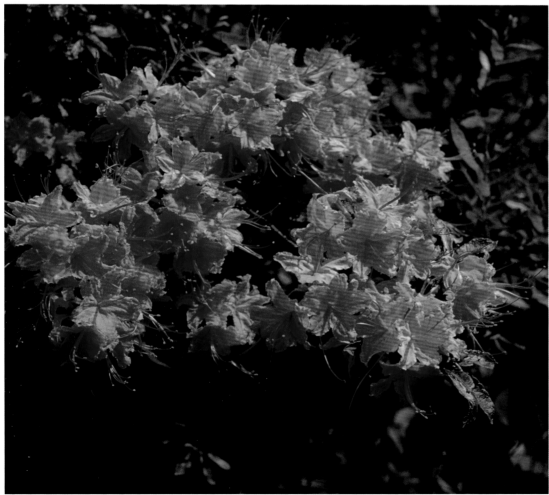

(ABOVE) *Dogwood blossoms, Highlands, North Carolina*
The dogwood blossoms that spangle the forest with white define spring for many people. Their red berries are a favorite of migrating songbirds, and their roots accumulate calcium, making the soil under dogwoods especially fertile. Like hemlocks and several other tree species, dogwoods are being attacked by a nonnative pest, in this case a fungus. (Photograph by J. Manson Valentine)

(BELOW) *Flame azalea, Wayah Bald, Nantahala National Forest, North Carolina*
Flame azalea flowers vary from pale yellow to brilliant scarlet, making the plant a darling of horticulturalists. Like many members of the rhododendron family, flame azaleas have poisonous parts and even the honey from the flowers may be toxic. But the Cherokee knew how to prepare a tea to treat women's troubles, and peeled and boiled twigs to rub on rheumatic limbs. (Photograph by J. Manson Valentine)

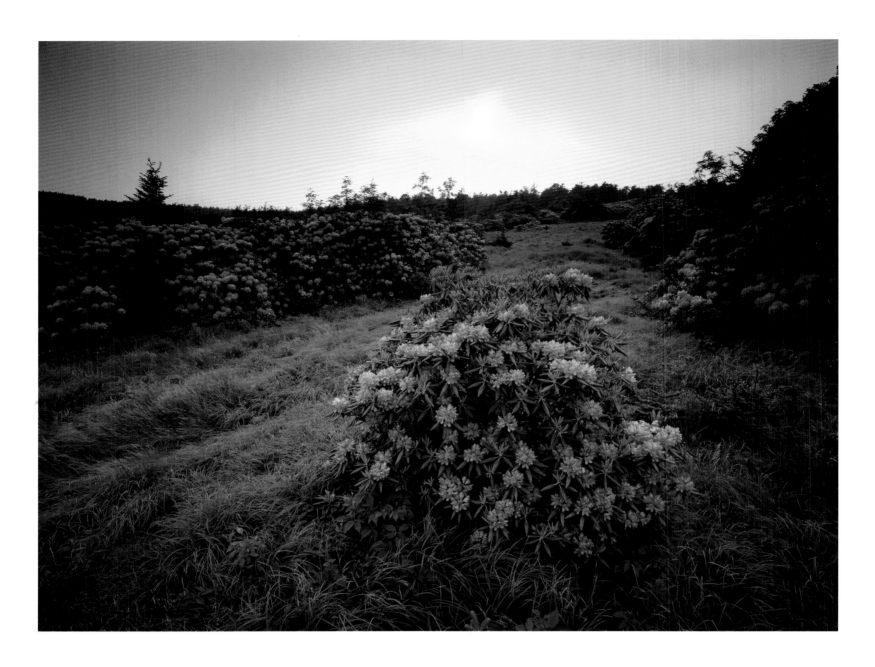

Roan High Bluff, Pisgah National Forest, North Carolina/Cherokee National Forest, Tennessee
Since 1947, the Roan Mountain Citizens Club has held a two-day Rhododendron Festival every June to celebrate the Roan Mountain Rhododendron Gardens. Tourism based on scenic beauty and outdoor recreation is a multibillion-dollar business in the Southern Appalachians.

(OPPOSITE) *Rhododendrons, Craggy Gardens, Blue Ridge Parkway Milepost 364, North Carolina*
Spent blossoms begin the journey back to the soil. Forest processes are entangled, endless loops that can sustain all native biodiversity when allowed to operate under reasonably natural conditions.

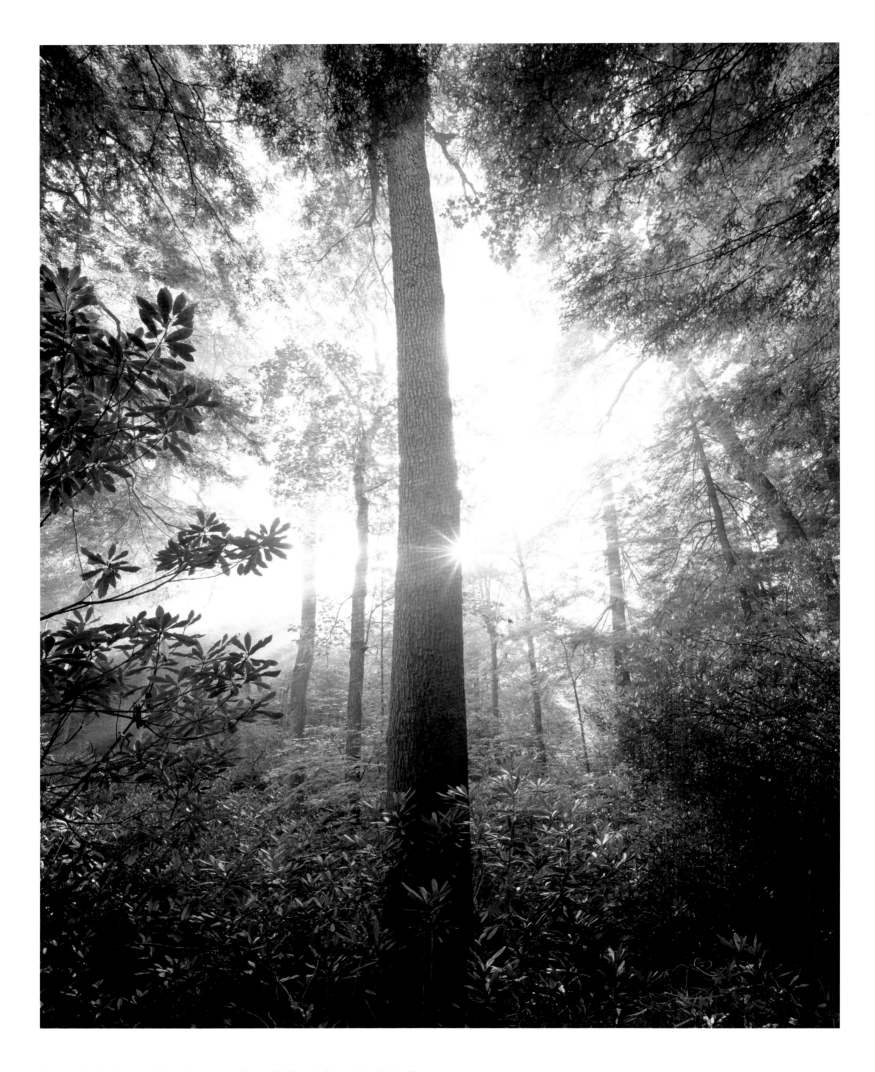

Eastern hemlock, 43.3 inches in diameter at breast height, Cashiers, North Carolina
Evergreen hemlock trees cast such deep, dense shade that only shade-loving plants like mosses can live beneath them. But as hemlocks die from attacks by nonnative woolly adelgids, they leave sunny openings that are no longer hospitable to such plants.

Big trees impress us, our society being easily swayed by superlatives. And rightly so, as big trees dwarf our human scale with magnificent bulk. But big trees are not necessarily old trees, and a tree is not a forest. It's the age of the forest community that counts in ecological time. Even the term "old growth" doesn't mean old trees but an old forest, one that hasn't suffered any widespread leveling catastrophes in centuries.

Hemlocks, oaks, hickories, and many other trees require centuries to mature to their fullest biological potential. Oaks hardly begin to bear good acorn crops before age sixty, and wildlife—from bears to turkeys to mice—depends on acorns in the absence of chestnuts. The older the forest, the gnarlier its architecture of habitat niches for plants and animals. The older the soil, the more carbon it holds.

If the past is any guide, Southern Appalachian forests tend to be old and big, covering entire mountainsides. "Forest interior" animals, including hundreds of songbird species, depend on large stands of mature trees for nesting and foraging. Forest gaps larger than a few downed canopy trees invite edge effects: drying out from sun and wind; invasion of nonnative plants like tree of heaven, which rob habitat from native species; and predation by assorted nonindigenous pests, such as the cowbirds that parasitize bird nests.

Most Southern Appalachian forests today are relatively young and patchy, still recovering from an onslaught of rapid ecological changes: clearing, logging, burning, demise from an exotic blight of an estimated 4 billion chestnut trees (one of every four trees in the Southern Appalachians before 1940), loss of predators, and soil chemistry changes from acid rain. Ongoing invasions by dozens of exotic species and diseases complicate the recovery, as does climate change.

In *The Deciduous Forests of Eastern North America* (1950), considered the bible of eastern old-growth studies, author E. Lucy Braun cautions: "The secondary forest not only may tell nothing about the nature of the original cover, but also it may even be very misleading in its implications." Remnants of the Great Forest, as historians call the original forest that covered most of eastern North America when Europeans arrived, are glimpses into the shadowy past. The largest remnant, about 100,000 acres in Great Smoky Mountain National Park, is a baseline for the forest that was, and the on-going All Taxa Biological Inventory continues to document an amazing number of life-forms there.

Yet many other smaller remnants have unique species of their own, as forests differ across landscapes. And the new and coming forests, just now approaching maturity, offer many possibilities for applying what can be learned from the remnants to conserve Southern Appalachian forests, which serve us in so many ways.

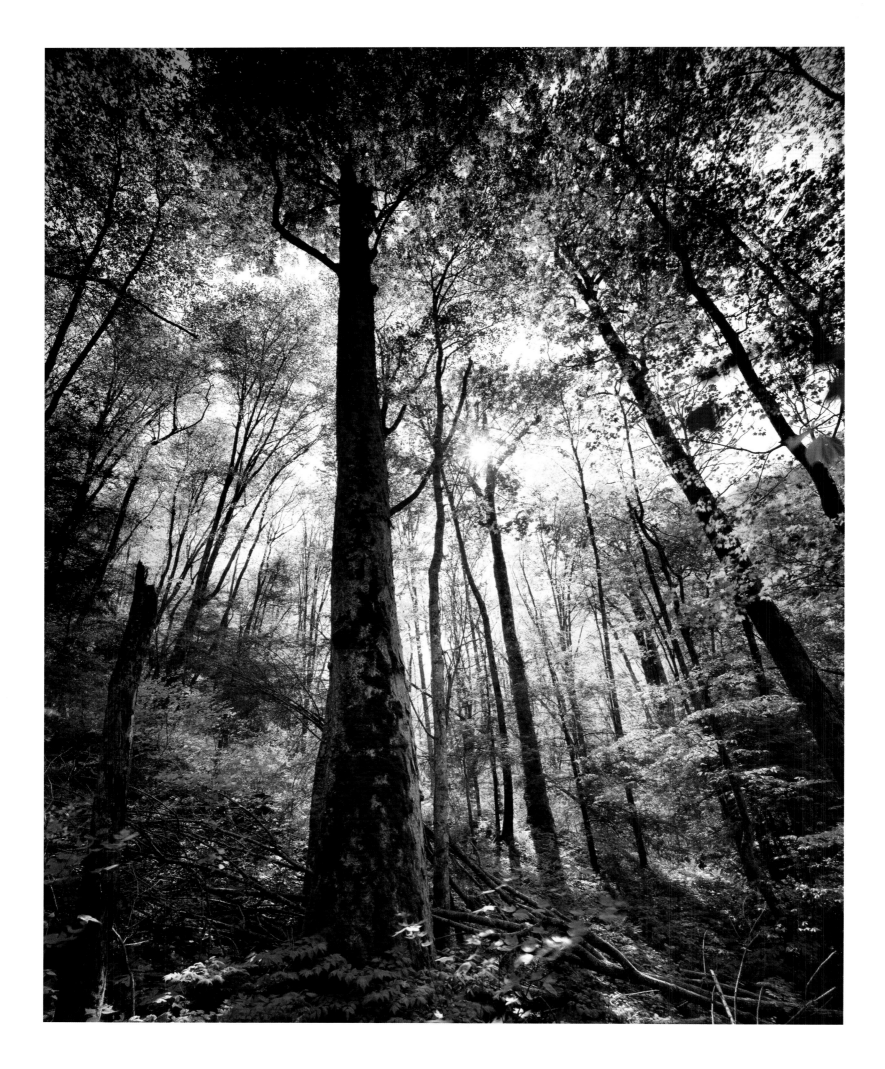

Yellow buckeye, 53.6 inches in diameter at breast height, Nantahala National Forest, North Carolina
Yellow buckeyes reach their largest size in coves, which are deltas of deep soil formed by millennia of stream deposition. Southern Appalachian coves produce the most biodiverse woods in North America, sometimes called "mixed mesophytic" forests because of the dozens of canopy tree species that grow in the moist but not sodden soil. Yellow buckeyes are one of the indicators of a mixed mesophytic forest.

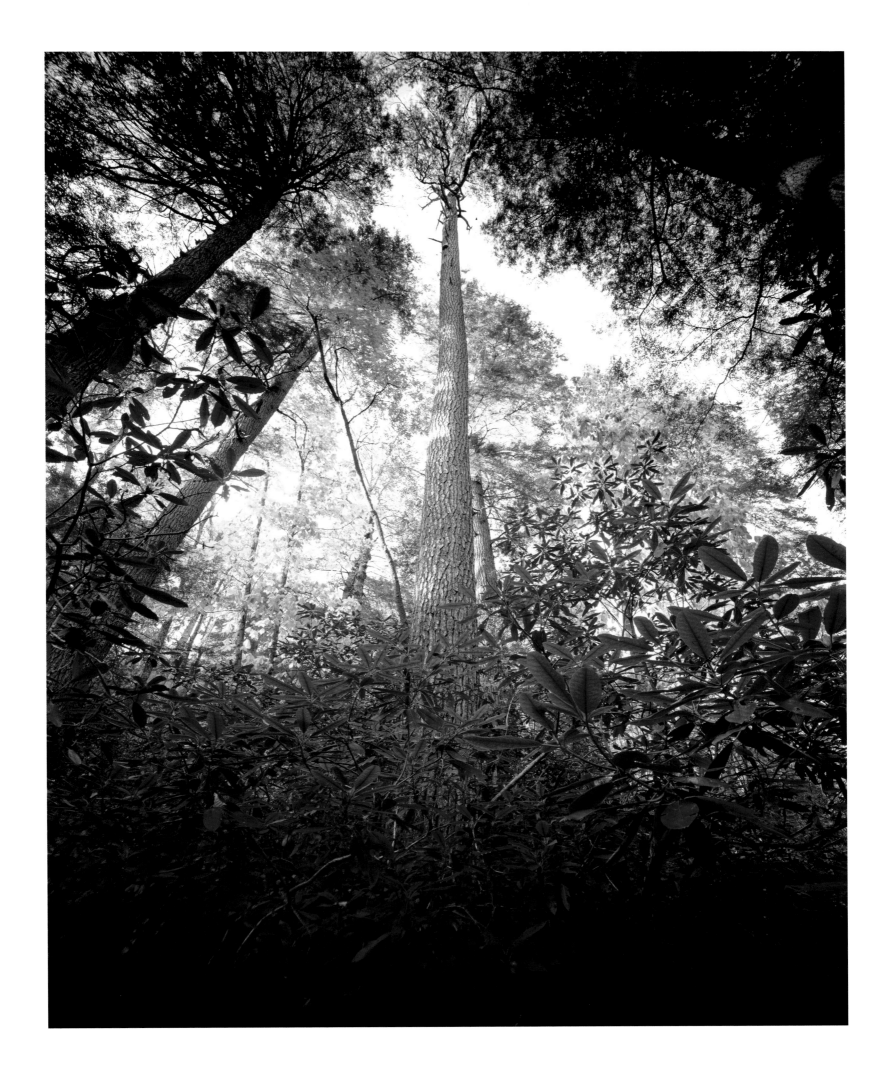

White pine, 45 inches in diameter at breast height, Linville Gorge Wilderness, Linville, North Carolina
White pines are native across southern Canada and New England and down the Appalachian Mountains to Georgia. Because they often grow very tall and straight—this tree is 168 feet high— they were highly favored for lumber. The Cherokee could make canoes 40 feet long from them.

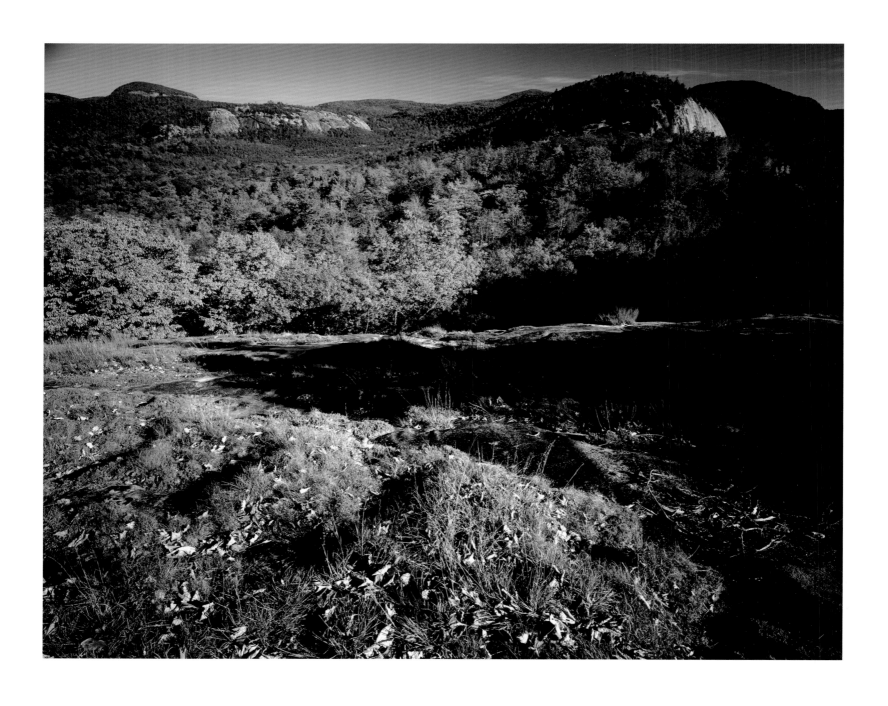

Panthertown Valley, Nantahala National Forest, North Carolina
This broad, flat valley floor, flanked by granite domes rising 300 feet above it, offers an
unusual combination of waterfalls, bogs, forests, and rock faces, with accompanying diversity
of natural communities. Named after the eastern cougar, called panther or painter in the
Southern Appalachians, it has the rocky cliffs panthers like for denning.

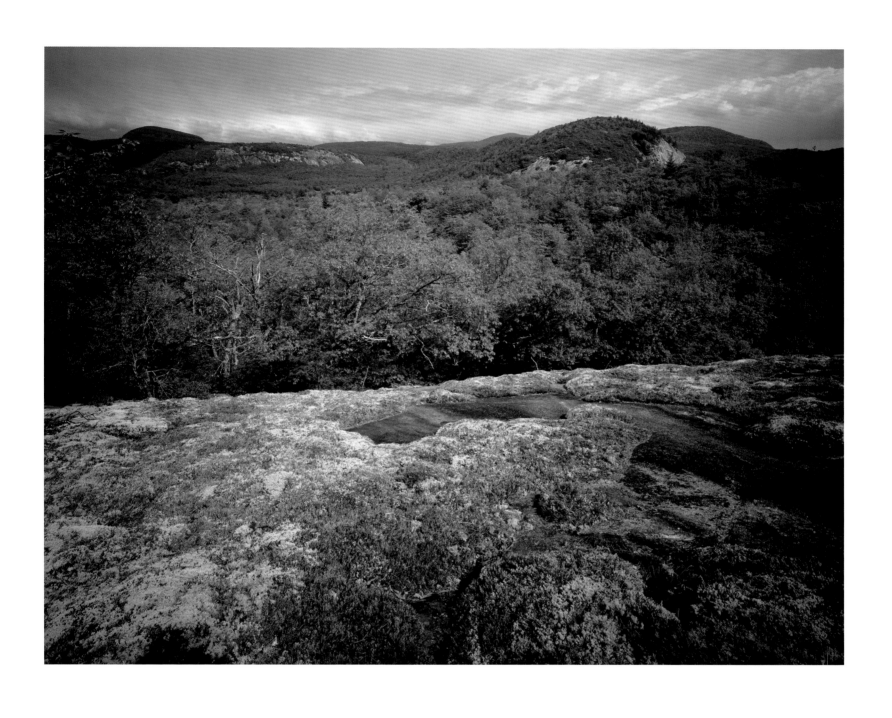

Panthertown Valley, Nantahala National Forest, North Carolina
Summer brings so many hikers, mountain bikers, horseback riders, and rock
climbers to this 6,300-acre area that the Forest Service now restricts commercial
permits. Heavy use compacts the ground, tramples the understory, pollutes the
water, encourages erosion, and constantly disturbs the neighborhood.

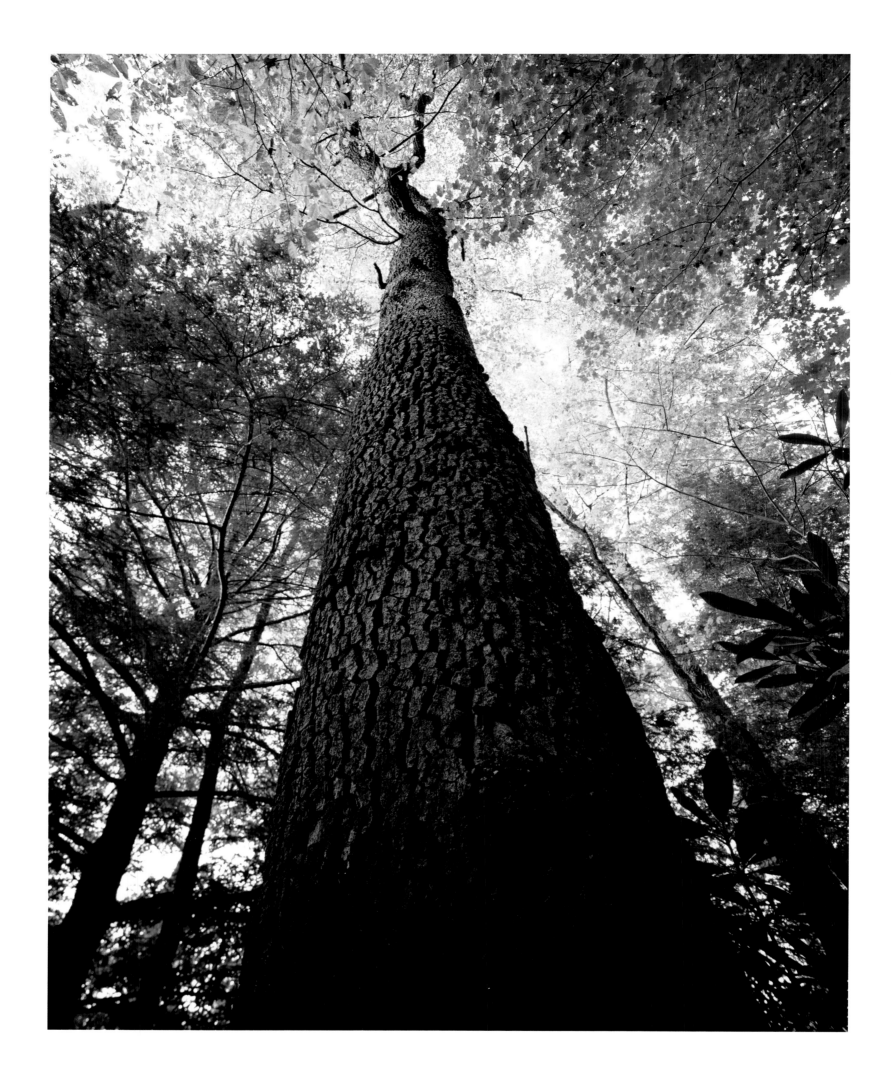

Black gum tree, 25.2 inches in diameter at breast height, Pisgah National Forest, North Carolina
Widely distributed across the eastern United States, black gum trees have flowers from which tupelo honey is made. The nutritious, blue-black berries are eaten by many birds and mammals. Black gums can live five hundred years or more and often form cavities in their wood, making them excellent den trees.

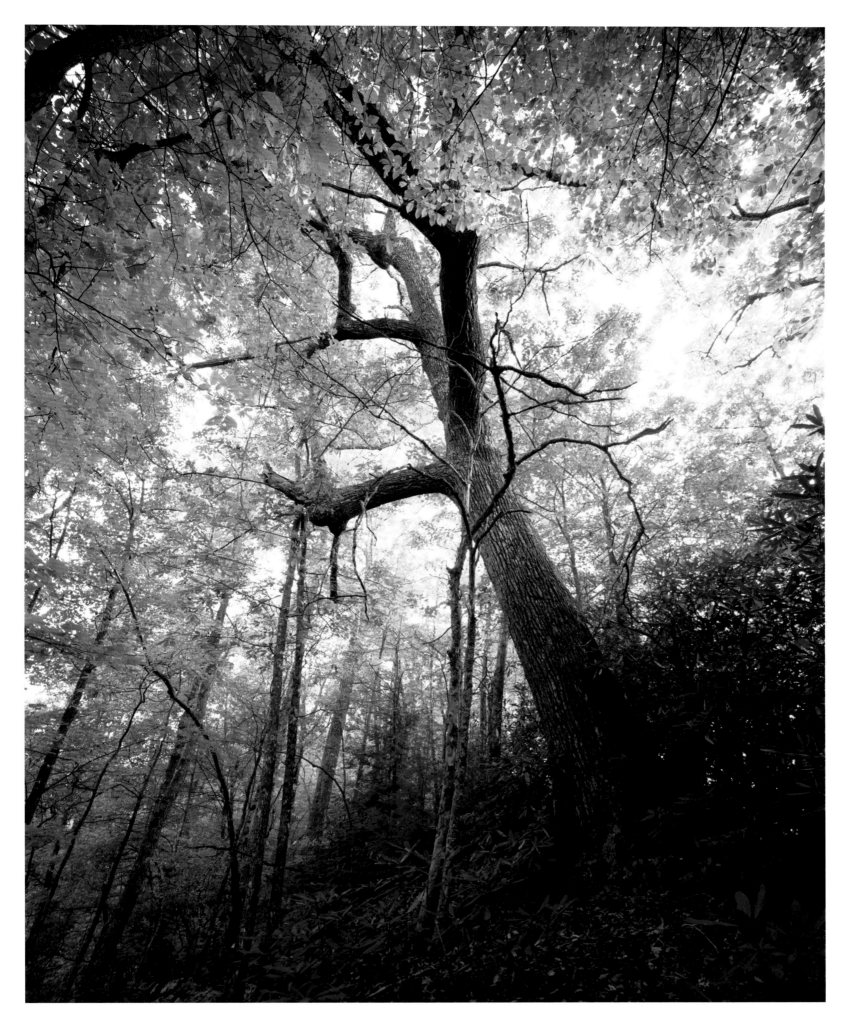

Chestnut oak, 39.4 inches in diameter at breast height, Pisgah National Forest, North Carolina
In some parts of the Southern Appalachians, it's uncommon to find a chestnut oak with a single trunk.
Like hemlocks and American chestnuts (a separate species whose leaves are similar to chestnut oaks),
chestnut oaks have tannic acid in their bark that used to be leached to tan leather. Many chestnut oaks
in the Southern Appalachians were harvested a century ago for their bark only. The stumps sprouted
readily into multiple strong trunks, unlike most conifers and many other hardwoods.

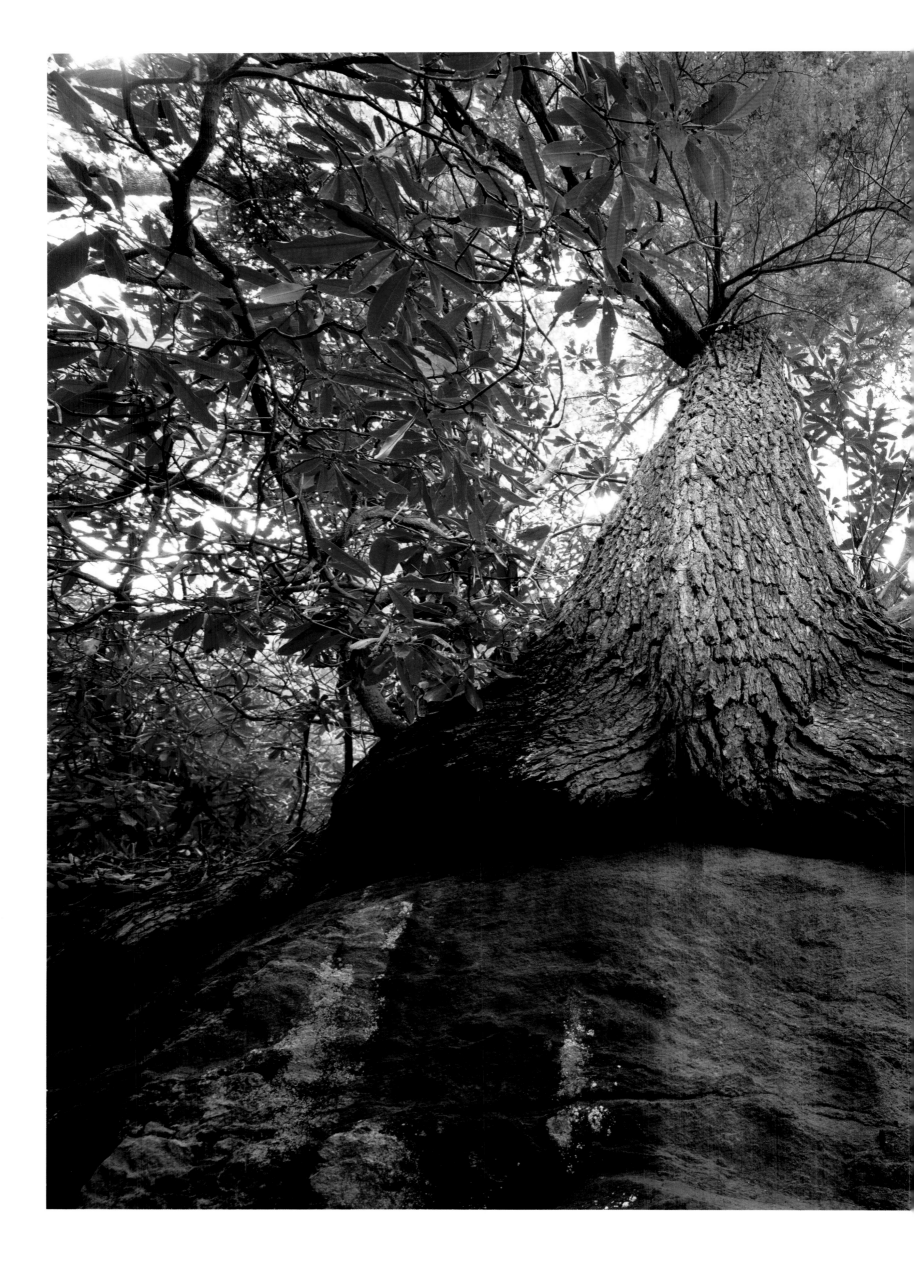

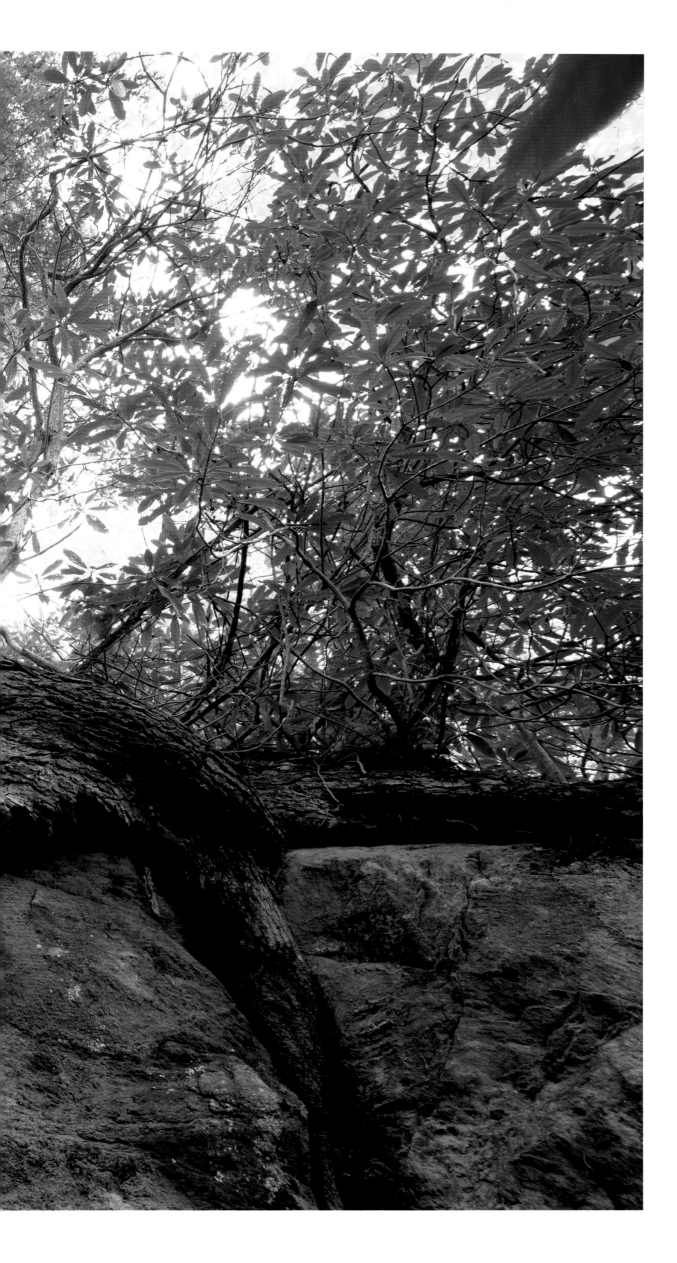

Eastern hemlock, 37 inches in diameter at breast height, Pisgah National Forest, North Carolina Hemlocks are slow-growing trees, taking three hundred years to reach maturity and living for more than six hundred. Bark in many species of old trees changes markedly as the trees age, becoming thick and deeply riven with canyons that provide habitat for fungi, mosses, lichens, and insects. The special habitat niches created by hemlocks are disappearing as hemlock woolly adelgids kill the trees.

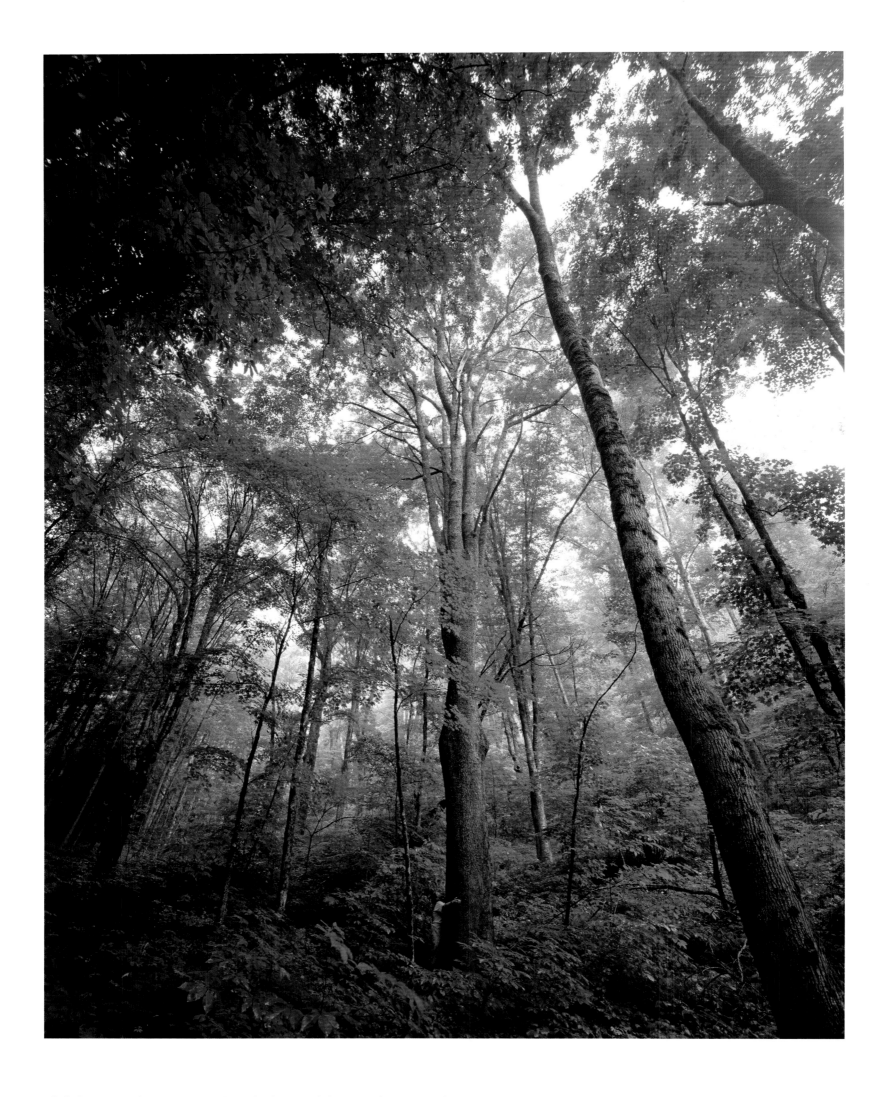

Black cherry, 36 inches in diameter at breast height, Nantahala National Forest, North Carolina
Big black cherry trees are highly valued for their reddish lumber. Their fruits are also highly valued
by wildlife in late summer, pulling in dozens of bird species and enticing raccoons and even bears to
climb up. Fallen cherries are relished by mice, moles, and other ground dwellers.

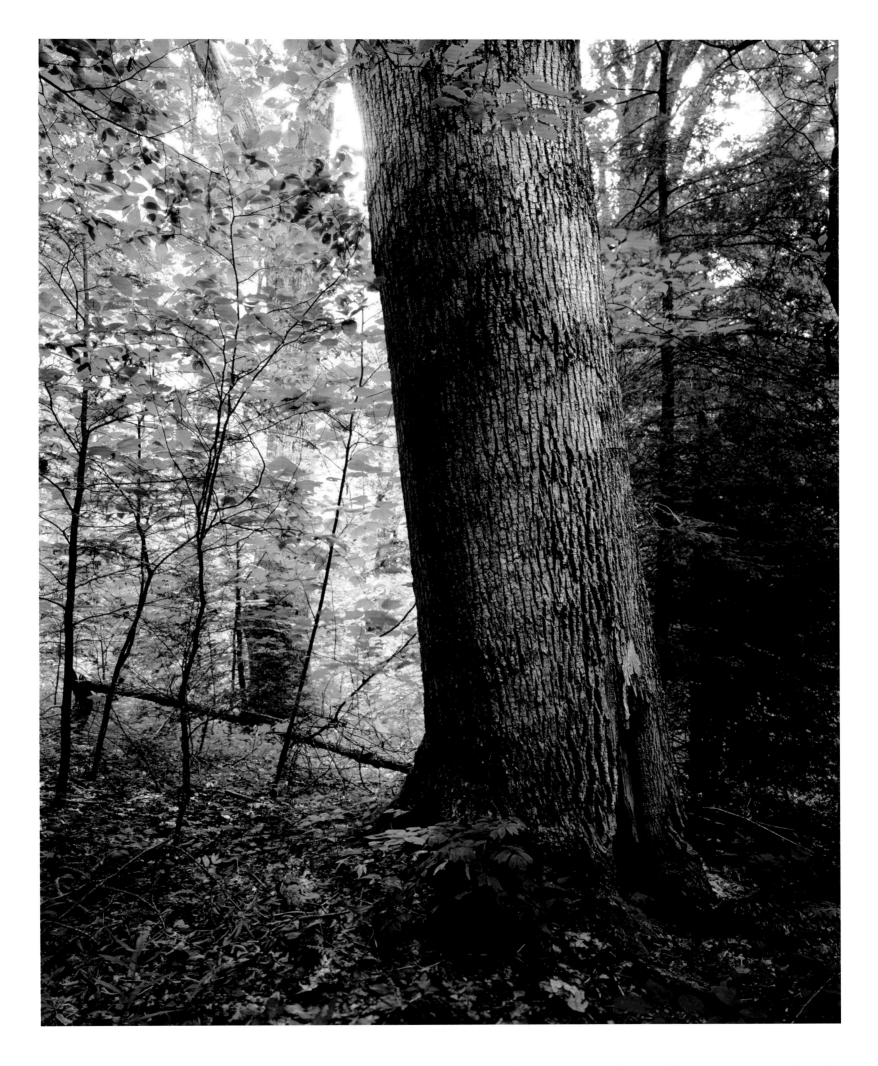

White ash, 43 inches in diameter at breast height, Nantahala National Forest, North Carolina
This white ash would make a lot of baseball bats. Its light yet strong wood resists shock and is sought for rackets, polo mallets, and many other kinds of recreational equipment. Yet a white ash will readily form a cavity if the top is broken off by wind or a tree falling into it, and a large specimen like this could shelter pileated woodpeckers, wood ducks, owls, and even black bears, which prefer dens at least fifty feet high.

Red spruce, Roan Mountain Gardens, Pisgah National Forest, North Carolina/Cherokee National Forest, Tennessee
Red spruce trees can grow for four or more centuries, forming odd shapes in response to available light. Their range extends from the Maritime Provinces of Canada south to New Jersey, but they reach their maximum growth in the occasional stands that remain along the highest ridges of the Southern Appalachians.

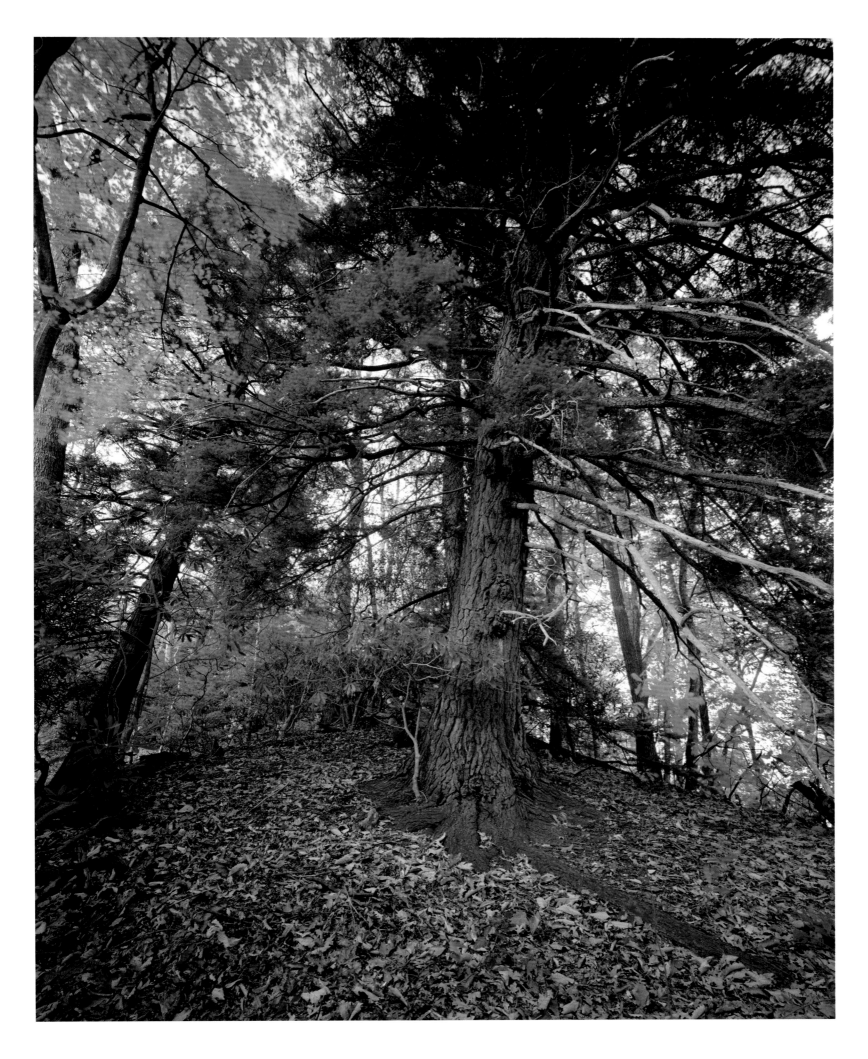

Carolina hemlock, 32.2 inches in diameter at breast height, Pisgah National Forest, North Carolina
Carolina hemlocks are closely related to eastern hemlocks, but are limited to mountains from Virginia south to Georgia, while eastern hemlocks range as far north as Nova Scotia. The Cherokee used the inner bark of both kinds of hemlocks for basketry and other tree parts to make medicines for a variety of ailments.

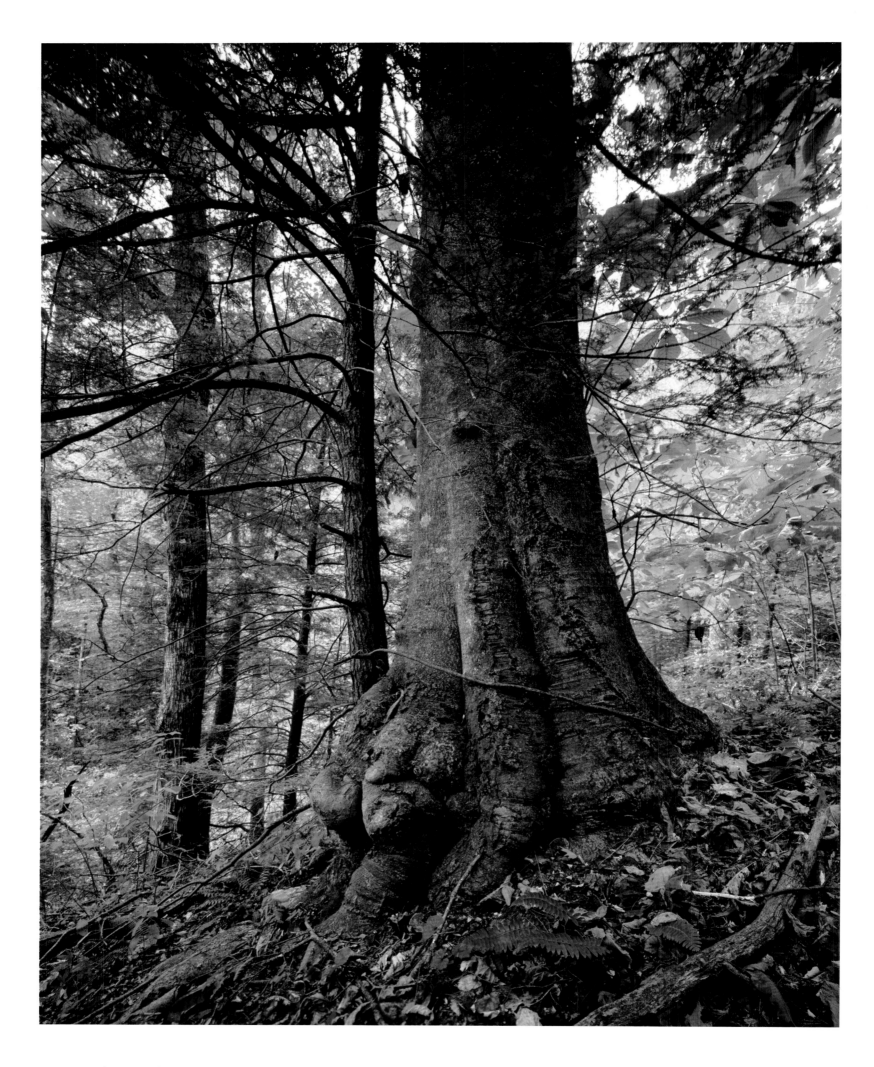

Fraser magnolia, 39.8 inches in diameter at breast height, Pisgah National Forest, North Carolina
This is a large Fraser magnolia, which tends to be a relatively small tree. The species is mostly limited
to the mountains of West Virginia, Virginia, North Carolina, and Tennessee, although its large,
showy blossoms have attracted some ornamental use beyond those bounds.

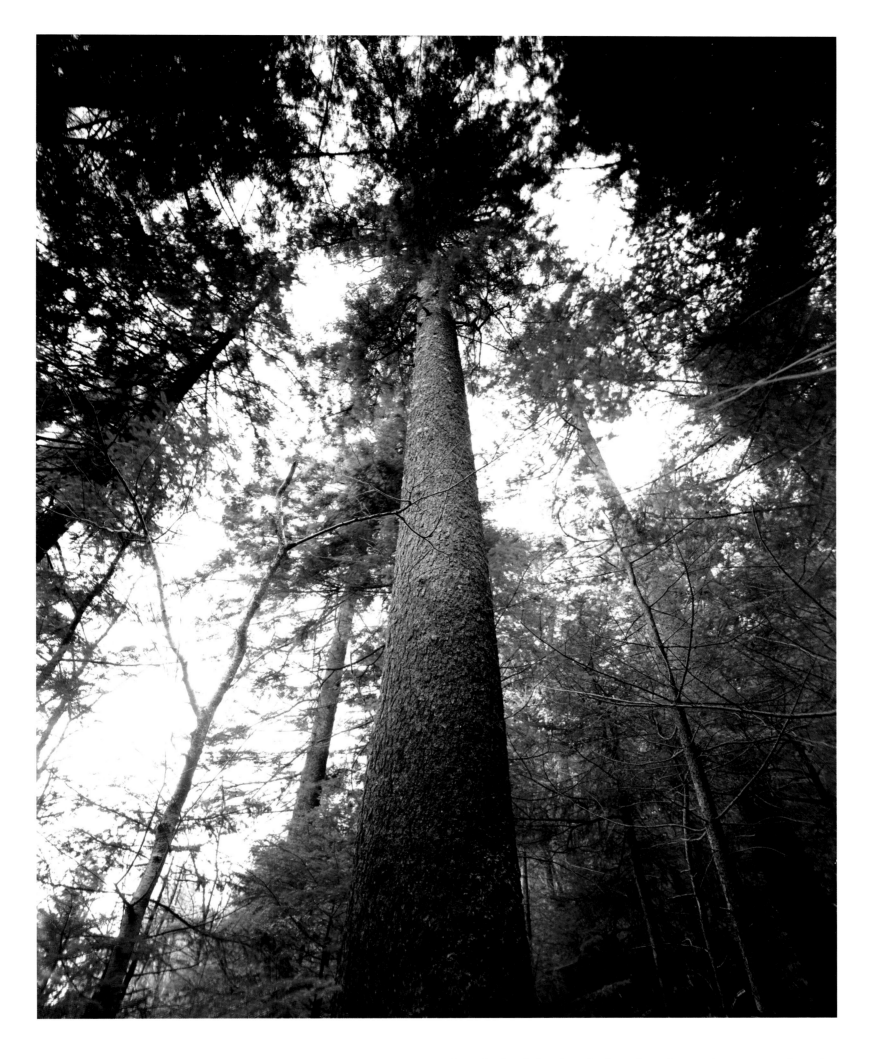

Red spruce, 31.8 inches in diameter at breast height, Blackstock Knob, Blue Ridge Parkway Milepost 364, North Carolina
One of the "Southern Sixers"—Southern Appalachian mountain peaks over 6,000 feet—Blackstock Knob offers red spruce trees the cool, wet climate they need. They are doing well here, but red spruce at some high elevations elsewhere are dying, in part from pollutants in rain carried from coal-burning power plants in the Tennessee Valley to the west.

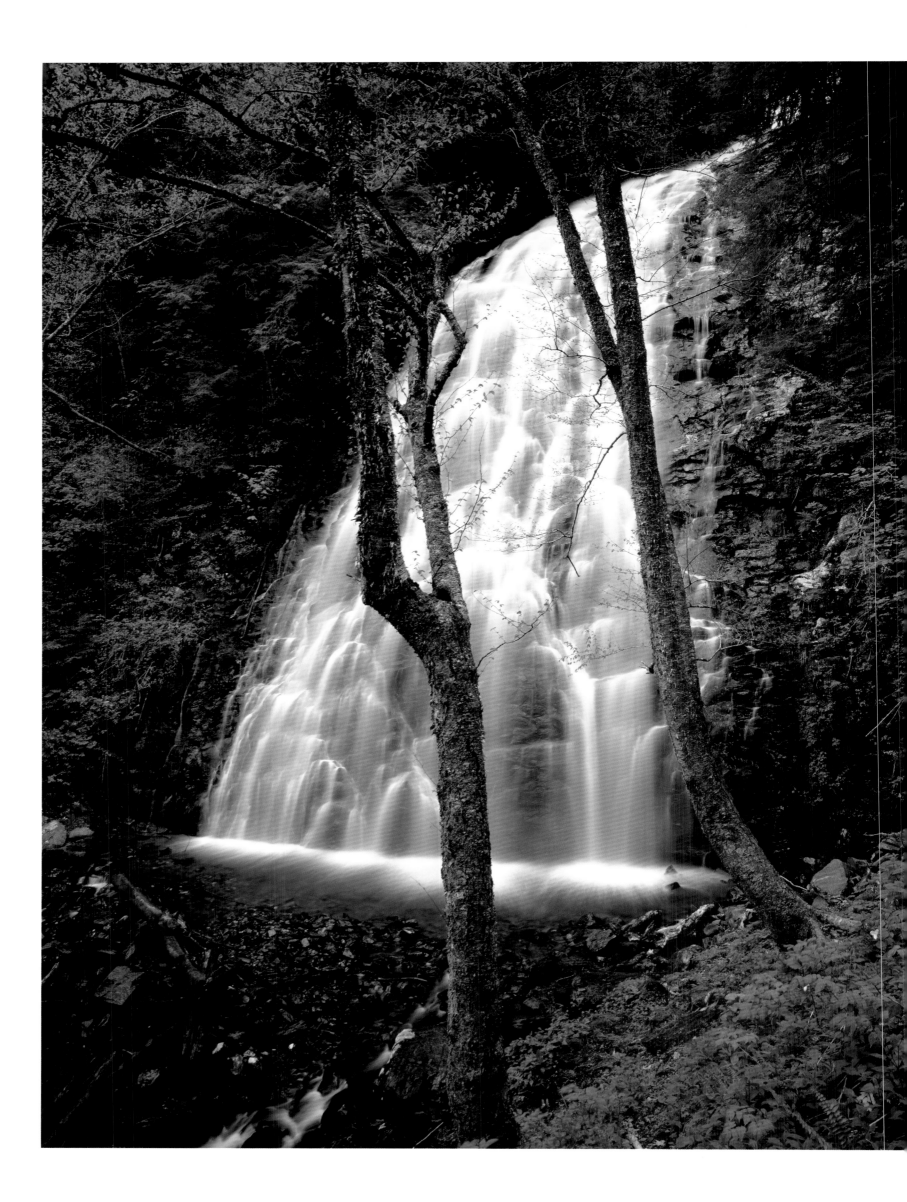

What does the Long Man think? Listen closely to any body of clean, moving water, and you may hear his thoughts, because he always speaks. The Long Man is the Cherokee god of rivers, a living spirit with his head in the mountains and his toes in the sea. Seeing deity in rivers reveals the essentially ecological, watershed worldview of the Cherokee. Tribal boundaries and travel paths generally followed the contours of watersheds. Water follows the lowest contour, working it ever lower. A waterfall was a doorway to a different world, the world of spirit people.

In the everyday world of the Cherokee, the spiritual importance of clean water was manifest in the ancient purification ritual of "going to water." Water provided physical and emotional cleansing before ceremonies and ball games, as well as renewal for daily life. "Going to water" included a baptismal rite uncannily similar to that of the Baptists, which made it easier to convert Cherokees to Christianity than other Native Americans.

The uncountable number of seeps, springs, rivulets, runs, creeks, streams, and rivers of the Southern Appalachians contained the world's greatest array of temperate zone fishes, mussels, crayfish, snails, and aquatic insects when Hernando de Soto passed through in 1540. By the early 1800s, trees were being cut along the main river courses and floated by the millions downstream to mills, gouging and scouring the banks as they went. Roads and railroads were often laid right over creek beds. Sediment and sawdust from logging clogged many streams, and removal of the forest cover caused massive flooding, in which the Cherokee no doubt heard the Long Man's angry voice.

It was this flooding, and the loss of much fertile farm land in the lowlands, that finally prompted the federal government to inaugurate national forests to regenerate denuded mountain headwater areas.

Cherokee traditions prohibited throwing anything unclean into water, because the Long Man was known for his power to seize and hold anything cast upon his surface. This characteristic has worked against him since de Soto's day, as a diversity of pollutants—from agricultural runoff, industrial air and water emissions, lawn chemicals, and sewage with its modern residue of prescription pharmaceuticals—foul his waters. Approximately five hundred aquatic species are endangered, threatened, or declining across the region.

Still, the Long Man speaks. Whispering, murmuring, shouting, roaring—all the voices express the age-old bargain offered by gods and natural resources: "Take care of me, and I will take care of you."

(OPPOSITE) *Yellow birches, Crabtree Falls, Crabtree Meadows Recreation Area, Blue Ridge Parkway Milepost 339, North Carolina*
Shaggy bark streaked with bronze gives this species its name. Yellow birches grow best in plentiful soil moisture and can often be found beside streams, as well as in the company of hemlocks, sugar maples, beeches, and red spruces.

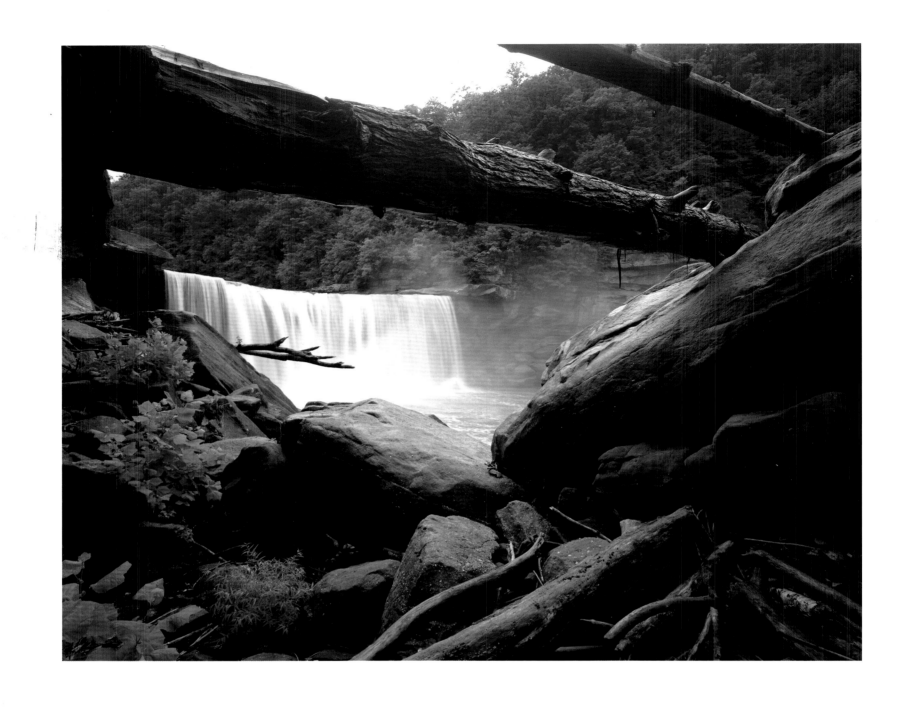

Cumberland Falls State Resort Park, Kentucky
Called the "Niagara of the South" by promoters, this waterfall forms a 125-foot wide curtain some 60 feet tall. On a clear night during a full moon, mist from the falls is said to create a moonbow, an elusive lunar rainbow.

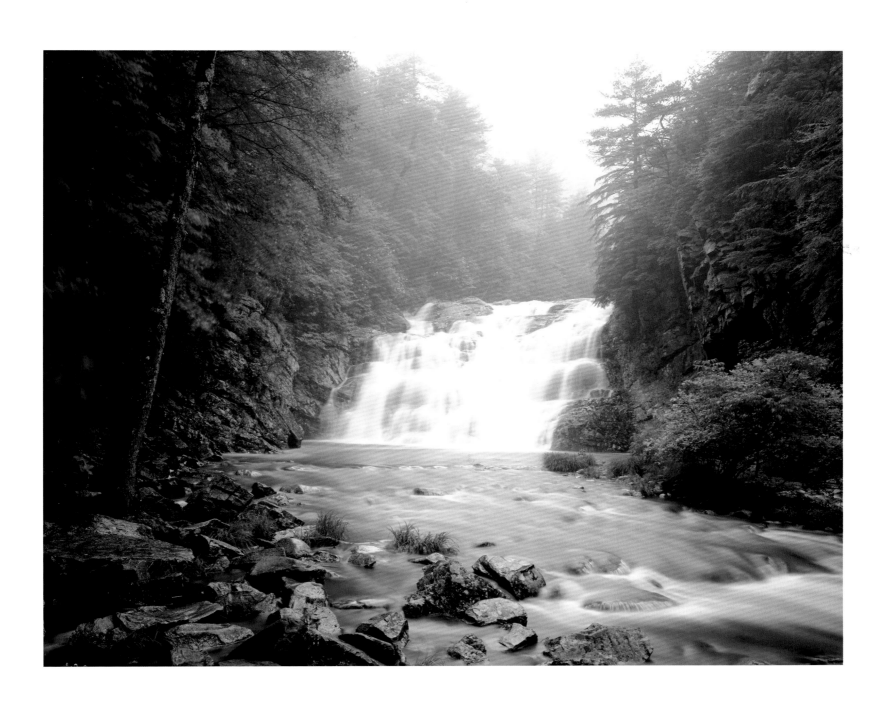

Laurel Creek Falls, Virgin Falls State Natural Area, Tennessee
Streams emerge from and disappear into caves in the limestone geology, called
karst, which characterizes this part of the Cumberland Plateau. Along with
caves, sinks and waterfalls are common. Many caves are now closed due to a fast-
spreading fungus, white-nose syndrome, which is killing bats by the millions.

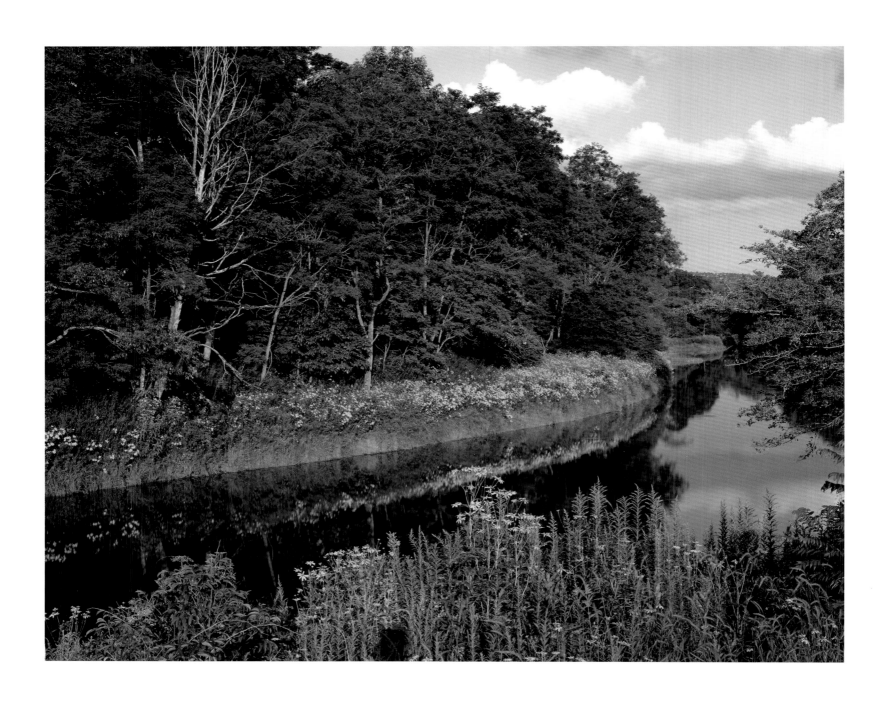

Tea Creek, Monongahela National Forest, West Virginia
An old railroad grade makes an easy start to trails along Tea Creek, named for its brown
color leached from tannins in trees and soil. But the trail soon turns rocky and wet and is a
favorite with mountain bikers, who describe the ride here as "mud, muck, and mayhem."

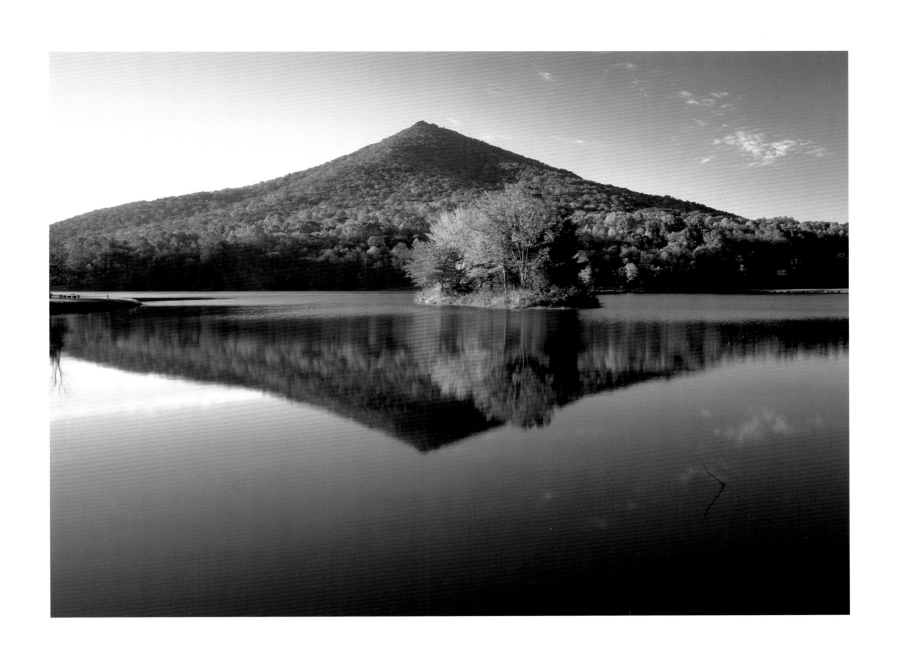

Peaks of Otter, Blue Ridge Parkway Milepost 86, Virginia
The otters must be elsewhere, or the water in Abbott Lake would not be so serene.
The lake is manmade and stocked to provide recreational fishing for parkway travelers.

100 | 101

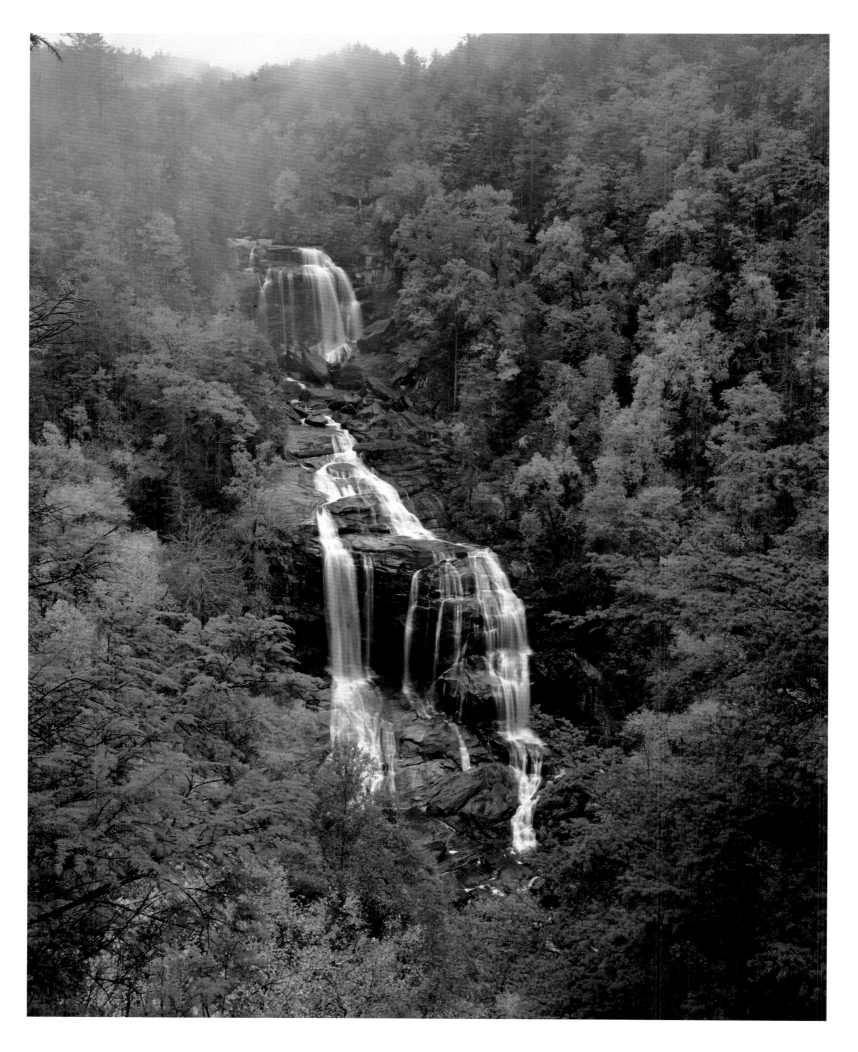

Whitewater Falls, Jocassee Gorge, Nantahala National Forest, North Carolina
At more than 411 feet, Whitewater Falls is one of the highest waterfalls east of the
Mississippi. With annual rainfall sometimes reaching 100 inches, the heavily forested
gorge is a temperate zone rain forest. Moist air rising from the Gulf of Mexico brings
rain as well as spores of tropical plants, especially ferns and mosses.

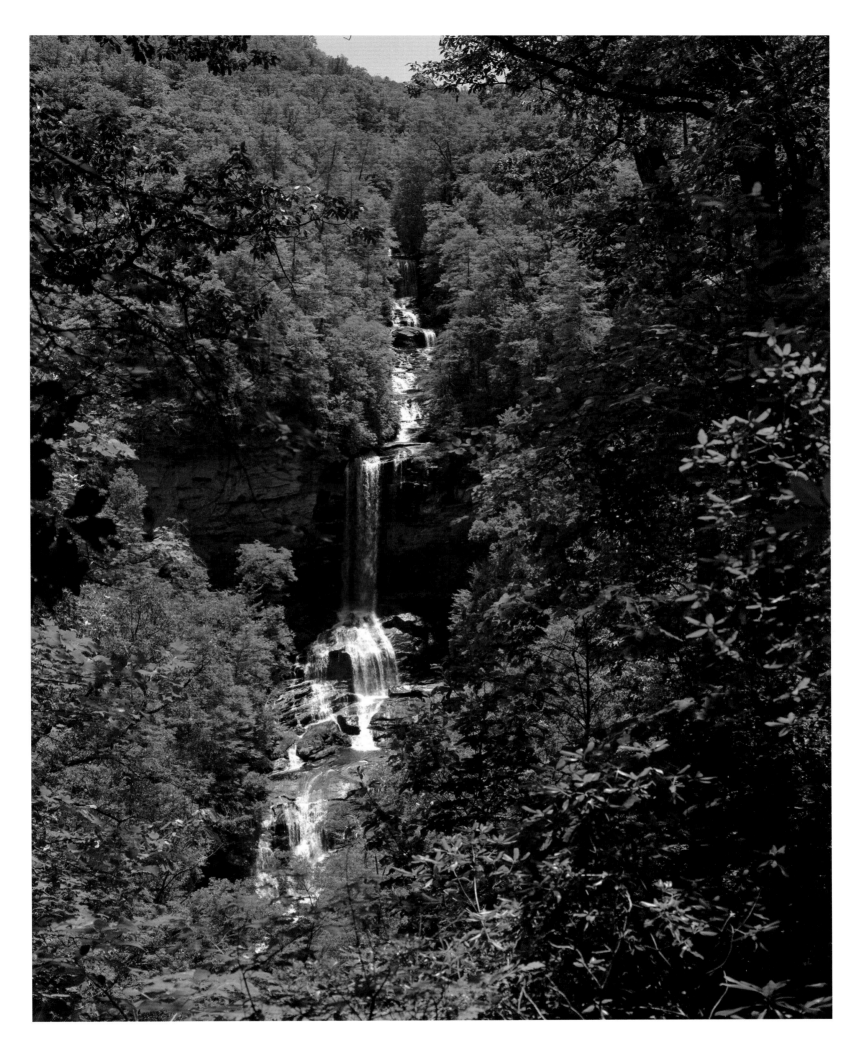

Raven Cliff Falls, Mountain Bridge Wilderness Area, Caesars Head State Park, South Carolina

Raven Cliff Falls (approximately 420 feet) rivals Whitewater Falls as one of the highest in the eastern United States. Waterfalls are abundant along the Blue Ridge Escarpment, the area in the Carolinas and Georgia where the mountains drop abruptly to the piedmont. Water is one of the great gifts of the Southern Appalachians, whose many rivers supply much of the Southeast with drinking water.

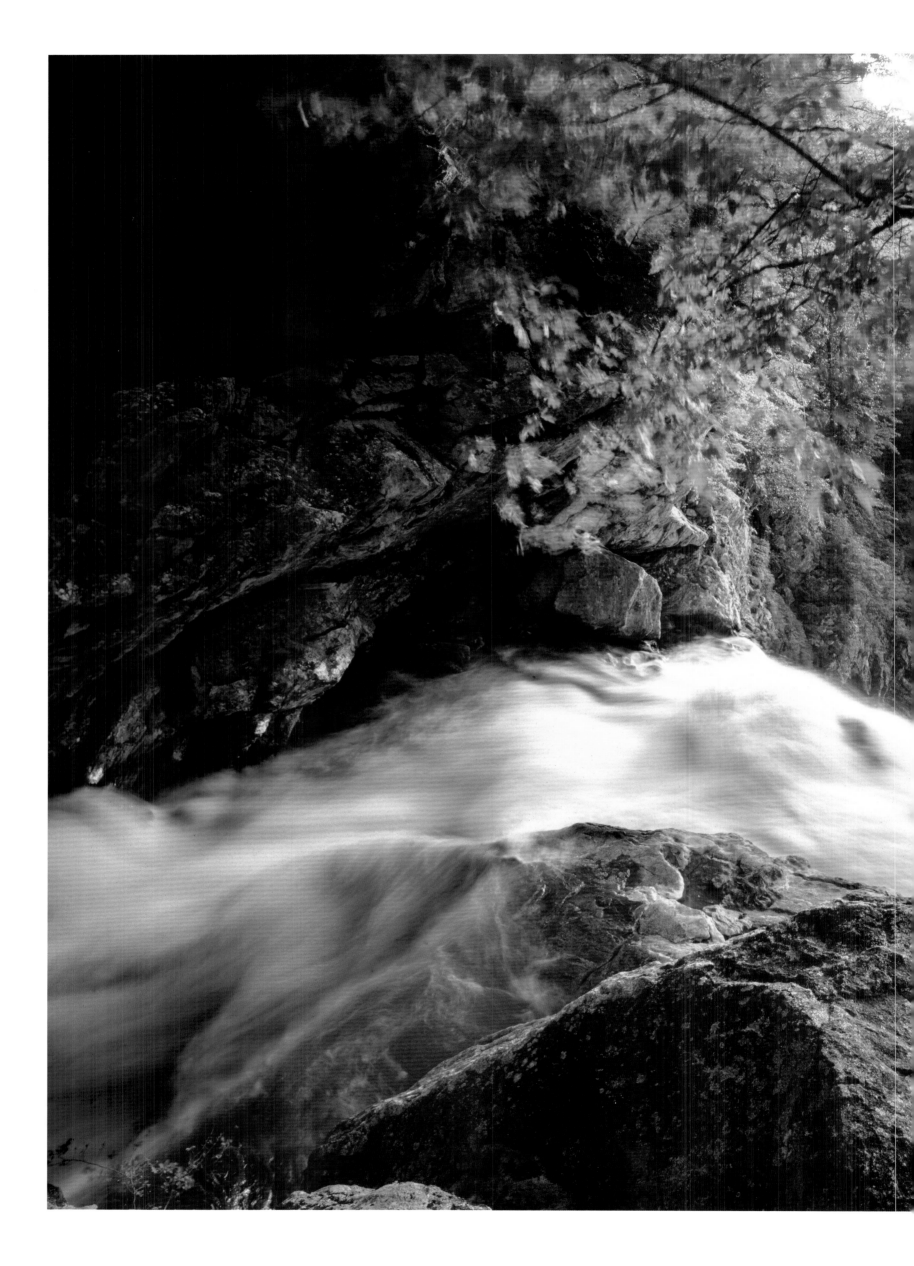

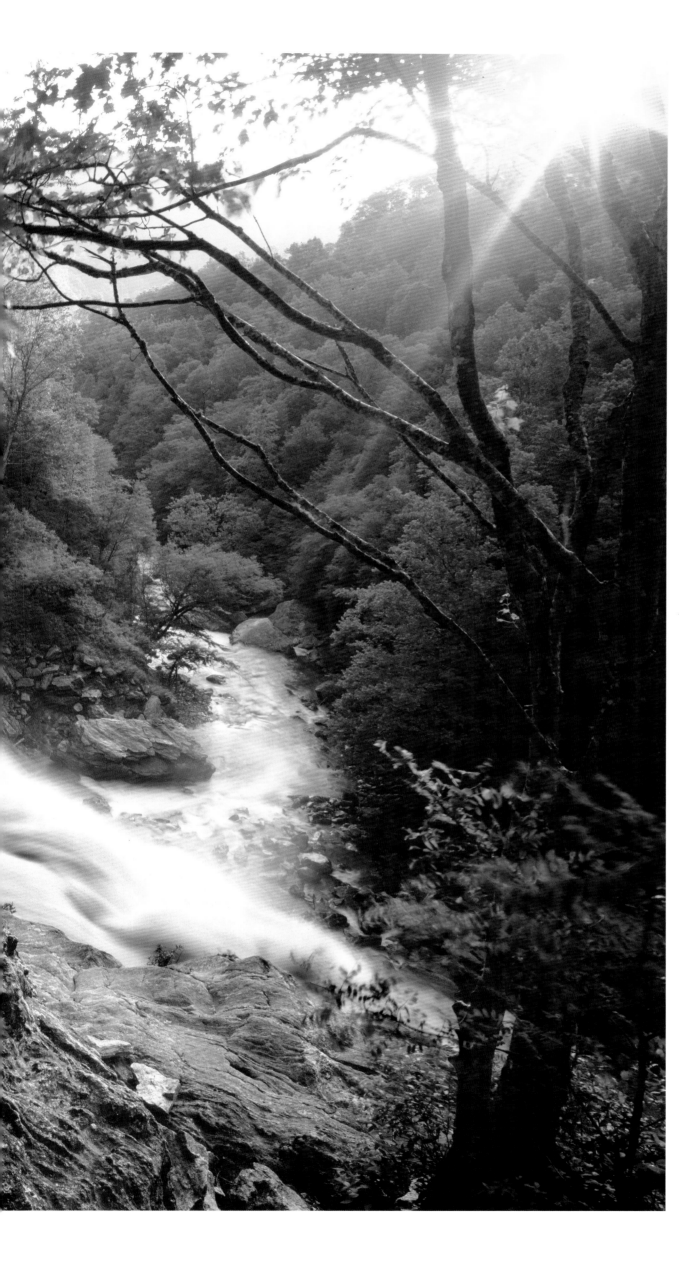

Cullasaja Gorge Falls,
Nantahala National Forest,
North Carolina
Nooks and crannies along
boulder-strewn streams
offer variations in light
and moisture that appeal to
small, creeping plants.

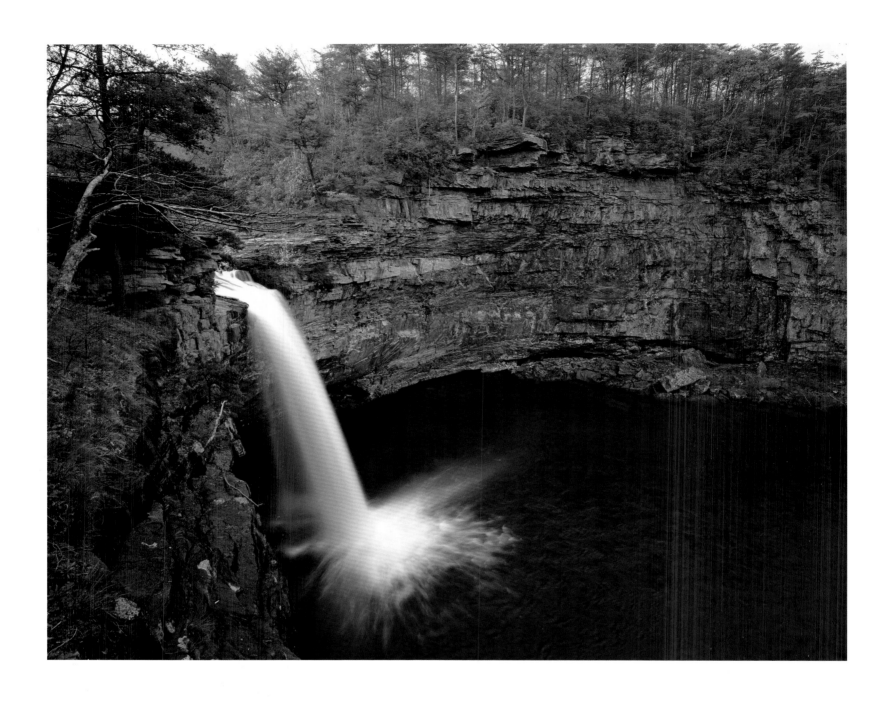

DeSoto Falls, DeSoto State Park, Alabama
In 1540, Spanish explorer Hernando de Soto passed nearby, looking (mostly unsuccessfully) for gold. If biodiversity could be measured in gold, he would have realized he was already a rich man. The Southern Appalachians are globally famous for their aquatic diversity, and Alabama has the largest number of freshwater fish species in the nation, although many are in danger of extinction.

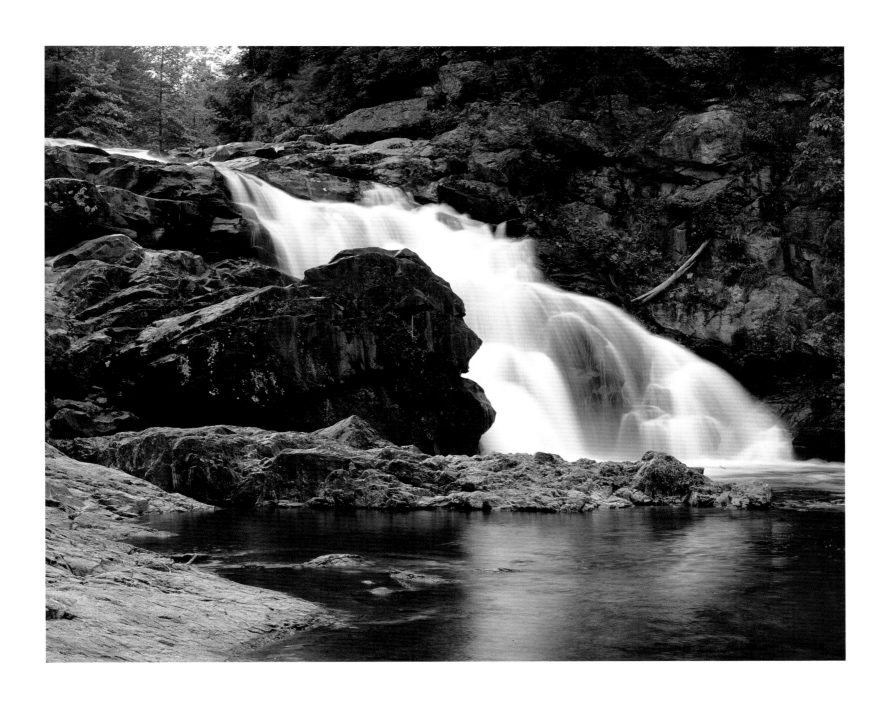

Jack's Creek Falls, Cohutta Wilderness, Chattahoochee National Forest, Georgia
Dozens of swimming holes lie along the 16-mile Jacks River trail, making it highly popular in the summer. At nearly 37,000 acres, the Cohutta is the largest federally designated Wilderness Area in the Southern Appalachians and draws by far the largest number of visitors, some 60,000 a year.

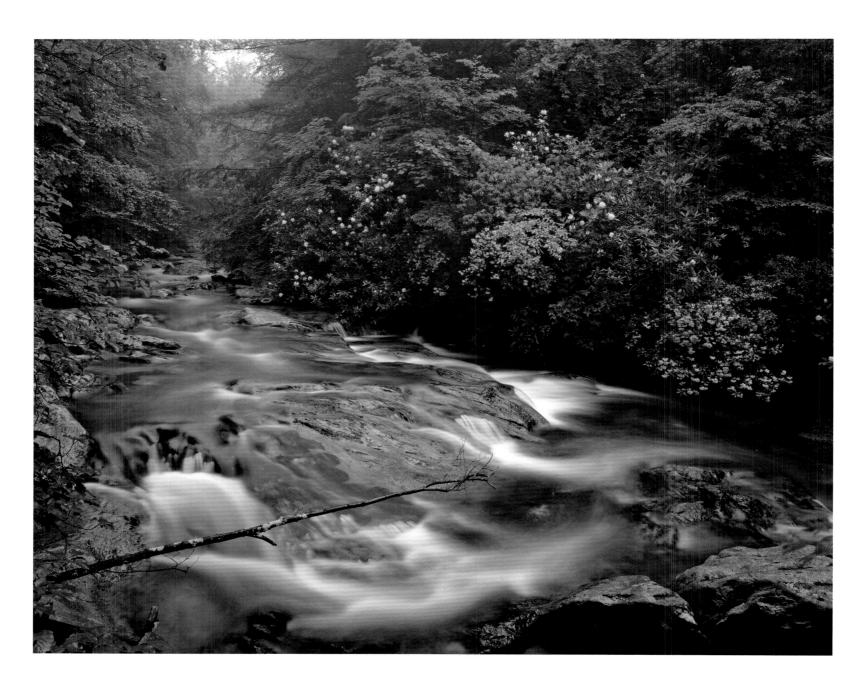

Laurel Creek Falls, Virgin Falls State Natural Area, Tennessee
The limestone geology (karst) that lies under this area can provide calcium as a
chemical buffer against the acid rain caused by emissions from coal-burning power
plants, factories, and vehicles. Some states have been liming streams that lack
buffering capacity in an effort to reduce the loss of aquatic life.

(OPPOSITE) *Crabtree Falls, George Washington National Forest, Virginia*
Five major cascades and several smaller ones fall a total of 1,200 feet. For generations, local people have
enjoyed Sunday outings to Crabtree Falls, as mentioned in *The Waltons*, a 1970s television series based on
a novel by Earl Hamner Jr. He grew up near the falls and wrote of living through the Great Depression of
the 1930s in a family of eight siblings, who loved the outdoors and "never knew we were poor."

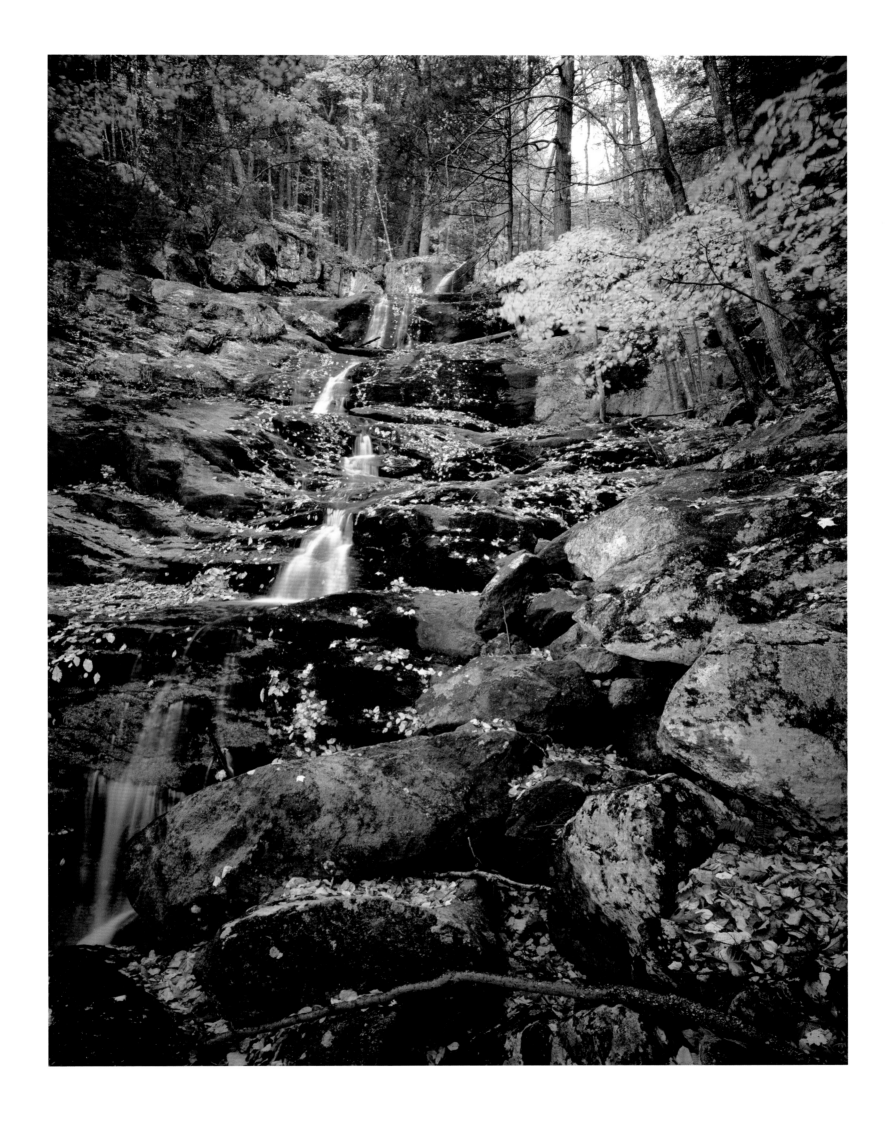

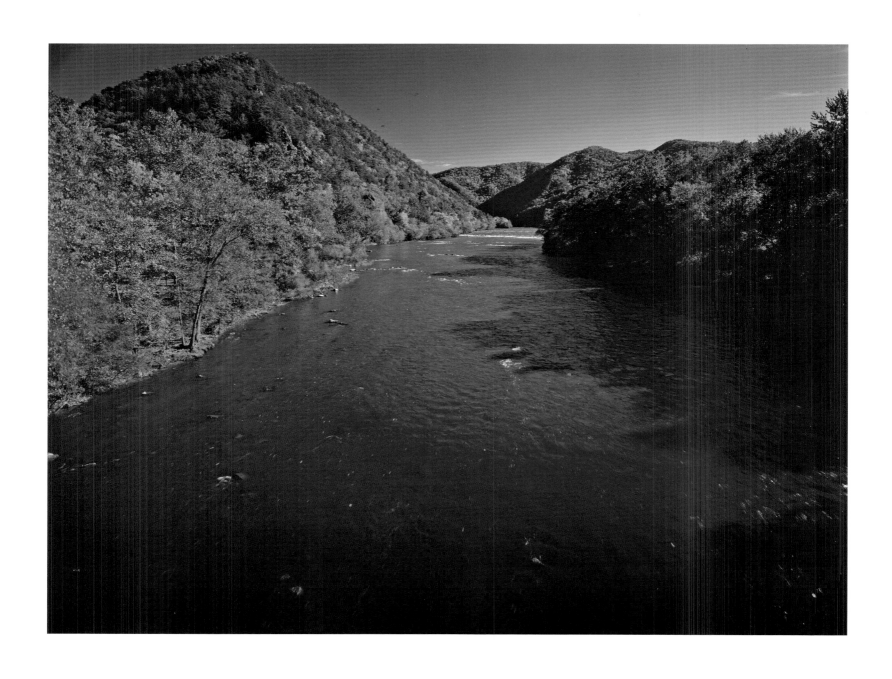

French Broad River, Pisgah National Forest, North Carolina
The French Broad was flowing before the collisions of landmasses that raised the Southern Appalachians some 300 million years ago, making it one of the oldest rivers on earth. Today it runs for 210 miles northward from western North Carolina through Asheville into Tennessee, where it joins the Holston to form the Tennessee River.

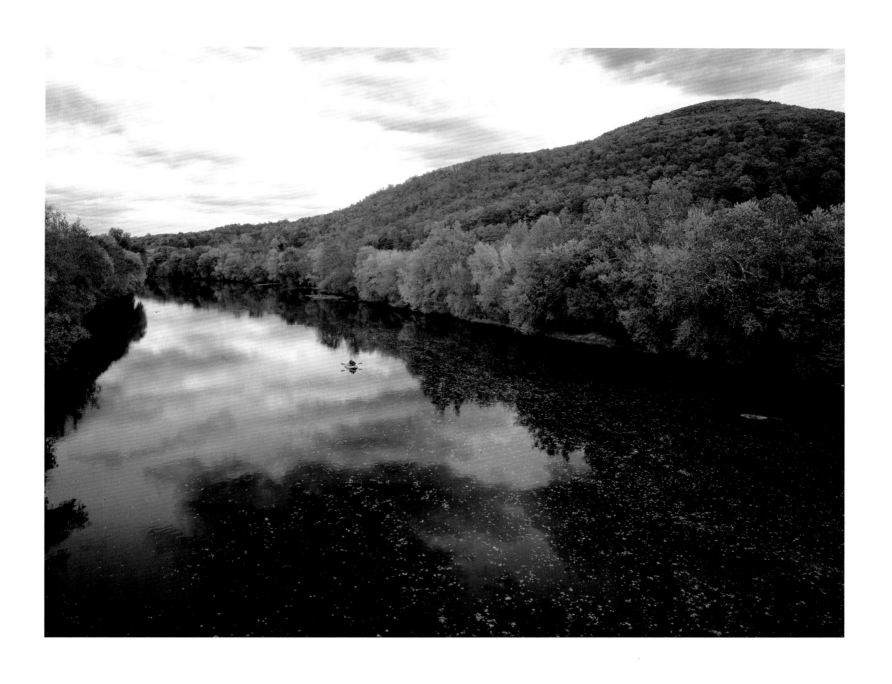

James River, Virginia
Rising in the Allegheny Mountains of western Virginia, the James flows for more than 400 miles across the entire state and empties into the Chesapeake Bay. In 1607, it provided water for Jamestown, the first permanent English settlement in North America. Today, it supplies water to the city of Richmond and many other communities.

110 | 111

Long before Jerusalem became a holy place for pilgrims, people worshipped and sacrificed at specific sites. Places where something holy was perceived to be present, or where a miracle had occurred, or where the spirit world was more easily accessible, were considered sacred.

The Cherokee believed that every place had its own personality, arising from physical structure and life-forms. The different personalities of place attracted different kinds of spirits. Any prominent or unusual feature of the landscape was likely to be the habitat of strong spirits.

One of highest mountains in the East, Clingman's Dome (6,642 feet), has a great outcropping of stones at the top. It was a place where Cherokees fasted and prayed. The massif of Whiteside Mountain was a powerful sacred place. Balds were sacred, as were springs and rivers.

"Other things that make a place sacred," a Cherokee medicine person once said, "are what our grandfathers and their grandfathers before us have put there . . . or the grandfather trees, or the power of the plants." Landscapes became repositories of tribal history and individual experience, told in stories from generation to generation.

"The land to me is very sacred, and we should all think of it as being sacred—any land, all land out there," wrote Cherokee elder Marie Junaluska. "It gives us all the things we need to live. It gives us so many blessings . . . and in return we should respect it, we should take care of it."

She is a descendent of Chief Junaluska, who saved the life of Andrew Jackson in the 1812 battle of Horseshoe Bend, and in return was forced by President Jackson onto the Trail of Tears. Where we bury our dead is among the few sacred places recognized by modern society, along with churches and battlefields. But, to the Cherokee, sacred places were not just ancestral graves, or even a tall mountain here and a deep gorge there. Instead, they saw themselves surrounded by sacred places, which were, in short, everywhere.

(OPPOSITE) *Forest floor, Cashiers, North Carolina*
All fresh water begins as rain falling on the ground. The streams that flow out of old forests with undisturbed soil are some of the cleanest waters ever tested. Undisturbed forest soil also sequesters hundreds of tons of carbon per acre, some of which is lost to the air when trees are logged and soil is torn up and dried out.

THINKING LIKE A SACRED PLACE

Summer storm, Blue Ridge Parkway, North Carolina
Climate models predict fiercer storms, higher temperatures, and less rainfall for the Southern
Appalachians. If fully protected, lands along the Blue Ridge Parkway and the Appalachian Trail
could serve as essential natural corridors for plant seeds and animals to disperse north or south,
or to higher or lower elevations, in response to climate change.

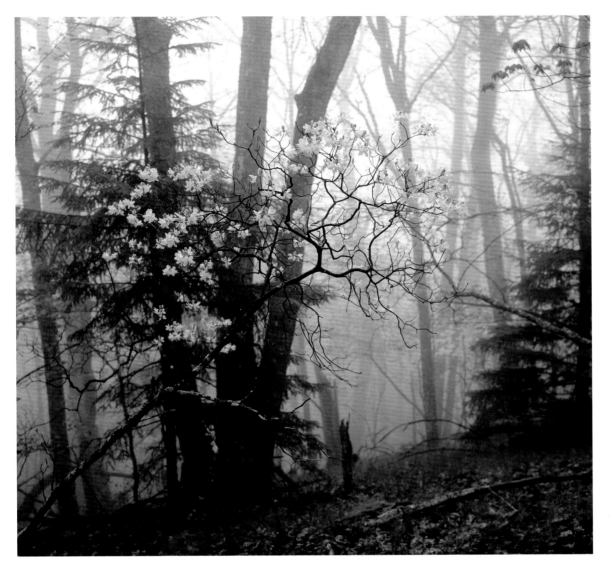

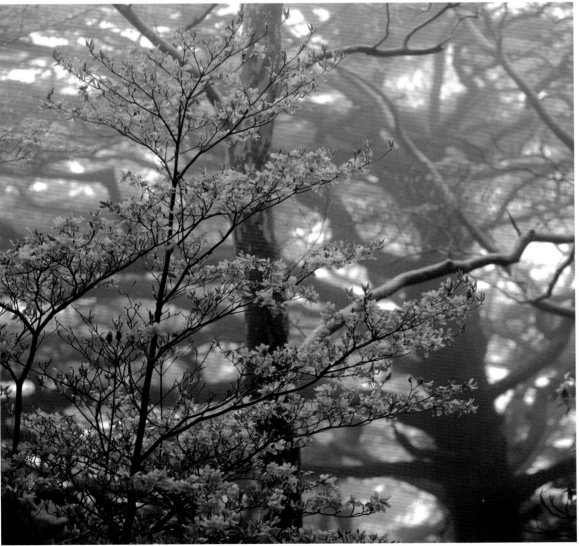

(ABOVE) *Pinkshell azalea,*
Wagon Road Gap, Blue Ridge Parkway
Milepost 412, North Carolina
Native only to North Carolina's
Blue Ridge Mountains, the pinkshell
azalea prefers wet soil and elevations
above 3,000 feet. It's believed to
attract butterflies and hummingbirds
even though it is scentless.

(BELOW) *Azalea, Hokkaido, Japan*
This Japanese azalea is strikingly
similar to the pinkshell of North
Carolina. The parallel botanies
of these and other "species pairs"
in Asia and America raise many
questions about where, when, and
how the world's plants developed.

Great Craggy Mountains, Blue Ridge Parkway Milepost 369, North Carolina
As sunset fades on the Craggies, creatures of the night awaken. Nocturnal flying squirrels,
the owls that feed on them, and many other species enliven the Southern Appalachian dark.

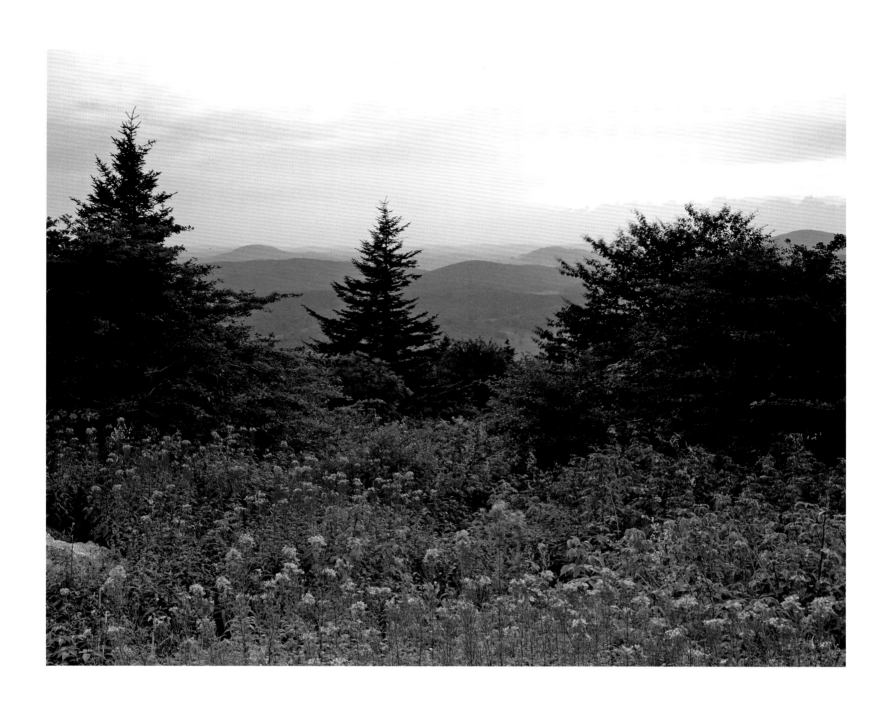

Spruce Knob, Monongahela National Forest, West Virginia
At 4,863 feet, Spruce Knob is the highest point in West Virginia, cold, windy, and rocky. Yet naturalist Robert Mueller documented dozens of plant species and their attendant bees, beetles, butterflies, birds, and mammals, many of them rare, during his dedicated walks in the 1990s around these "inspiring heights."

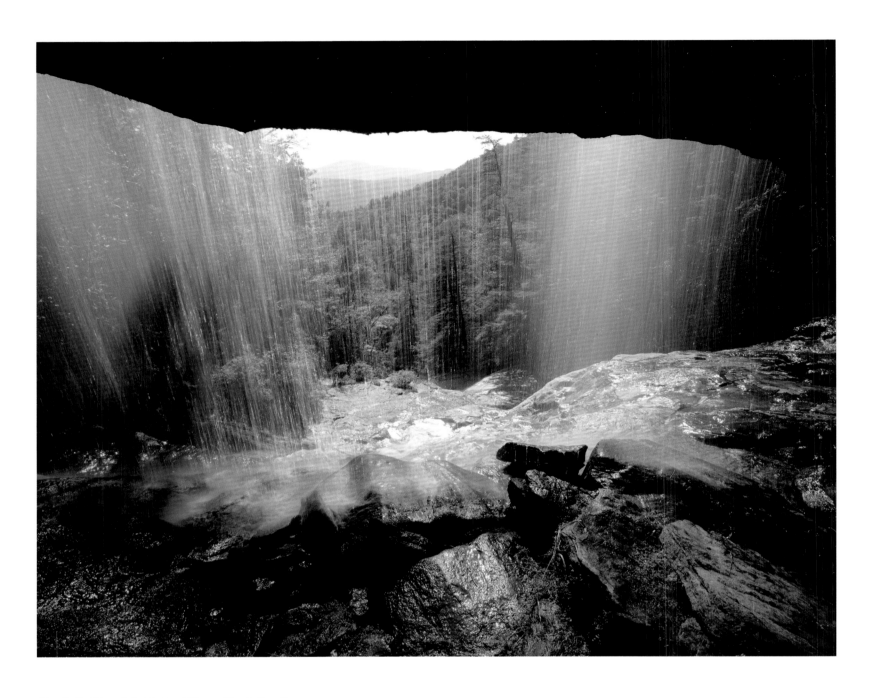

Glen Falls, Nantahala National Forest, North Carolina
Three waterfalls cascading down 640 feet make a lot of spray. Spray creates a
humid microclimate, attracting tiny ecosystems of plants and animals.

(OPPOSITE) *Rainbow Falls, adjacent to Mountain Bridge*
Wilderness Area, Caesars Head State Park, South Carolina
The Blue Ridge Escarpment, where mountains drop 2,000 feet
down to the Piedmont, has some of the highest natural diversity
of rare plants and animals found in the Southern Appalachians.

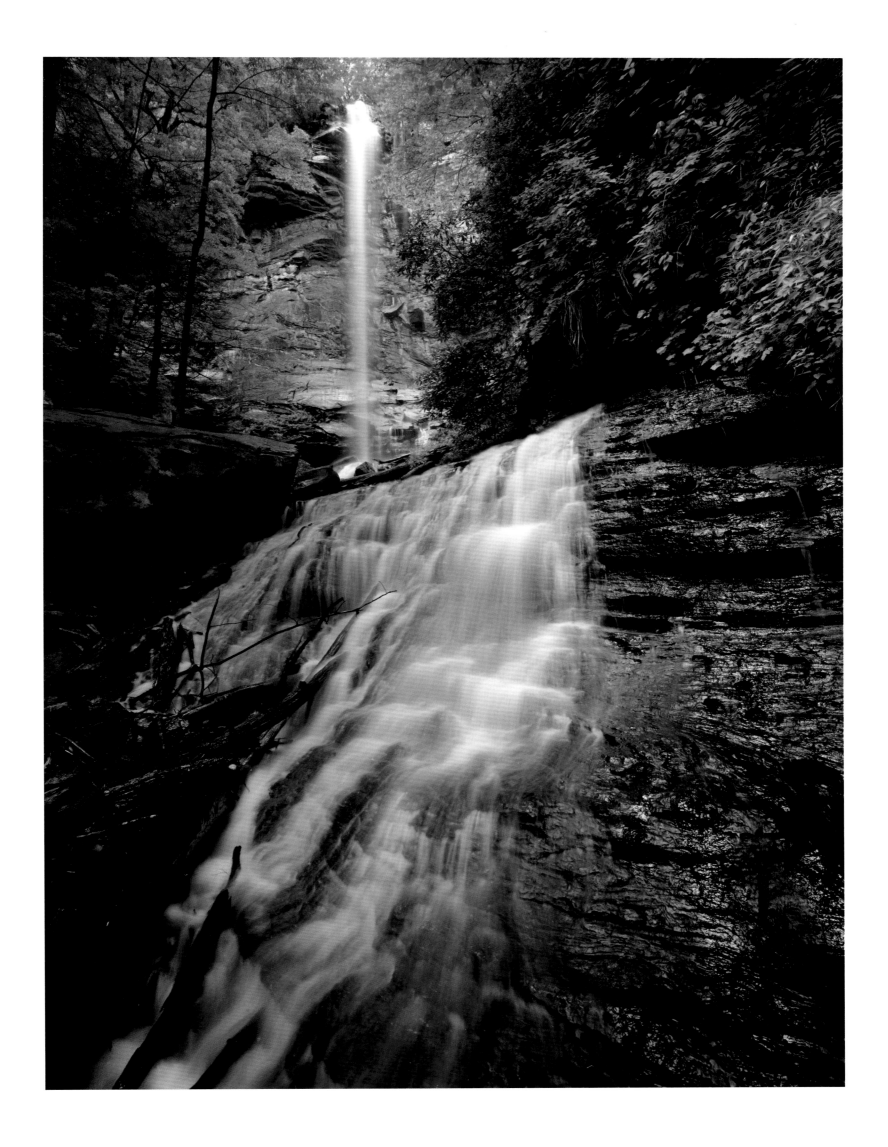

Fairfield Lake,
Sapphire Valley Resort,
Sapphire, North Carolina
The Sapphire Valley
was one of the nation's
leading gold production
areas until the California
Gold Rush of 1849. The
oldest man-made lake in
the state, Fairfield Lake
was built in 1896 over
a gold mine. Around
the world, clean water
is becoming nearly as
valuable as gold.

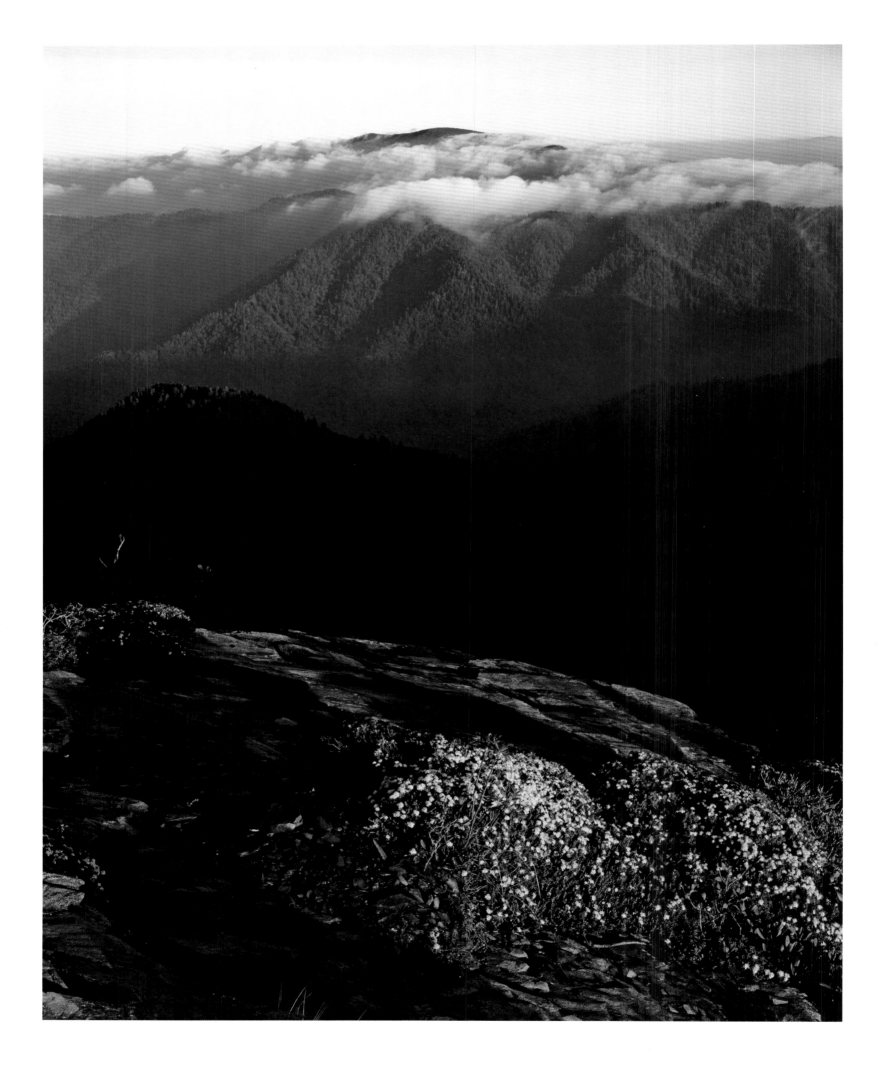

Clingman's Dome, as seen from Mt. LeConte with sand myrtle in foreground,
Great Smoky Mountains National Park, North Carolina/Tennessee
In Cherokee mythology, Clingman's Dome was known as Kuwahi or Mulberry Place, where a magic
lake healed sick and wounded bears. Throughout the mid-1800s, Kuwahi helped heal several hundred
sick and starving Cherokees who escaped from the Trail of Tears and hid on the mountain.

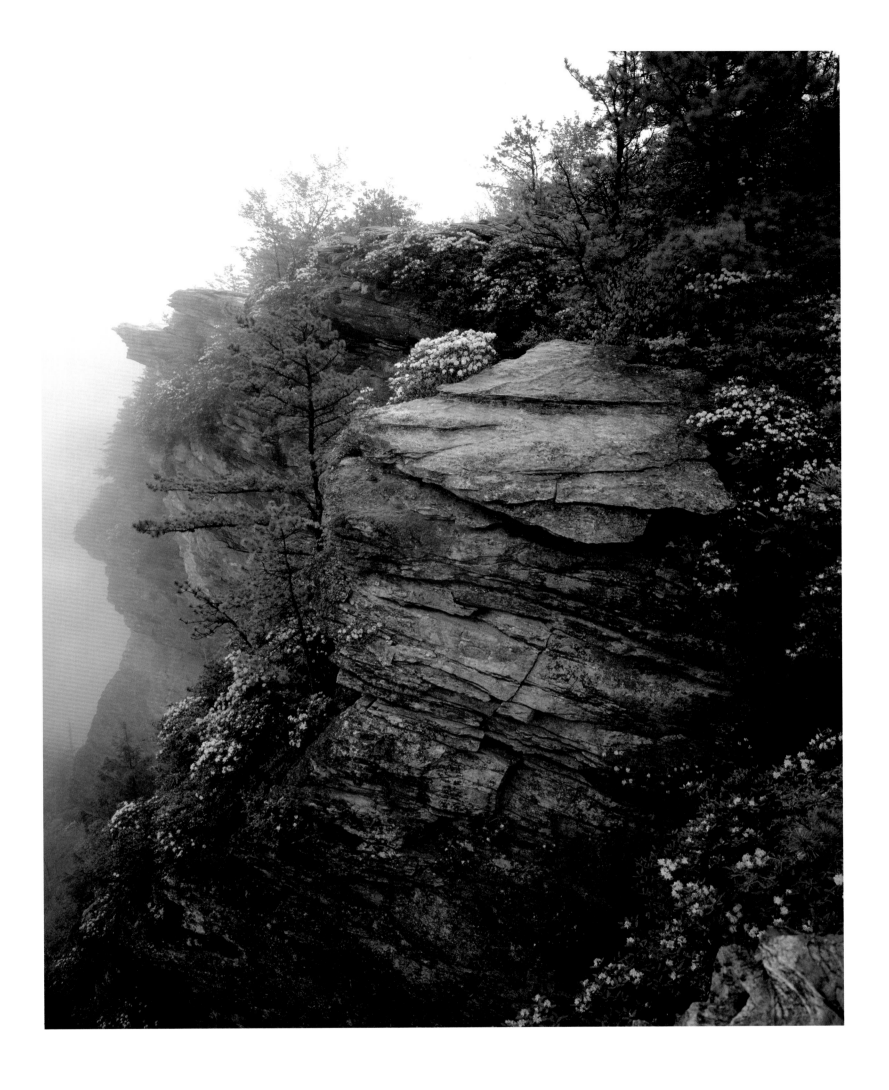

Linville Gorge Wilderness, Pisgah National Forest, North Carolina
Rhododendrons and pines cling to rocks above the abyss of Linville Gorge, creating their own small universe. The Cherokee believed that gorges served as gateways to other worlds.

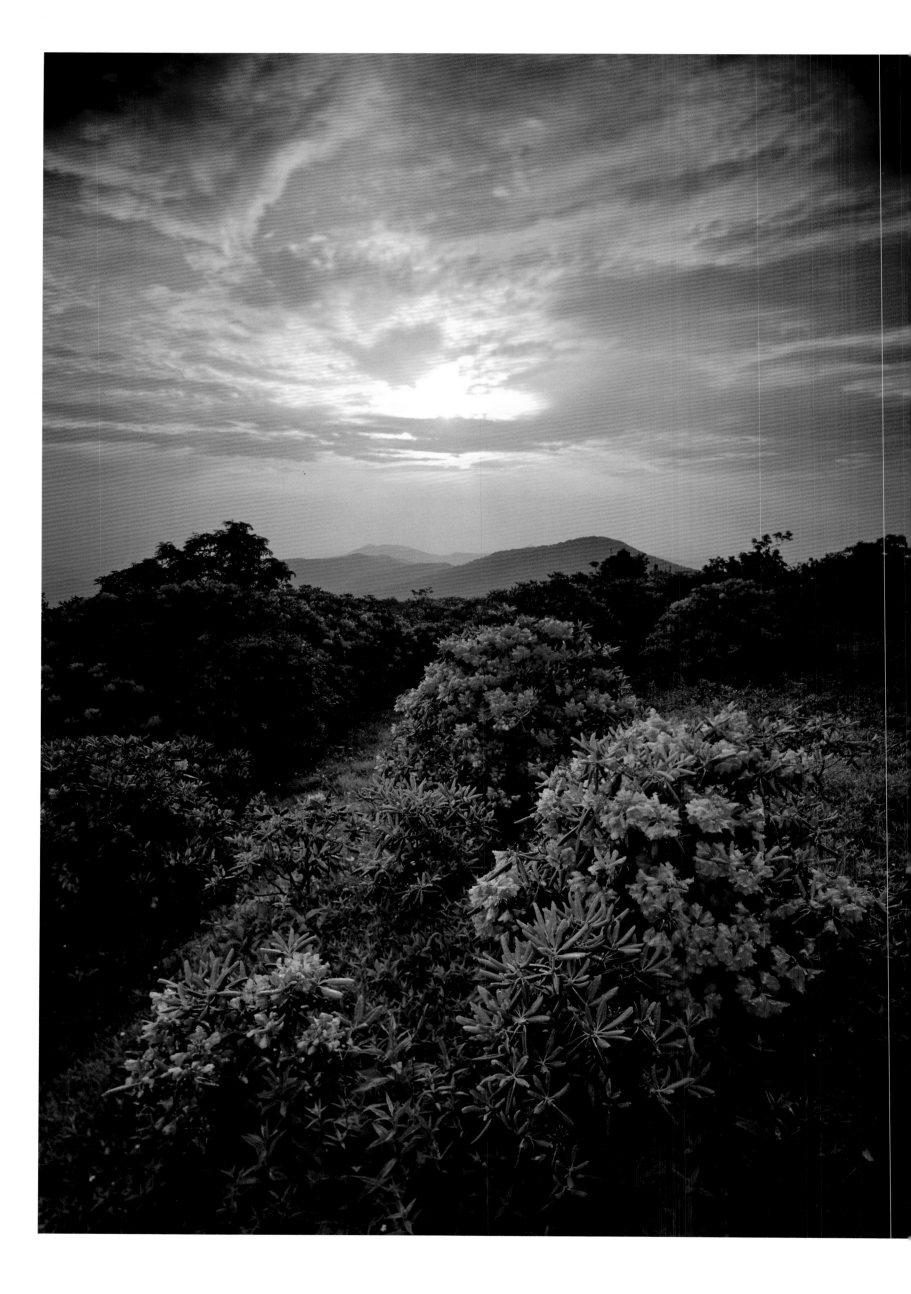

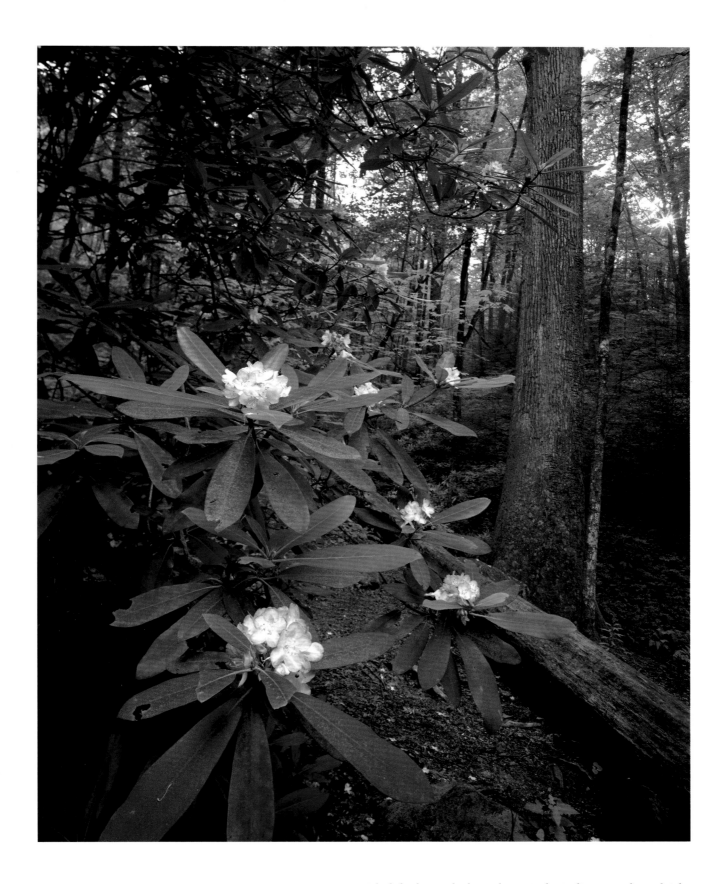

Rhododendron and tulip poplar, 74 inches in diameter at breast height,
Nantahala National Forest, Horse Cove, Highlands, North Carolina
The famous "Bob Padgett tulip poplar" stands 127 feet tall next to rhododen-
drons. Various species of rhododendrons dominate many parts of the Southern
Appalachians, from bogs to balds to tulip poplar/red oak forests. They have
been the object of horticultural lust since the eighteenth century, yet not much
is known about their ecological relationships in wild forests.

(OPPOSITE) *Rhododendrons, Craggy Gardens, Blue Ridge Parkway Milepost 364, North Carolina*
Native rhododendrons and azaleas make the Parkway a national showcase for Southern Appalachian
biodiversity. But the Parkway also highlights threats to that diversity, from glowing sunsets due to
air pollution to traffic jams at overlooks.

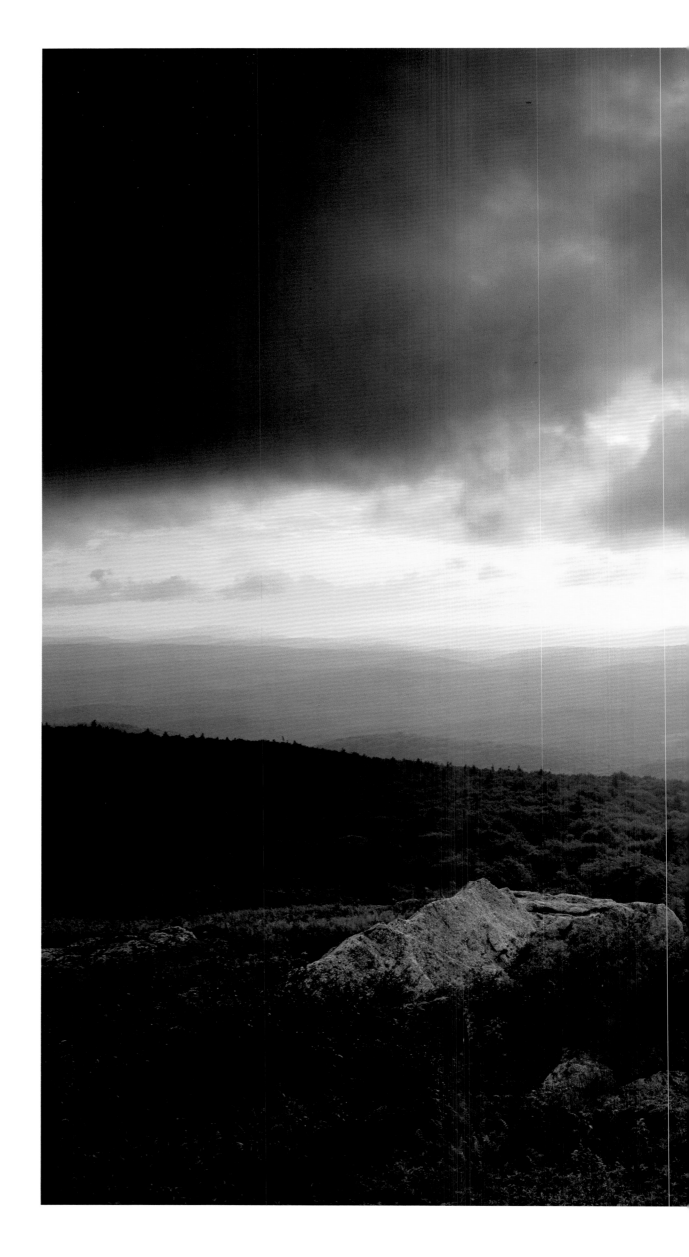

Spruce Knob, Monongahela National Forest, West Virginia Superlatives pall and numbers numb when describing the Southern Appalachians. These mountains are a region apart, globally ranked for their biological richness, locally beloved for their beauty and bounty.

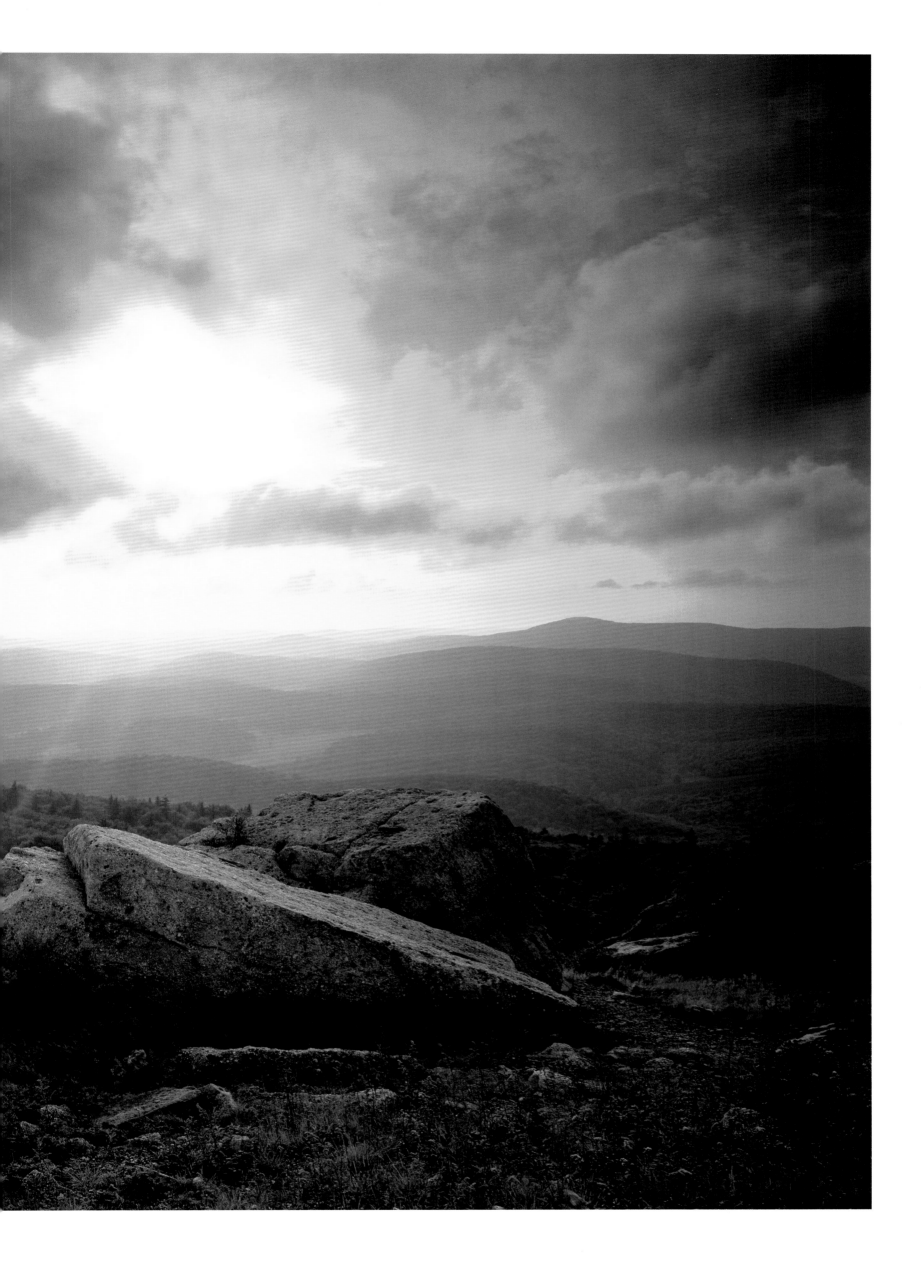

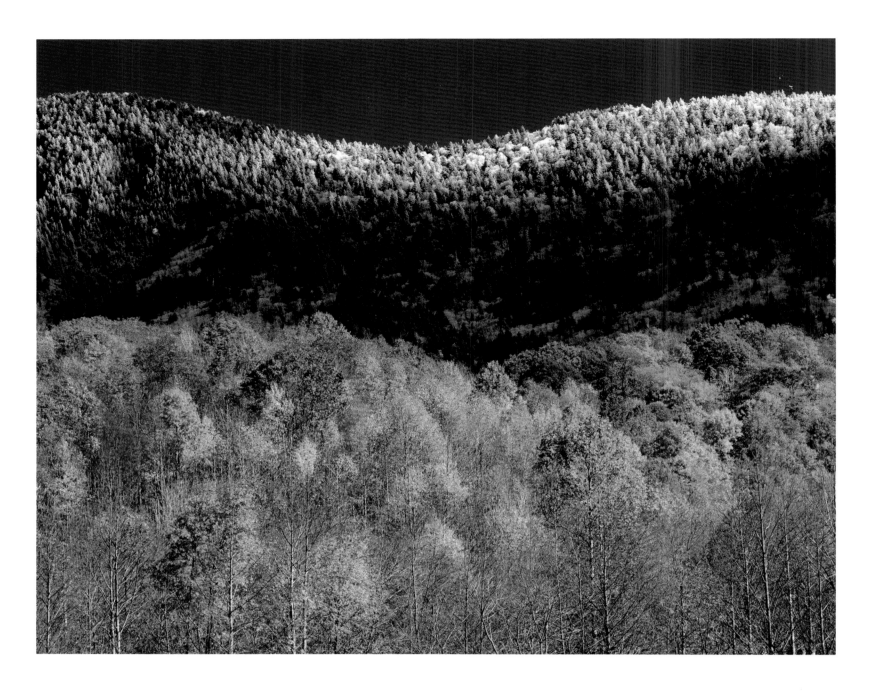

Mt. Mitchell State Park, Blue Ridge Parkway Milepost 355, viewed from Celo, North Carolina
Winter comes early to the heights of Mt. Mitchell, at 6,684 feet the tallest mountain east of the Mississippi River.

(OPPOSITE) *American chestnut stump and nursery-grown seedling, Shumont Mountain, North Carolina*
Until an imported fungus killed them in the early twentieth century, chestnut trees were the most abundant and
valuable timber in the Southern Appalachians. Their rich nuts fed people and wildlife, and their rot-resistant
wood provided building materials from cradle to coffin. The American Chestnut Foundation is breeding blight-
resistant seedlings for a new generation of this critical missing component of forest biodiversity.

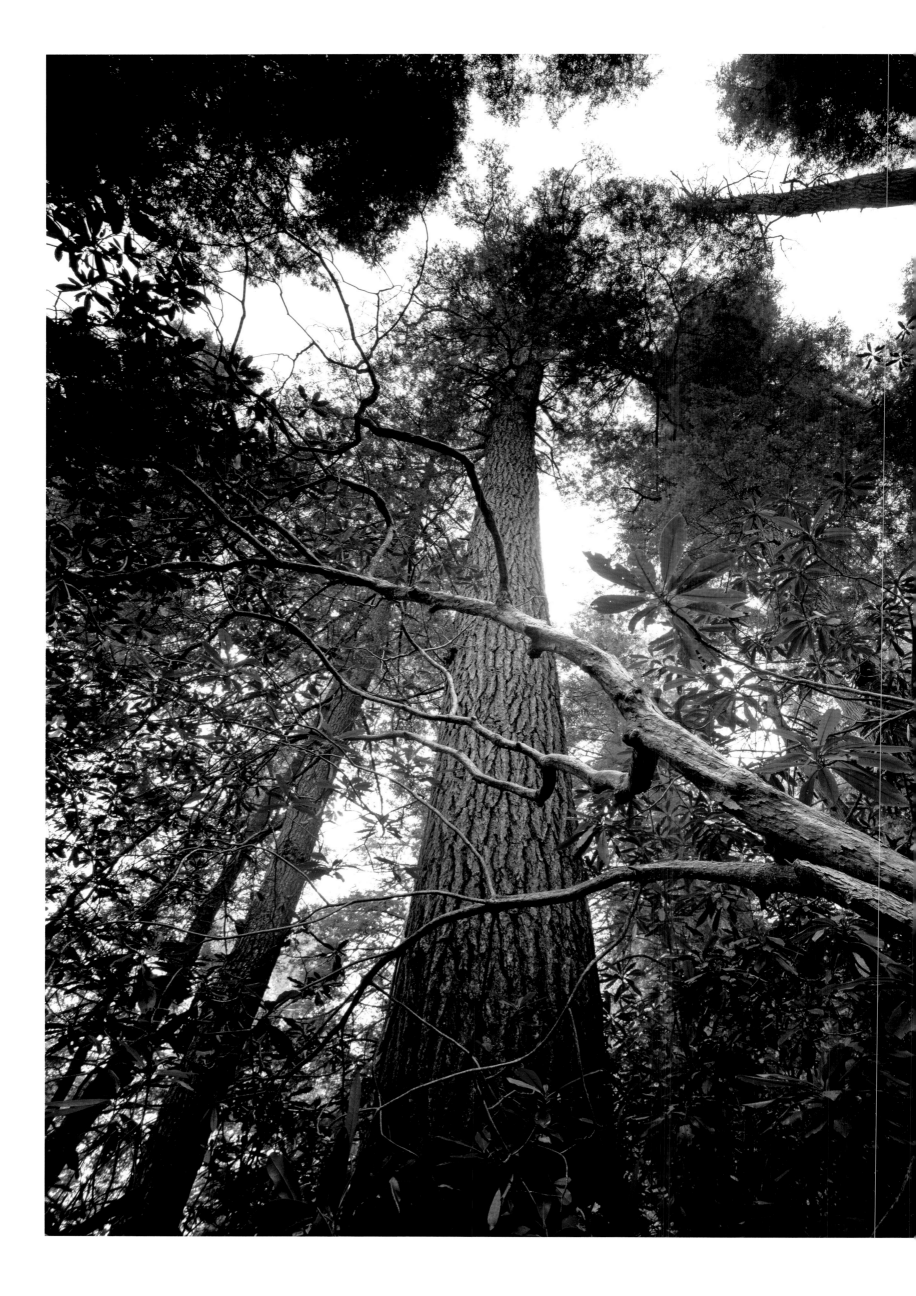

(ABOVE) *Hooper Bald, Nantahala National Forest, North Carolina*
Ice encases Hooper Bald's famous copper azaleas, which produce exceptionally large and bright orange blooms, as well as the shrubs and small trees that are crowding them out. Volunteers working with the U.S. Forest Service are cutting and pruning around the azaleas here and on other balds where the process of forest succession threatens to overwhelm them.

(BELOW) *Rainbow Falls, Pisgah National Forest (adjacent to Gorges State Park), North Carolina*
Rainbows in summer spray disappear into winter whitewater, but the force of erosion continues. Water and wind have worn down Southern Appalachian rocks into soil over hundreds of millions of years.

(OPPOSITE) *Eastern hemlock, 54.6 inches in diameter at breast height, Cataloochee, Great Smoky Mountains National Park, North Carolina/Tennessee*
Dead hemlocks have become a common sight here since the early 2000s, when hemlock woolly adelgids first appeared in the Park. Usually carried into the United States via horticultural imports or packing materials, nonnative insects, diseases, and invasive plants are one of the greatest threats to native Southern Appalachian biodiversity. The National Park Service is trying chemical insecticides for the short term and three species of predatory beetles for long-term biological control of the adelgids, in hopes of saving at least some hemlock trees.

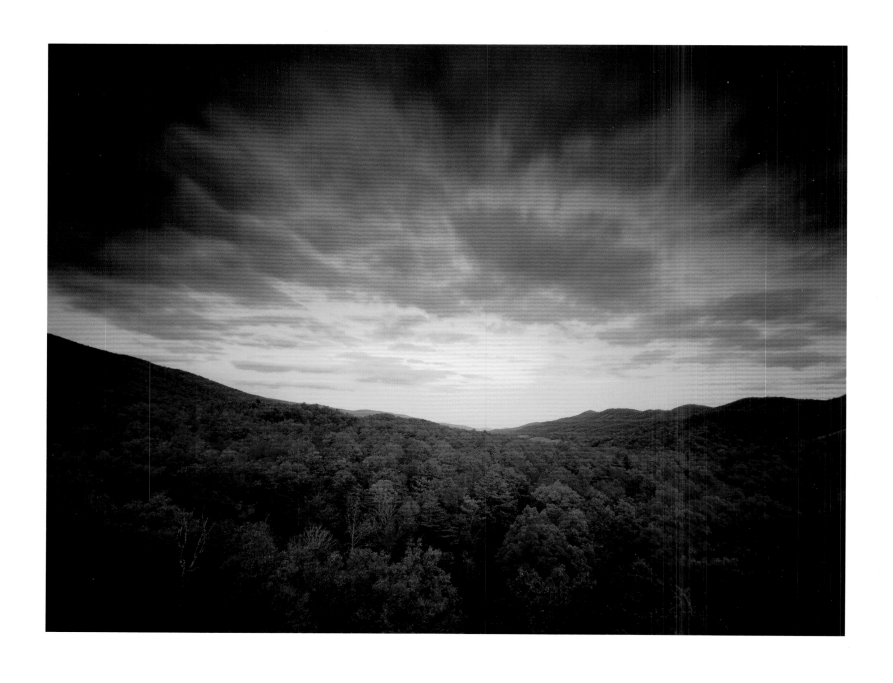

Big Walker Mountain, Jefferson National Forest, Virginia
When skies are clear, a walk up the 100-foot tower on Big Walker Mountain will reward you
with pastoral views into five states. Below, forests on the mountainsides and farms in the valleys
continue a traditional pattern of human occupation of the Southern Appalachians.

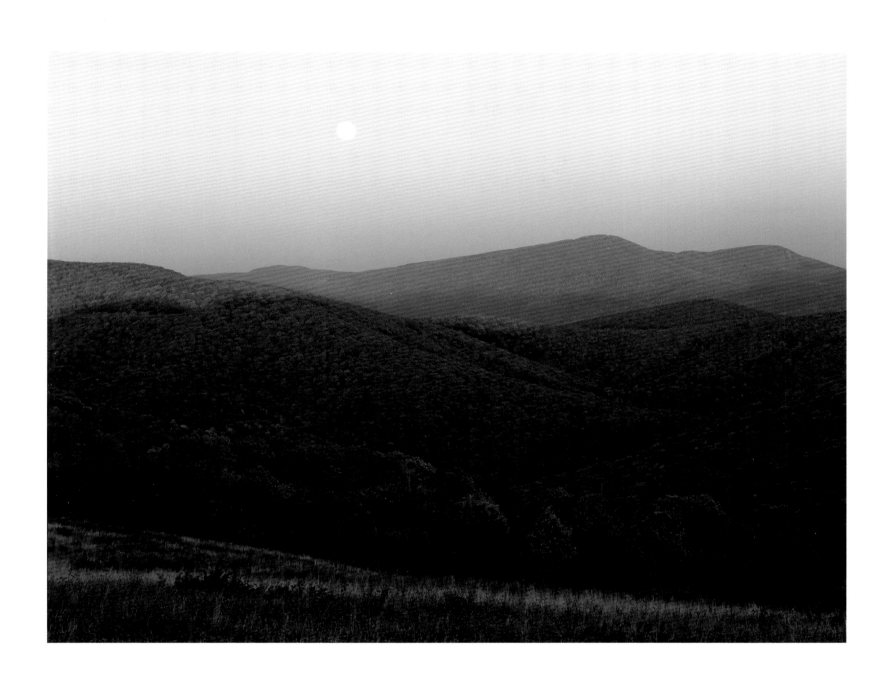

Humpback Mountain, Blue Ridge Parkway Milepost 6, Virginia
How many moons have passed over the Southern Appalachians? Time has been generous to these ancient mountains, allowing them to build complex communities of forests like no others on earth.

<div style="writing-mode: vertical">*Acknowledgments*</div>

My father, J. Manson Valentine, was ahead of his time as he explored deep into a scientific understanding that nature's evolution was empowered by a spiritual principle connecting all life. His philosophical view of evolution was substantiated by extensive research into biological life forms and was elaborated in his book *The Miracle That We Call Evolution*. He was well versed in archaeology and anthropology, giving him a well-rounded historical and humanitarian view of the world. And he was one of the first proponents of continental drift, as a result of his astute biological studies connecting the cave beetles of the Cumberland Caves of Tennessee to similar fauna found in the Old World. I quote from Walter B. Jones, state geologist, the Geological Survey of Alabama (Museum Paper 34, University, Ala., 1952): "Assuming that the anophthalmid fauna of eastern North America (south of glaciation) does consist of two, separate stocks, both of Eurasian origin, would we be any closer to a solution of this puzzling problem of distribution by introducing continental drift?" This globally important breakthrough that biologically connected the two continents via minute blind cave beetles, which survived major cataclysms, is astounding. The discovery was made before the emergence of the shifting tectonic plate model that now verifies the Old World's bond with eastern North America.

The insect linkage of the Appalachians to other parts of the planet to the east is as important as the flora connection to the Asian world. Manson Valentine wrote in "Wilderness Gardens" that

> the Appalachian flora of our Eastern continental slopes is precisely mirrored by the mountain flora of Eastern Asia, particularly China and Japan! Dominating the scenic beauty, as in the Carolinas, are the flowering shrubs, especially the rhododendrons, azaleas and laurels. Carpeting the ground is the same old galax, and even a Japanese version of our dog hobble (*Leucothoe*), that bane of Appalachian explorers. In sporadic abundance are the same groups of similarly painted trilliums and orchids. Some of the latter are so closely related to Eastern American species that they are almost identical. *Cypripedium flaveum* of the East and *Cypripedium reginae* of the West, for example, are two such parallel species. This, of course, is our showy lady slipper. Even some of our forest rarities are represented in Japan. I am thinking primarily of the endangered and highly localized *Shortia galacifolia*, that star of our South Carolina highlands known as Oconee bells. As for woody trees, practically every genus found in our Southeastern ecology is represented in the Eastern Orient, including such distinctive species as our sassafras and chestnut! Sharing similarly split ranges are our flowering shrubs, including the shad bush and redbud.

My father and I have joined our photographic talents to present a celebration of inflorescence in chapter 4 of this book, titled "Thinking Like a Wildflower." He used his vintage Voightlander camera equipped with a Zeiss lens, while I used 4"x5" Plaubel and Calumet vintage view cameras equipped with Schneider lenses. We both got under a black cape and looked at the image upside down on a ground-glass focusing plate. He used the old reliable 35mm Kodachrome, ASA 8, in the 1940s and 1950s, while I used 4x5 Ektachrome, ASA 64, and Fujichrome, ASA 64. His incredible flower images appear on pages 69 (Carolina lily), 72 (yellow lady slippers), 72 (pink lady slippers), 73 (Oconee bells), 73 (showy orchid), 75 (toadshade trillium), 77 (dogwood blossoms), and 77 (flame azalea).

The inspiration and photographing for the development of this book has spanned more than four decades. Special recognition needs to be given to the Blumenthal Foundation, the Lyndhurst Foundation, the Land Trust Alliance Southeast Program, The WILD Foundation, and The Wilderness Society. A number of people deserve special thanks: Bill Mead-

ows, for his foreword; my long-time dearest friend Bob Zahner, for his introduction, and Glenda Zahner, whose love for the mountains goes very deep; Chris Bolgiano, whose text makes the Appalachians come alive, and her husband Ralph; Jennifer Michaels, whose love is endless; Cy Peck Jr., who celebrates the great spirit in all things; Rob Messick, old-growth researcher; Will Blozan, arborist; Moseley and Helen Waite; Franklin and Louise McCoy; Sid and Sue McCarty; Thomas S. Kenan III; Dr. J. Dan Pittillo; Dr. James T. Costa; Dr. Gary Wein; Dr. Thomas G. Barnes; Dr. D. Bruce Means; Dr. L. L. Gaddy; Dr. Peter White; Philip and Amy Blumenthal; Rhea Rippey; Charles E. Roe; William Friday; Jim and Betsey Fowler; Rev. Rufus Morgan; Peter Kipp-duPont; and my dearest loving mother, Elizabeth, who had a master's degree in chemistry and gave so very much during her lifetime, encouraging me to fully embrace nature; and finally my children—Lisa, Phillip, Mark, and Forest—who have always been so wonderfully supportive.